WAR HORSE

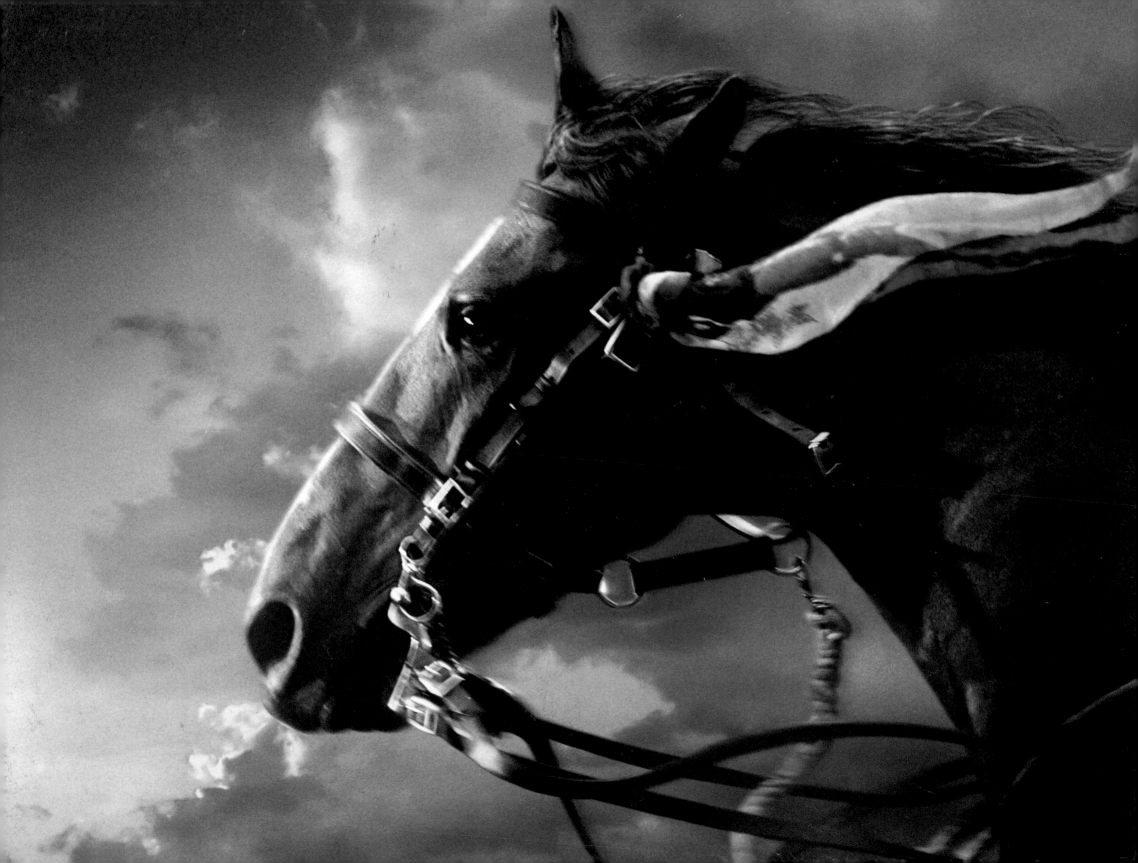

A STEVEN SPIELBERG FILM

WAR HORSE

THE MAKING OF THE MOTION PICTURE

Forewords by STEVEN SPIELBERG, KATHLEEN KENNEDY,
MICHAEL MORPURGO, *and* RICHARD CURTIS

Screenplay by LEE HALL *and* RICHARD CURTIS

Based on the Novel by MICHAEL MORPURGO

Interviews by LAURENT BOUZEREAU

Edited by CHRISTOPHER MEASOM *and* KEITH HOLLAMAN

Designed by TIMOTHY SHANER

A NEWMARKET PICTORIAL MOVIEBOOK

There are big days,
and there are small days . . .

Designed Timothy Shaner at Night & Day Design (nightanddaydesign.biz).

HarperCollins books may be purchased for educational, business, or sales promotional use.
For information address HarperCollins Publishers, 10 East 53rd Street, New York, NY 10022.

FIRST EDITION

Library of Congress Cataloging-in-Publication Data is available upon request.

ISBN 978-0-06-219261-5

11 12 13 14 15 PHO/NJ 10 9 8 7 6 5 4 3 2 1

www.newmarketpress.com

Other Newmarket Film and Entertainment Books include:

Angels and Demons: The Illustrated Movie Companion

Anonymous: William Shakespeare Revealed

The Art & Making of Arthur Christmas

The Art of How to Train Your Dragon

The Art of Monsters vs. Aliens

*Bram Stoker's Dracula: The Film and the Legend**

*Chicago: The Movie and Lyrics**

*Dances with Wolves: The Illustrated Story
of the Epic Film**

*E.T. The Extra-Terrestrial: From Concept to Classic**

Gladiator: The Making of the Ridley Scott Epic Film

*Good Night, and Good Luck: The Screenplay and
History Behind the Landmark Movie**

*Hotel Rwanda: Bringing the True Story of
an African Hero to Film**

The Jaws Log

*Making Tootsie: A Film Study with
Dustin Hoffman & Sydney Pollack*

Memoirs of a Geisha: A Portrait of the Film

Milk: A Pictorial History of Harvey Milk

The Mummy: Tomb of the Dragon Emperor

*Ray: A Tribute to the Movie, the Music, and the Man**

Rescue Me: Uncensored

*Saving Private Ryan: The Men, The Mission,
The Movie*

Schindler's List: Images of the Steven Spielberg Film

*Titanic and the Making of James Cameron:
The Inside Story of the Three-Year Adventure
That Rewrote Motion Picture History*

*Includes the screenplay

Contents

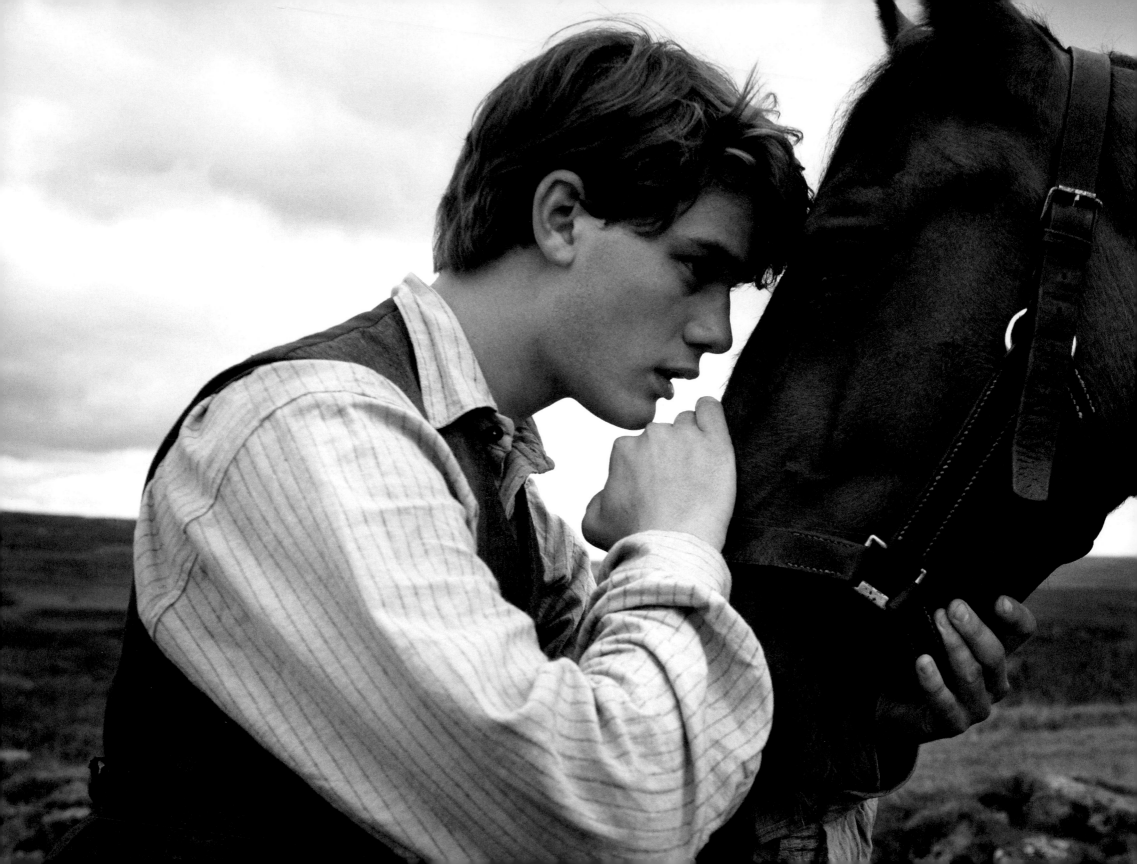

What Could Be Braver Than That?

by Steven Spielberg
Director

When the the Great War started, it was ironically called "the war to end all wars." Horses were once considered an essential offensive component of a military force, and a cavalry charge was, perhaps, the most superior shock tactic prior to World War I. Caught in the transition from manual to mechanized warfare, horses that had once been the mainstay in battles were now part of the shocking toll that contemporary combat was taking on its participants—both human and animal.

It was against this harsh reality that Michael Morpurgo found a beautiful story for his *War Horse*. I was immediately drawn to both the historical backdrop and the emotional depth of this story. The story of Joey encompassed his days on an English farm in the care of a young boy, Albert, to the grim canvas of wartime Europe where he, among soldiers of many nations, became a hero in his own right.

Through the eyes of Joey and Albert, I embraced the opportunity to explore the vast scope of World War I. Despite the exposition to the horrors of war and the shattering of their innocence our heroes encounter on their journey to be reunited, this film is not about who is right in war. It is about the remarkable humanity that an animal is able to bring to these characters—be they English, German, or French.

Beyond the backdrop of the War, there were two distinct stars in the film. The first was the Dartmoor region of England. I have never before

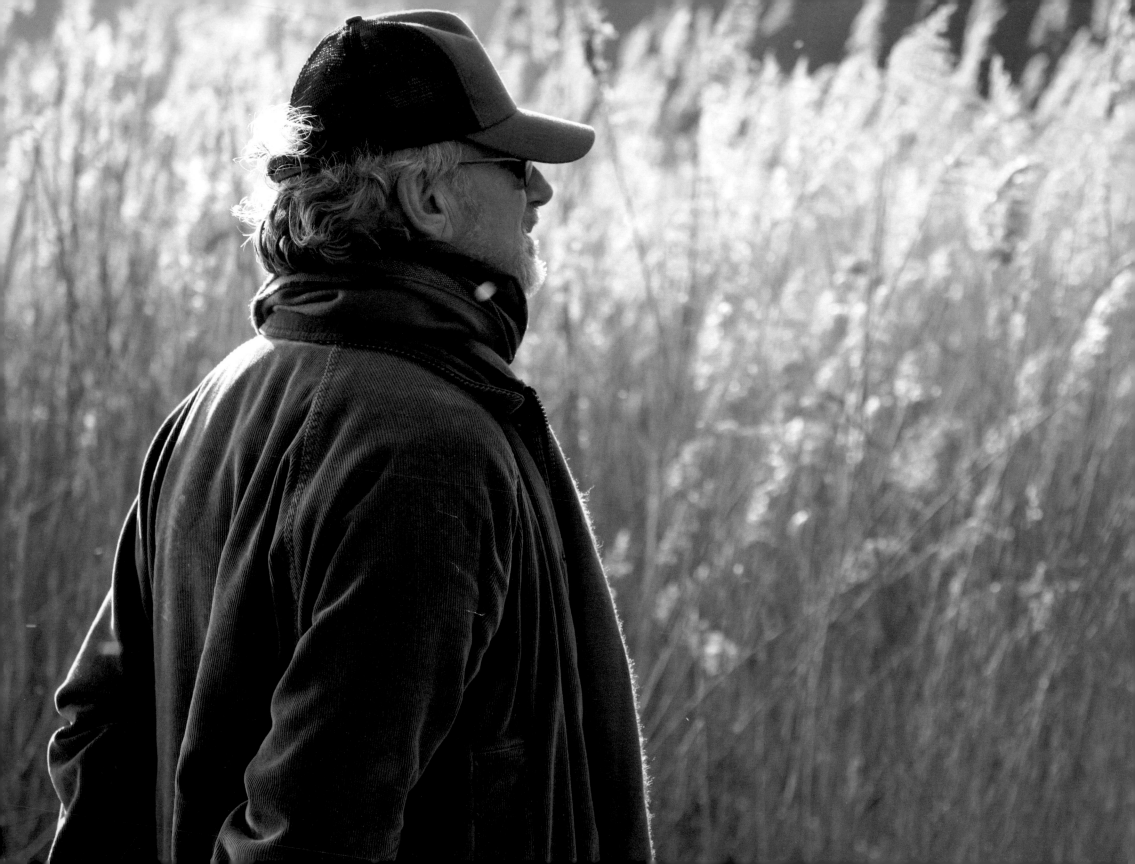

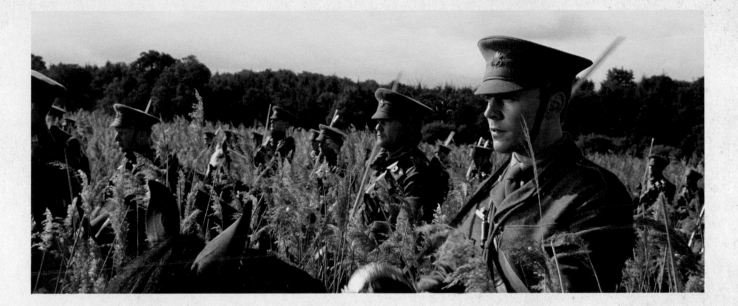

been gifted with such an abundance of natural beauty. Despite my extensive coverage of landscapes and skies, I hardly scratched the surface of the visual opportunities that were offered to me. It was a breathtaking place and a particularly rewarding experience to be there on location.

The other stars of *War Horse* were our extraordinary horses. On screen, the film illustrates the many contributions and sacrifices horses made to and for the war. Behind the camera, we witnessed firsthand their amazing contributions to our film. Having lived with horses for so many years, I knew they were intuitive and that they would capture the emotion we ourselves were feeling while filming this beautiful story in such an exceptionally beautiful countryside.

War is a heartbreaking part of life, and unfortunately World War I was not the "war to end all wars," as they forecasted once upon a day. When I thought about that prediction and the conflicts that have transpired since then, I found myself looking for the distinguishing characteristic of this past century of warfare. I believe it is courage.

I first fell in love with the story of *War Horse* because I was moved by the relationship between a boy and an animal in Michael Morpurgo's novel and the screenplay by Richard Curtis and Lee Hall. But, ultimately, I made it because of what both the book and the screenplay say about courage. It is about the courage of Joey and what he endures to survive and the courage of Albert in his attempt to find his best friend in a time of war.

With every frame of this film, it was my hope to issue a call for courage in our daily lives, a call to "be brave." ■

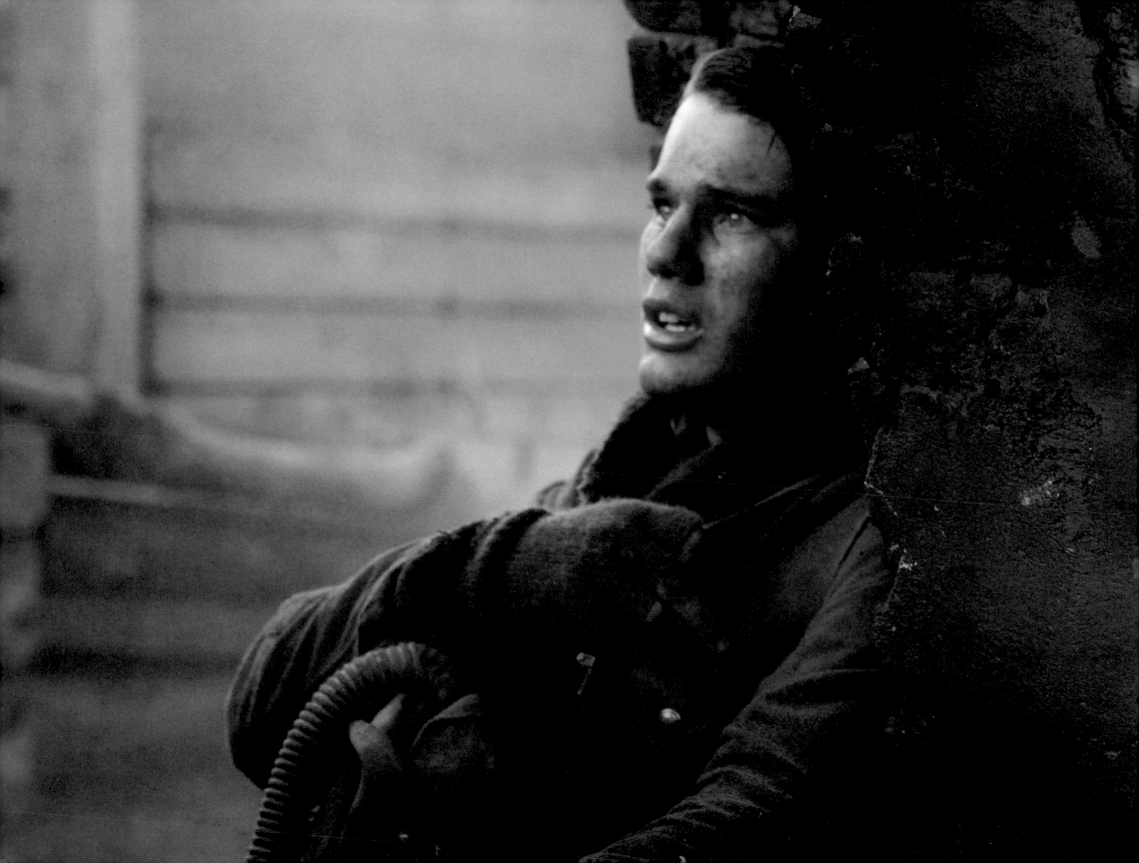

The Undying Human Spirit

by Kathleen Kennedy
Producer

The story of *War Horse* is that rare idea that gives rise to a book, a play, and a film, and with every retelling takes full advantage of the medium's unique creative opportunities, while still capturing the narrative's dramatic core. And in each form, it remains engaging and accessible for audiences the world over.

Originally published in 1982, Michael Morpurgo's novel is a vivid and emotional chronicling of the beauty of pastoral Devonshire, the horrors of the front lines of World War I, the test of true friendship, and the charity, kindness, and generosity of which humans can be capable, even in the near absence of hope. Told entirely from the perspective of Joey, the horse, the story serves as the reader's window into the undying human spirit during one of the most brutal periods in our recent history. And while the book is a work of fiction, it captures an authentic essence of the war and the true nature of those individuals made to endure it.

At the National Theatre, Tom Morris, Marianne Elliot, and Nick Stafford, in tandem with the innovative work of the Handspring Puppet Co., transformed the book into a magnificent stage show and convinced countless audiences that life-size amalgams of sticks and wire were living, breathing horses.

It is an exploration of the human capacity for love and innocence, even in the darkest of times.

After seeing that show and then promptly tracking down my own copy of Michael's book, it was impossible to deny the power of *War Horse*. It had succeeded both on the page and stage, and I could not help but think, "Why not a film?" Steven Spielberg's validation of that instinct and his natural love of horses created the perfect opportunity for our own cinematic adaptation.

War Horse was one of those unusual productions that comes together in an incredibly short time, and for all the right reasons. Everyone involved understood the film's potential, the richness of the characters, the depth of emotion, and the strength of the story's message. Working with that level of creative synchronization is a rare and wonderful experience.

War Horse, on the surface, is deceptively simple: a boy joins the army to find his horse.

It is the layers added by their separate journeys and the resonant characters they encounter along the way that give the story its complexity and gravity. And even though the central character is a horse, the story is, perhaps, more telling of humans than it is of animals. It is an exploration of the human capacity for love and innocence, even in the darkest of times; Joey serves as the reminder of this potential for those people with whom he comes into contact. It is through steadfast adherence to this central theme that the story can be told in so many iterations.

The honor and privilege that it was to be a part of *War Horse* will never be forgotten, and I hope that this story touches you just as it has me. ■

RIGHT: Kathleen Kennedy on set with Joey.

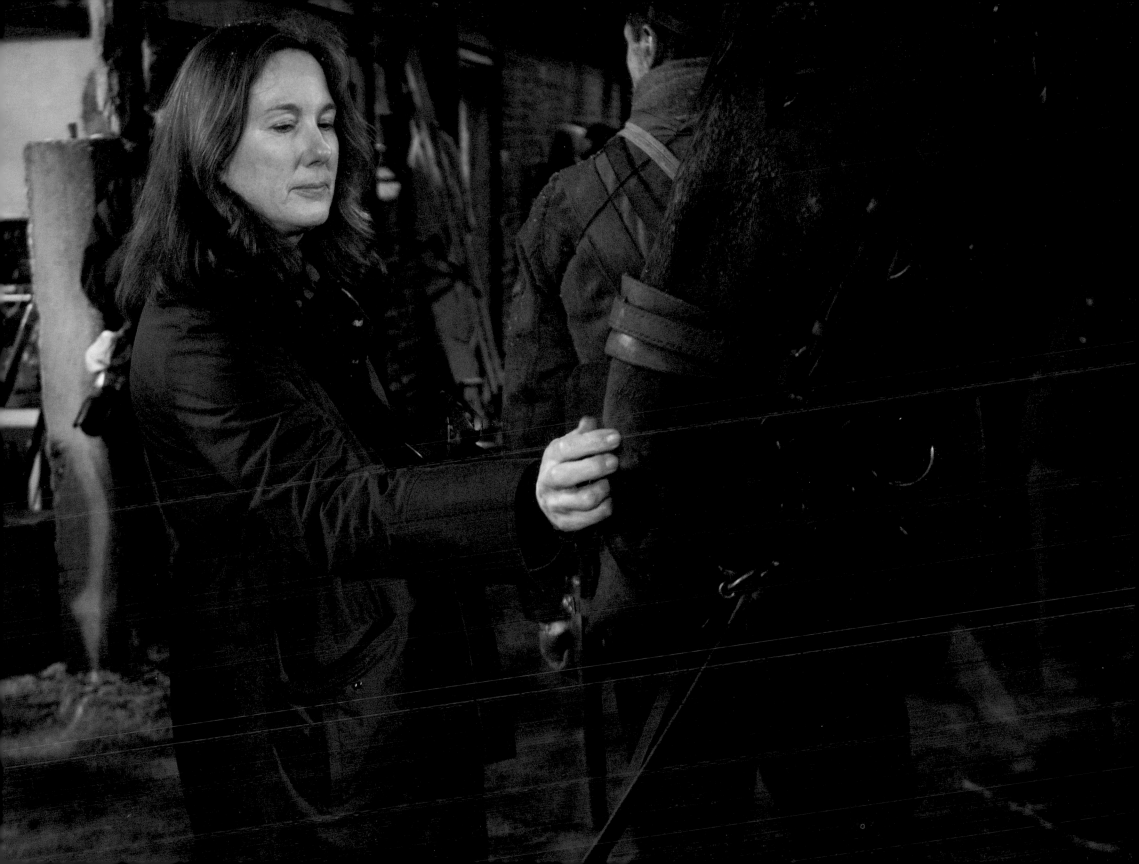

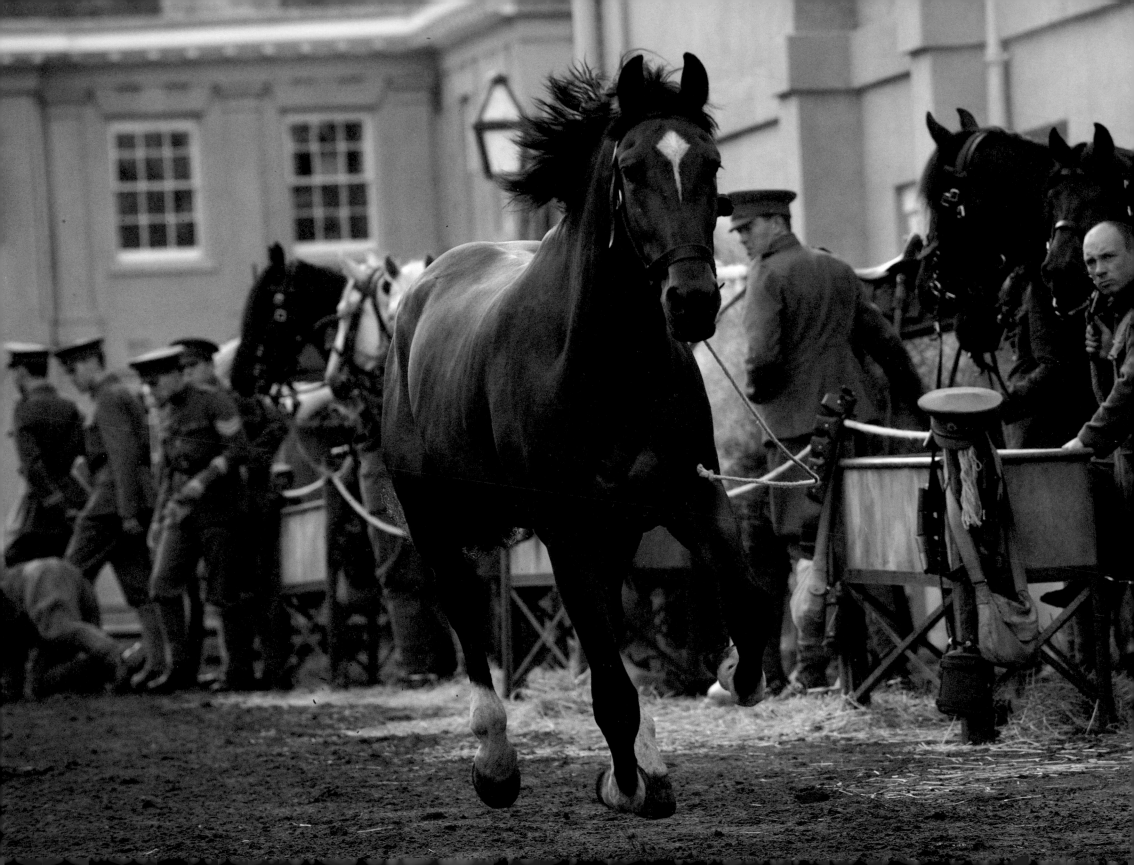

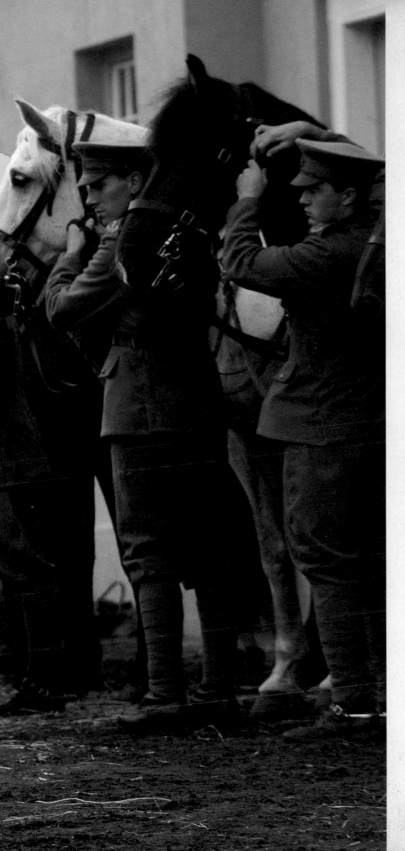

A Human Animal Story

by Michael Morpurgo
Novelist

For me, the beginning of a book is fired by a combination of good fortune and coincidence; if I try to plan and to plot my characters or my stories, I find that I enter them with a dead weight around my feet. It was as true when I started writing as it is today. And when it came to thinking about the book that would become *War Horse*, over thirty years ago now, I still remember what it was that prompted me to begin.

At the time I was deeply involved in a story of a white horse, the white horse of Zennor, for a collection of twentieth-century legends. It might seem, looking back, that I was obsessed with horses. I wasn't. But my wife, Clare, and my daughter, Rosalind, certainly were and, no doubt, a little of it rubbed off on me. Through them I certainly gained some insight as to the depth of the bond and understanding between a horse and a rider. But I have always preferred the docility of cows. And, at the time, I had a lot to do with cows. From the mid-1970s onwards, with Clare, I ran the educational charity, "Farms for City Children," and spent most of my waking hours working with teachers and children from inner-city schools, involving them in the life of a farm and a farmer, feeding pigs, milking cows, checking sheep, collecting eggs, and grooming horses.

I would squeeze in my writing between times and in the school holidays. But some evenings, I would take advantage of my captive audience and go up to the Victorian house where the children stayed and use them as guinea pigs

I began to wonder then about the consequences,

the casualties, the blind brutality of war.

for whichever story I was writing, reading aloud to them before bed. I would know immediately if I'd been over-wordy or patronizing or had simply missed the mark. Their coughs and yawns would say it all.

I learned over those years that everything that one writes for children should be able to be enjoyed equally by grown-ups; that children have a far greater perception and sophistication than we give them credit for; that the great children's books are also great books, full-stop: Hughes's *The Iron Man*, Kipling's *Just So Stories*, Stevenson's *Treasure Island*, Pullman's *His Dark Materials*. The bar is set high: inventive, resonant, exciting, funny, and disturbing—sometimes all in one book. And I knew that this is what I had to aim for too: not to write children's stories, but to write stories engaging enough that they would be stories for grown-ups too.

Perhaps it was because I wanted a distraction from the book I was supposed to be writing that I ended up one afternoon in our attic. In amongst the usual junk, I came across a picture propped up against a box of books. It had prob-

ably once belonged to my father-in-law, a watercolour drawing of a cavalry charge from the First World War. I looked at it more closely than I must have done before. This time I could see that the horses were being charged forward into No Man's Land straight into the wire. The full horror struck home. How unbelievably stupid the generals must have been to have ordered such an attack. And I began to wonder then about the consequences, the casualties, the blind brutality of war.

I read around the subject—I couldn't get it out of my head. And then I happened to mention the picture up in the pub in my local village of Iddesleigh in Devon, to some of the old men who lived there. A couple of them were old enough to have experienced that war at firsthand. They began to tell me stories of their time in the yeomanry, stories of the relationships that would develop between a horse and his trooper. Through them I was able to relive something of those hellish years and to learn how much their horses had meant to them. It occurred to me that it would not be long before there was no one left to pass on such direct accounts and I determined, with

their blessing, that I would do what I could to write their experience down. Not in a historical way—that had been documented well enough already—but in a way that would bring the human and the animal story alive, one which I hoped would inform as well as move a reader who, at this remove, might have no conception of either the history or the horror of the First World War. To it, I brought my experience as a bit of farmer, as a bit of teacher, and as a bit of a writer—a jack-of-all-trades, you might say.

War Horse is the story of the life of a horse, Joey—the separation from his mother in an auction ring in Devon, his early friendship with a young farm boy, his training as a working farm horse, to his selling on into the army as a cavalry mount. It is Joey's experience as a war horse that forms the main narrative—his training on Salisbury plain, his shipping over to France, and his first bitter taste of the action on both sides of enemy lines. Along the way Joey befriends and is befriended by English and German soldiers alike; he even enjoys a period of respite on a French farm where he is adopted by an old

farmer and his daughter, Emilie. But it is the friendship between him and the farm boy, on which all subsequent friendships are based, that provides the narrative heart of the story—a tale of one horse and his boy.

I knew in writing this down that I had to strike a delicate balance. I did not want in any way to glorify war or to take a partisan stance. I didn't want to paint characters in black or white or to simplify a subject that is not simple. I wanted the reader to leave this book with his mind full of questions, not answers. Joey gave me a voice that was beyond patriotism. His was a gentle, compassionate voice that spoke on behalf of all conscripts, everywhere. And I am prouder than I can say that it has developed a life of its own, one that resonates and continues to resonate not only from the page, but from theatres and cinemas around the world, touching the hearts of many more readers than I could hope to have reached, and asking the questions that we need to keep asking. ◼

RIGHT: Michael Morpurgo on set with Joey.

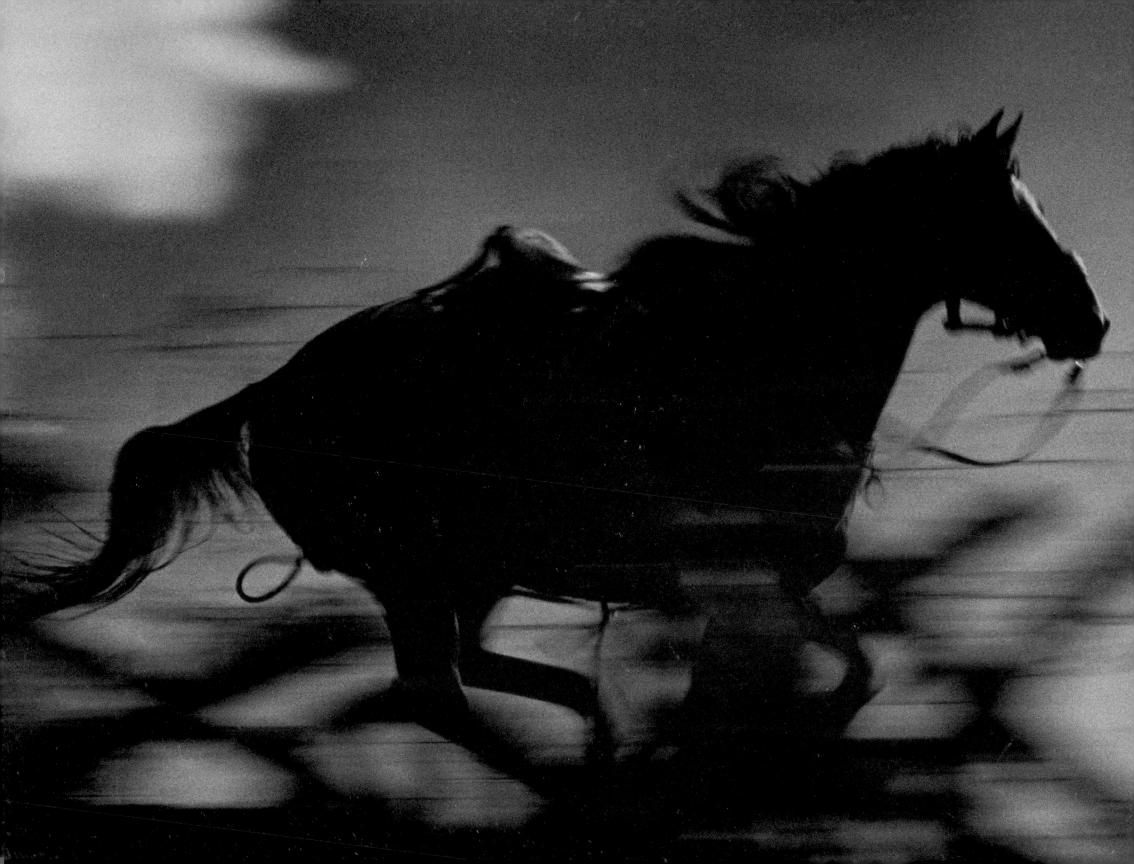

Following the War Horse

by Richard Curtis
Co-Screenwriter

I always assumed Steven Spielberg hated me. In Paris in 1994, *Four Weddings and a Funeral,* which I had written, was up against *Schindler's List* for best foreign film in the French Césars. It was so clear which was the better film that the presenter came on stage, looked directly at Steven, and said that if his film didn't win the prize, it would be a disgrace to the honour of France. Unfortunately, he then opened the envelope, and it turned out *Four Weddings* had won, a freak result because it was a public vote and *Four Weddings* had lots of stupid jokes in it. After the announcement there was total silence. Total disgrace for France. My poor girlfriend tried to start the applause. No one joined in. I wanted to

put a bag over my head and assumed that Steven wanted to put a noose around my neck. . .

So imagine my surprise when fifteen years later, Steven sat opposite me, no noose in hand, and asked if I'd like to think about working on the movie of *War Horse*. Of course, I said, "Yes." And then, "Sorry."

But before starting, I had to do my homework, and work out if I could do the job at all. The homework was wonderful. First I read Lee Hall's script, which seemed to me to have actually broken the back of the job. Then I saw the play, which is mighty and hugely emotional. Finally, I read the book—out loud as it happened, to my daughter, who was not well and in bed at

It's a curious thing that often you have to take the longest journey to get home again.

the time. This was the key experience—because seeing the intensity of my daughter's reaction to the end of the book gave me the courage to trust Michael Murpurgo's original structure, following the war horse right through the story.

I got back to Steven, Stacey Snider, and Kathy Kennedy with a few thoughts, and we decided I should have a go at the script. I needed to work fast, and it was a joy to do it. I hope I did some good work—what I *know* is that working with Steven was wonderfully not disappointing. The phone would go, it was Steven Spielberg on the line—that was fun enough. But then the conversations were really extraordinary—he has an ability to imagine whole chunks of cinema in a way that I've never come across at all, with anyone. I would have written a scene—then, on the spot, off the top of his head, Steven would suggest another, whole different one—completely imagined, in every detail. If I wasn't crazy about it, I'd say so—and Steven would immediately imagine a completely different scenario. If I liked that one, he'd just throw in a

third, completely new set of events, just in case number two didn't work in the end.

It's a curious thing that often you have to take the longest journey to get home again. I hope, after all the complex work it takes to get a film made, that we have returned to where it started, with Michael's beautiful book, expressing the courage of a horse at war. The play, with its amazing puppets, is so potent that more than once, when I've said I'm working on the film, people say, "But how are you going to do the horses?" I look a bit blank and say, "With horses." And then suddenly they click—and say, "Oh, yes, of course—real horses, that's right." But it was a real excitement when I came down to the set to see the beautiful, actual, magnificent horse, charging through the countryside or No Man's Land—all our work made living flesh and blood.

One day when I went to watch Steven work, I also met Michael, the author. Michael is a great hero in our household—my son Charlie's favourite book is the complex *Alone on a Wide, Wide Sea,* about an English orphan transported to Aus-

tralia in World War II. Jake loves the unbearably sad *Private Peaceful,* in a way a companion piece to *War Horse*—which they all love. Eventually Michael came to dinner at our house (ostensibly so we could talk, but really so the kids could meet him and get him to sign their books). He was in a bit of a rush because, having just spent a week in Palestine, he was about to go on a BBC late-night news programme to talk about the suffering of children in modern-day war. This is so typical of this excellent man. Many of his books have this particular, compassionate focus—rooting out sorrow and injustice in history and then describing it, modestly, personally, individually, through one particular tale. In that way, he is a perfect match with Steven—one element of the genius of Steven's work is to take the particular—and through that understand the epic. One boy, one extra-terrestrial revealing the wonder of the universe. One horse, one boy, revealing the horror and scale of the First World War.

I believe the journey of the *War Horse* is a brilliant way to talk about the First World War.

I've actually written about the war before, in the British situation comedy *Blackadder*. A strange idea, to try to deal with the horror with comedy—but strangely, it seemed to work. After five episodes trying to crack every joke possible about men with bad haircuts in trenches, we could, in the final episode, return to truth, and see all our characters die—just as all those millions of men had to die. *War Horse* deals specifically with the suffering of horses who were taken to war, almost a million of them. But it also touches on so many other things—the shared humanity of soldiers on both sides, the vulnerability of those on the fringes of the war, the first mechanisation of war, as machine guns first met flesh.

I hope through our film, a new generation will know more about, and be more interested in, that terrible war. I'm very honoured to have been part of the telling of the tale. ■

FROM LEFT TO RIGHT: Actors Jeremy Irvine (Albert), Matt Milne (Andrew Easton), and Robert Emms (David Lyons), on set with co-screenwriter Richard Curtis.

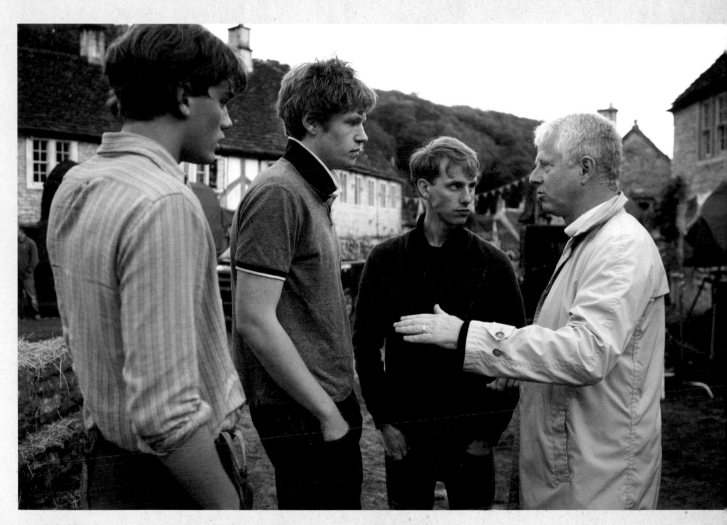

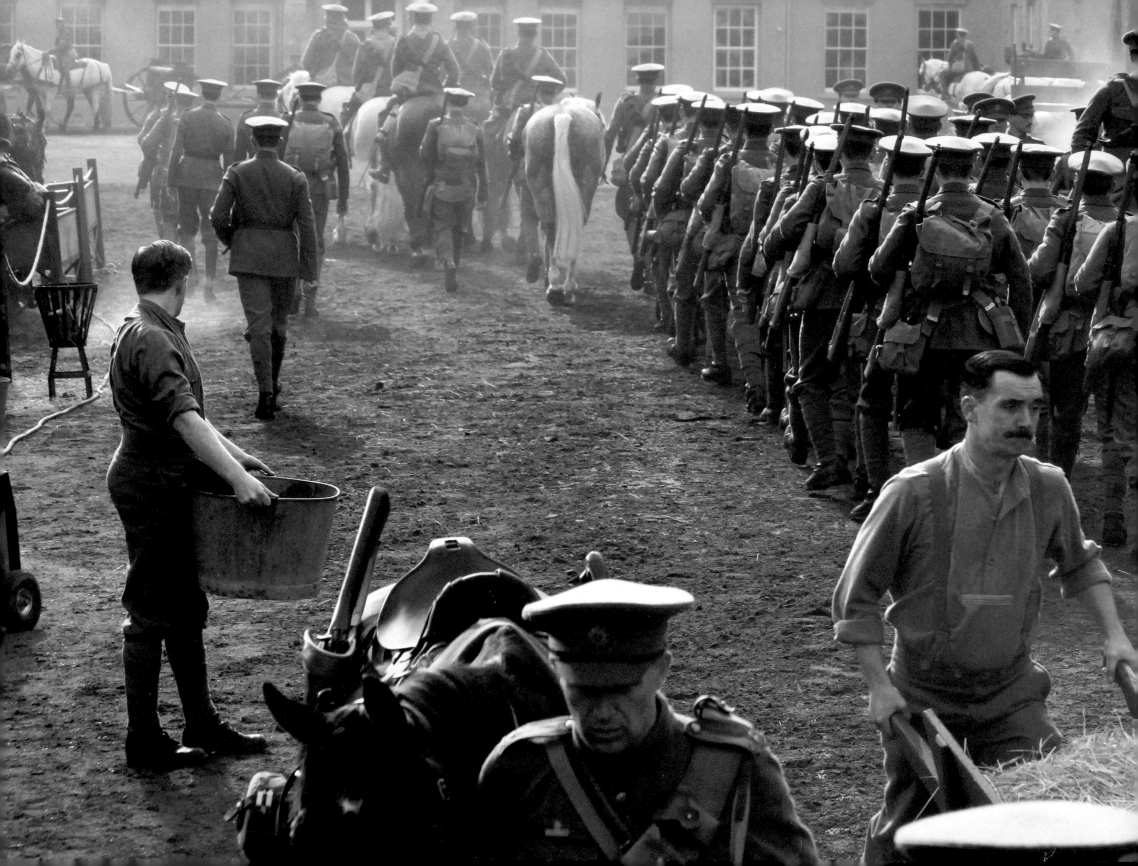

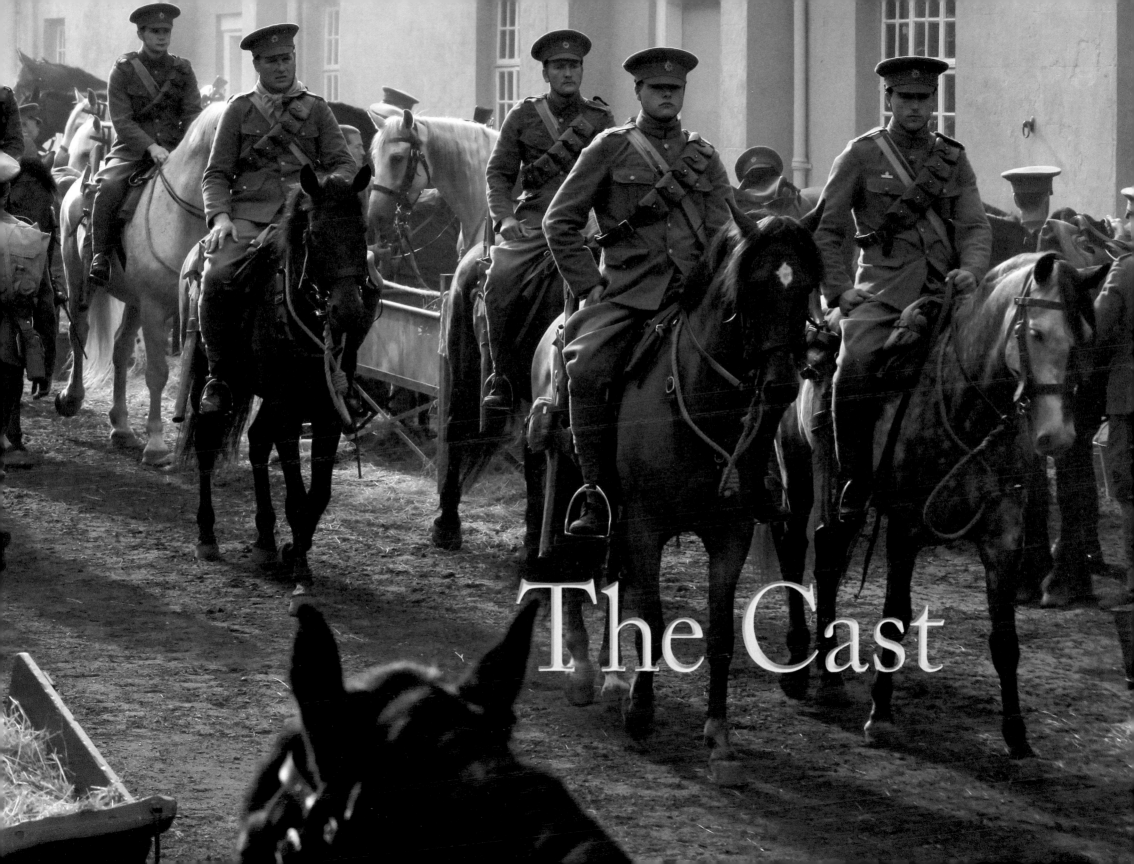

The Cast

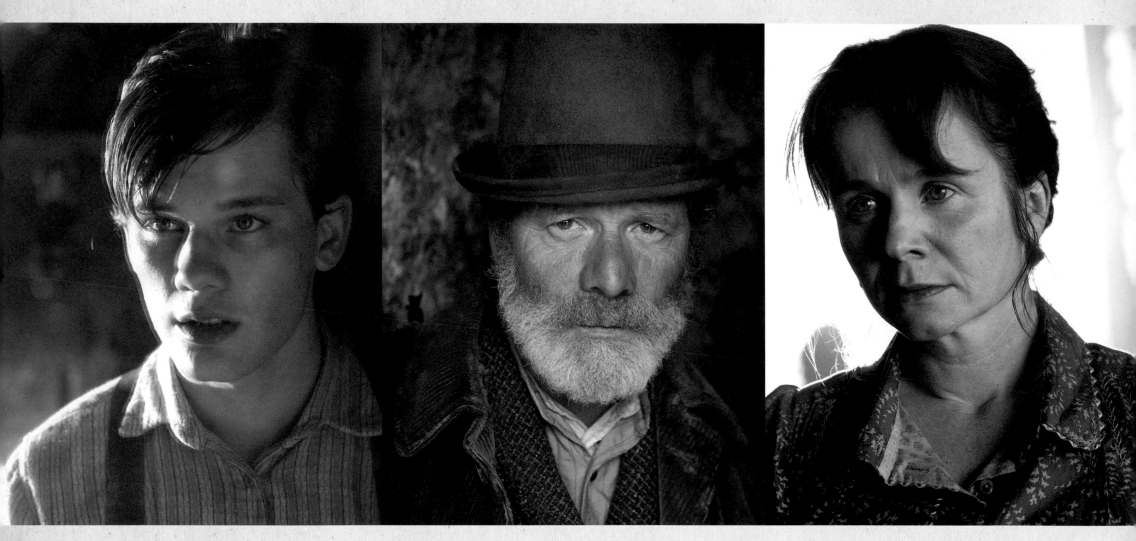

Albert Narracott
Jeremy Irvine

Dad—Ted Narracott
Peter Mullan

Mum—Rosie Narracott
Emily Watson

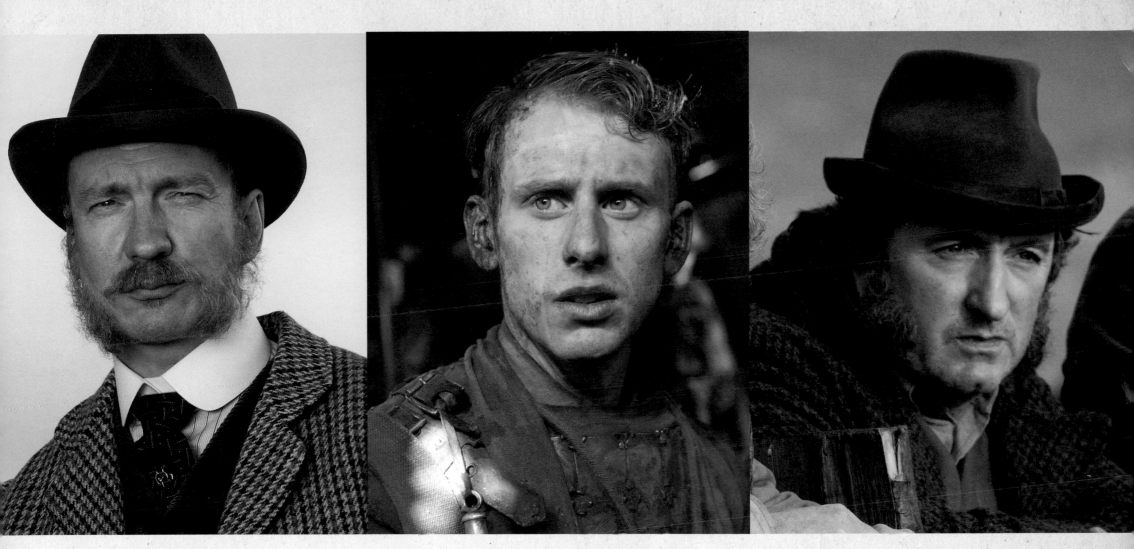

Lyons
David Thewlis

David Lyons
Robert Emms

Si Easton
Gary Lydon

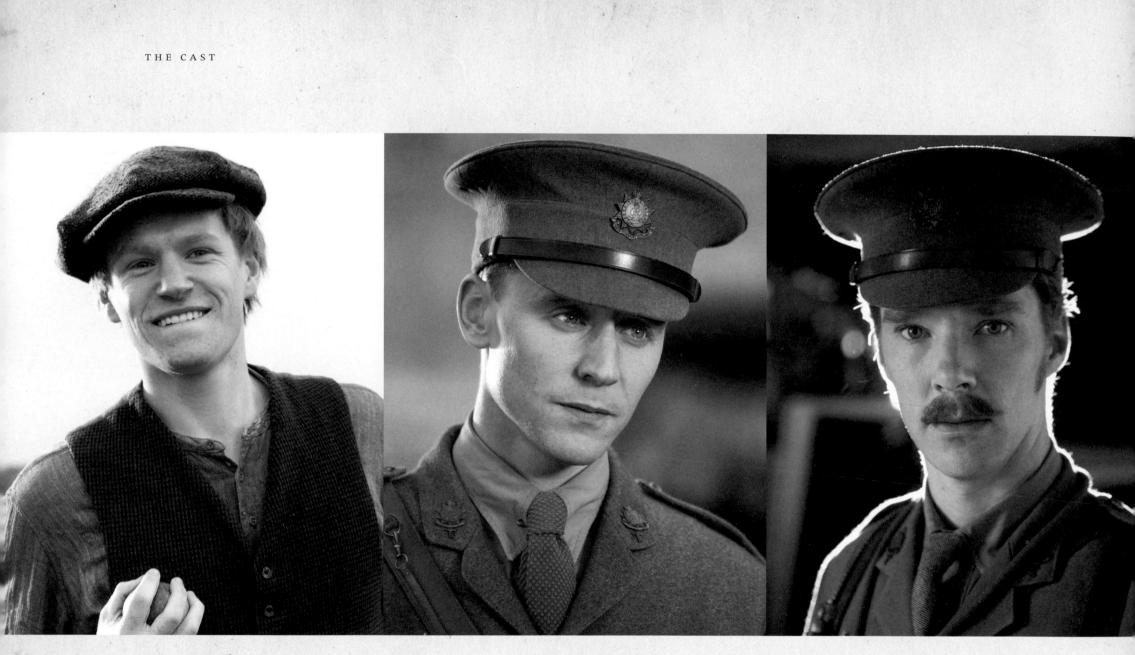

Andrew Easton
Matt Milne

Captain Nicholls
Tom Hiddleston

Major Stewart
Benedict Cumberbatch

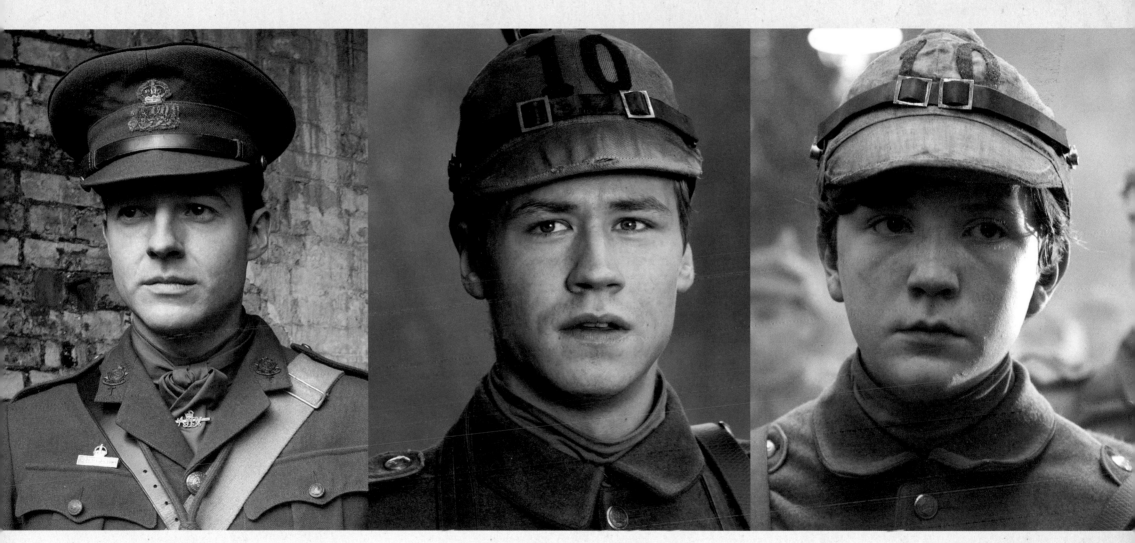

Lieutenant Waverly
Patrick Kennedy

Gunther
David Kross

Michael
Leonard Carow

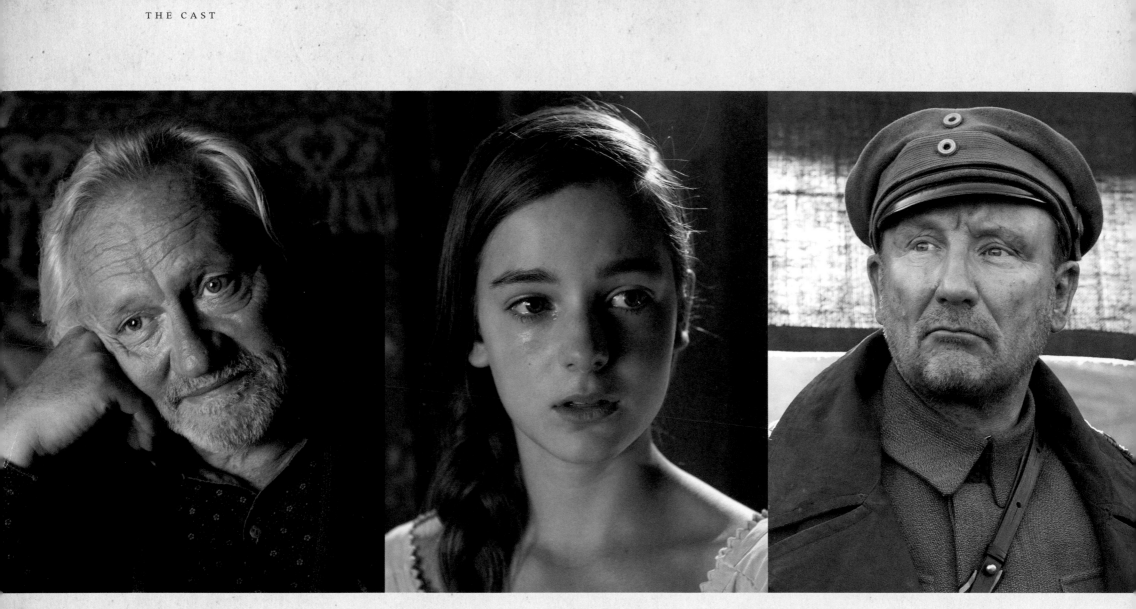

Grandfather
Niels Arestrup

Emilie
Celine Buckens

Brandt
Rainer Block

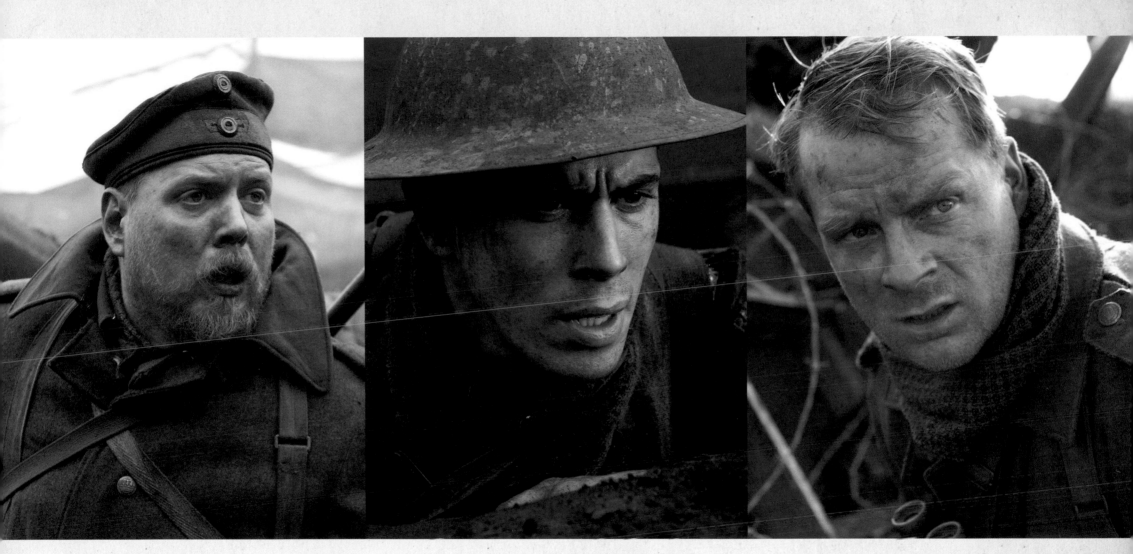

Friedrich
Nicholas Bro

Geordie Soldier
Toby Kebbell

German/Savoy Waiter
Hinnerk Schonemann

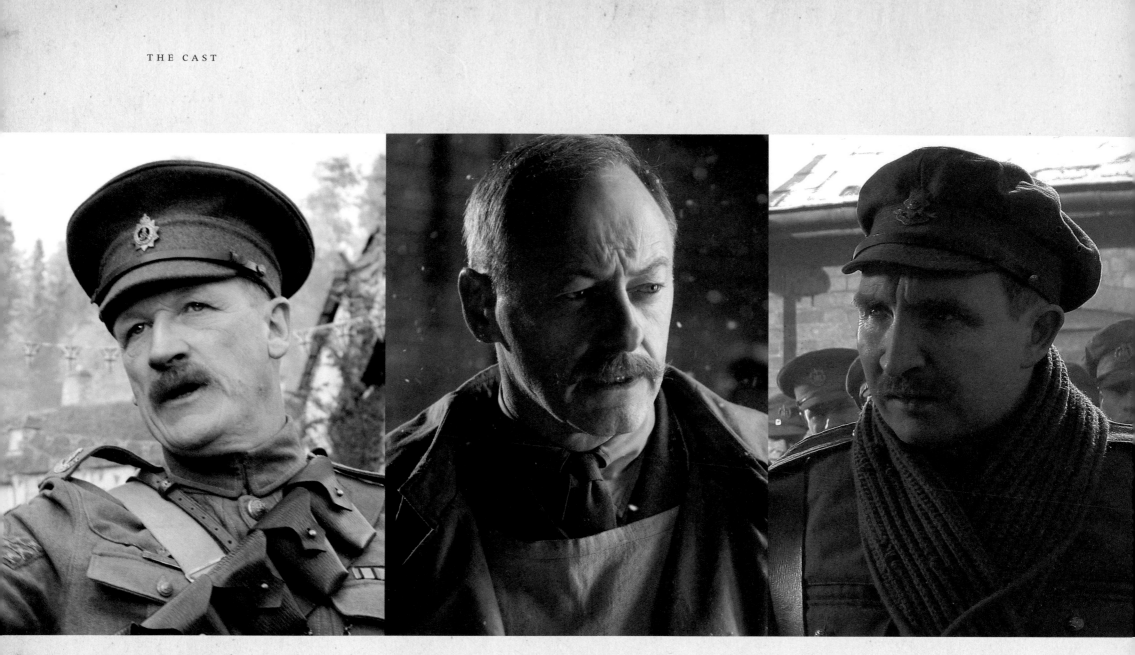

Sergeant Sam Perkins
Geoff Bell

Army Doctor
Liam Cunnningham

Sergeant Fry
Eddie Marson

Joey

Topthorn

Part 1
Joey's Journey

Life in Devon

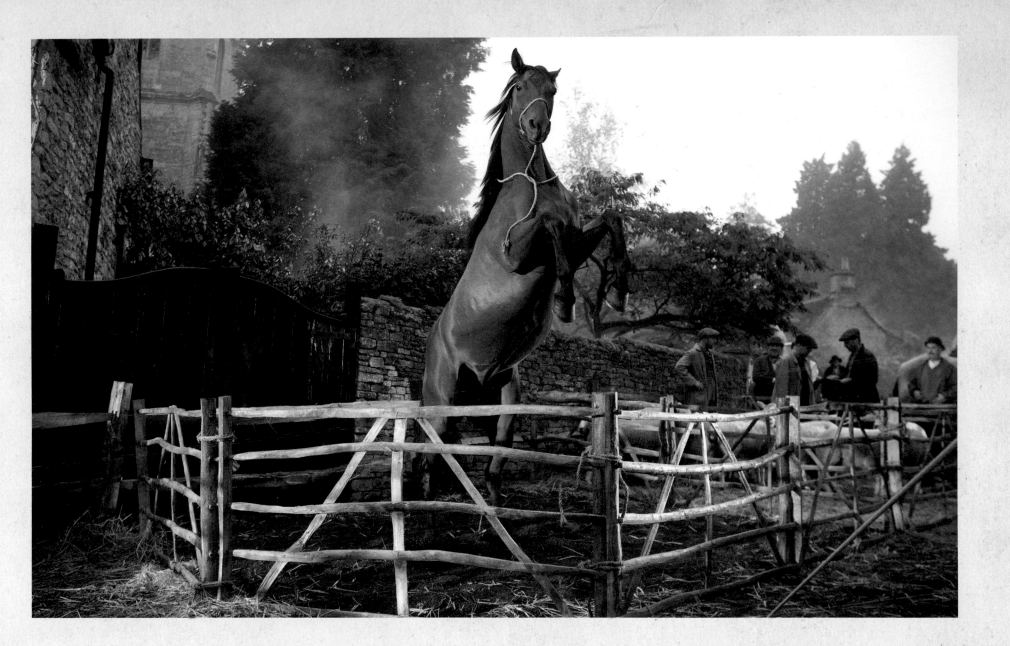

As Joey gets strong they run together, frolicking gayly in the last dregs of summer . . . a magnificent one year old. His distinctive red coat gleaming, now it is clear that he is half thoroughbred. He runs quickly around the field enjoying his own power and strength.

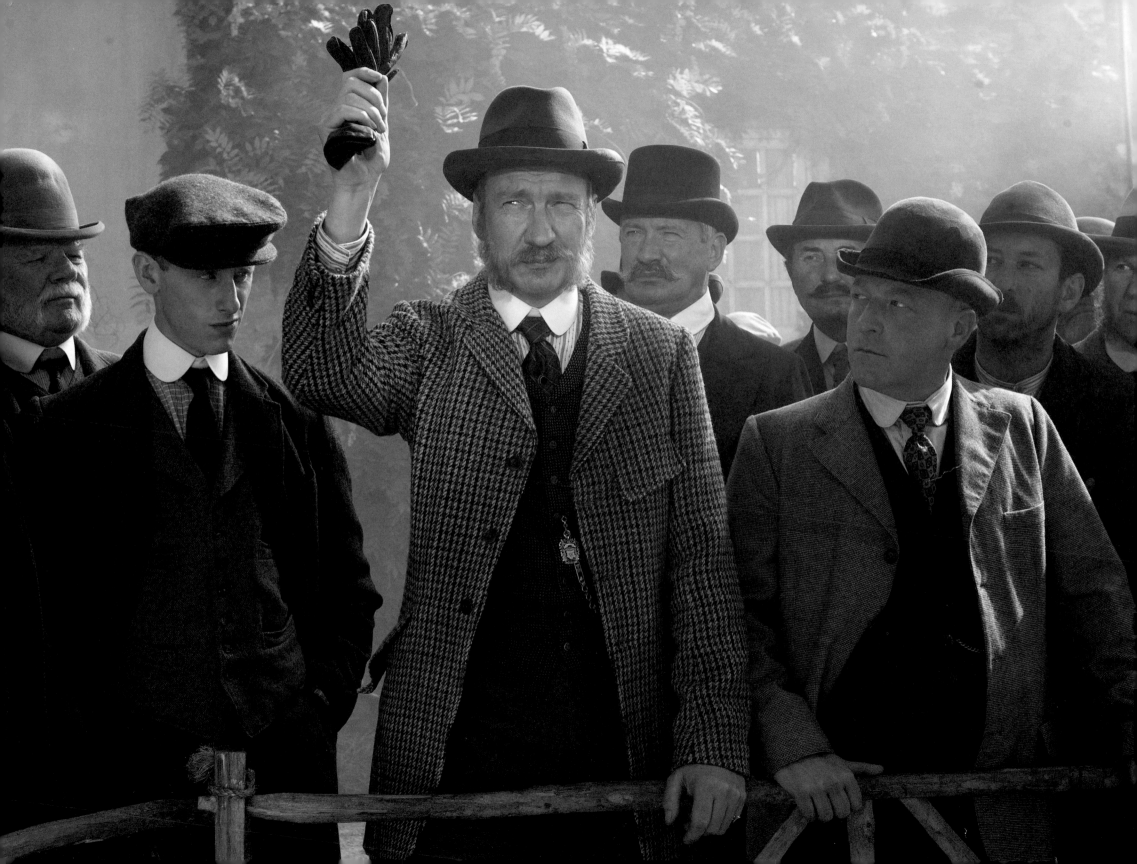

The Auction

Lyons, clearly a man of money, whispers to his son, David, 15, standing next to him. David eyes Joey skeptically.

LYONS
Five guineas.

DAD
Si Easton—I'm not gonna let that bastard see me off. *(bidding)* Six guineas.

SI EASTON
Oh for the love of . . . !

Joey is straining to get to his mother, the men are pulling him back.

LYONS
Seven.

DAD
Greedy sod thinks he can just buy anybody. *(bidding)* Eight.

SI EASTON
Stop it—he's your landlord—you can't be picking fights with him.

Joey breaks free, neighing desperately.

Lyons looks over. There is now tension in the crowd as they sense a Battle Royal for the horse.

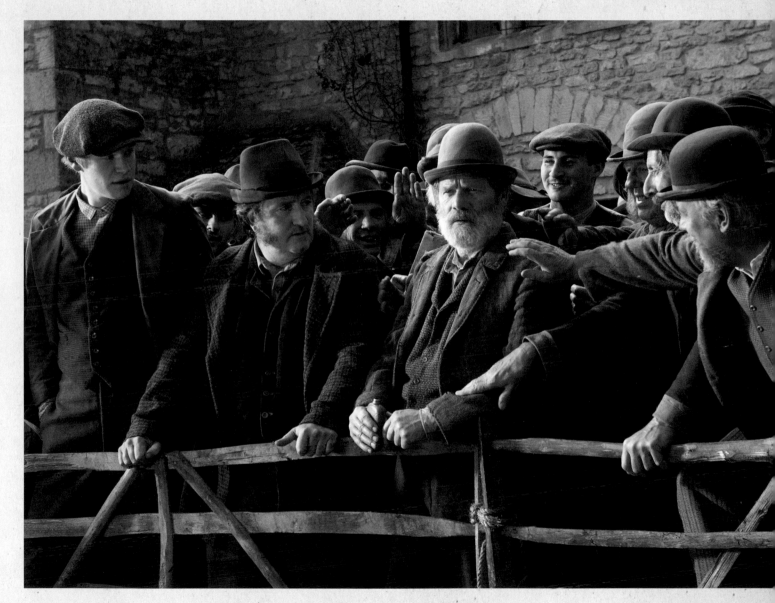

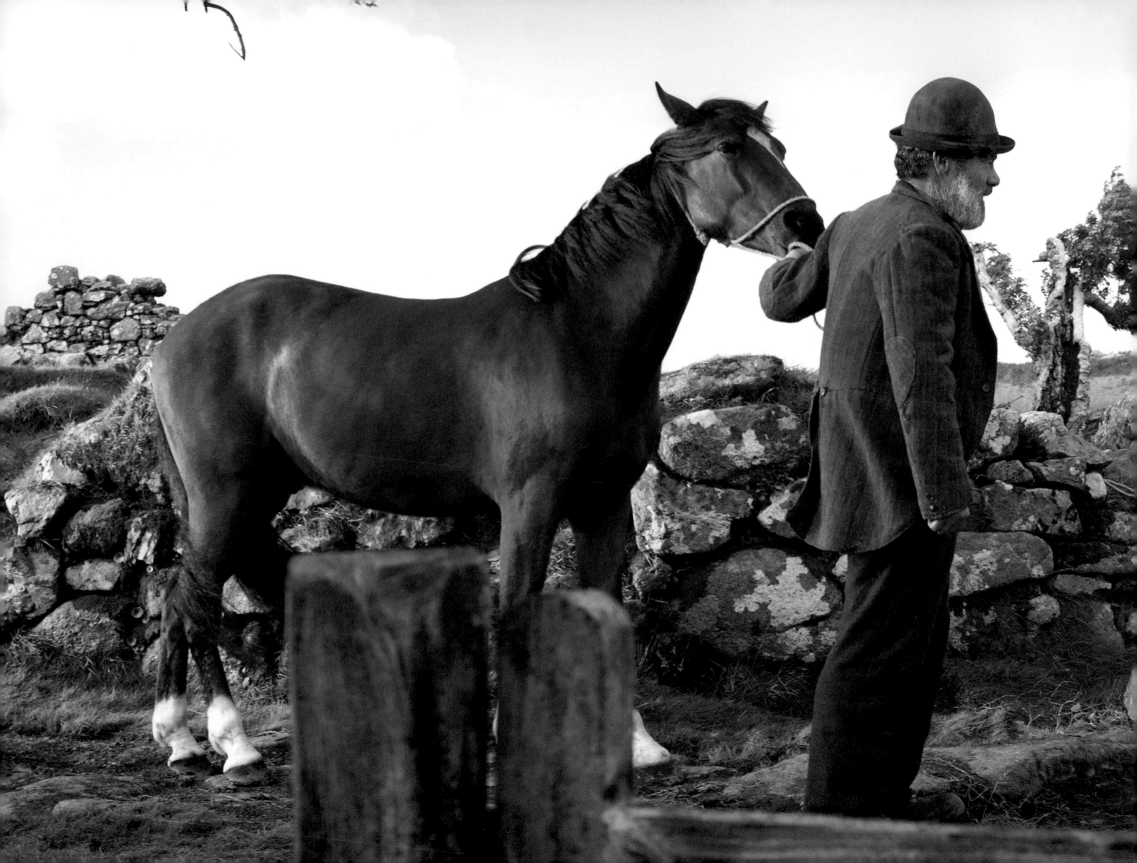

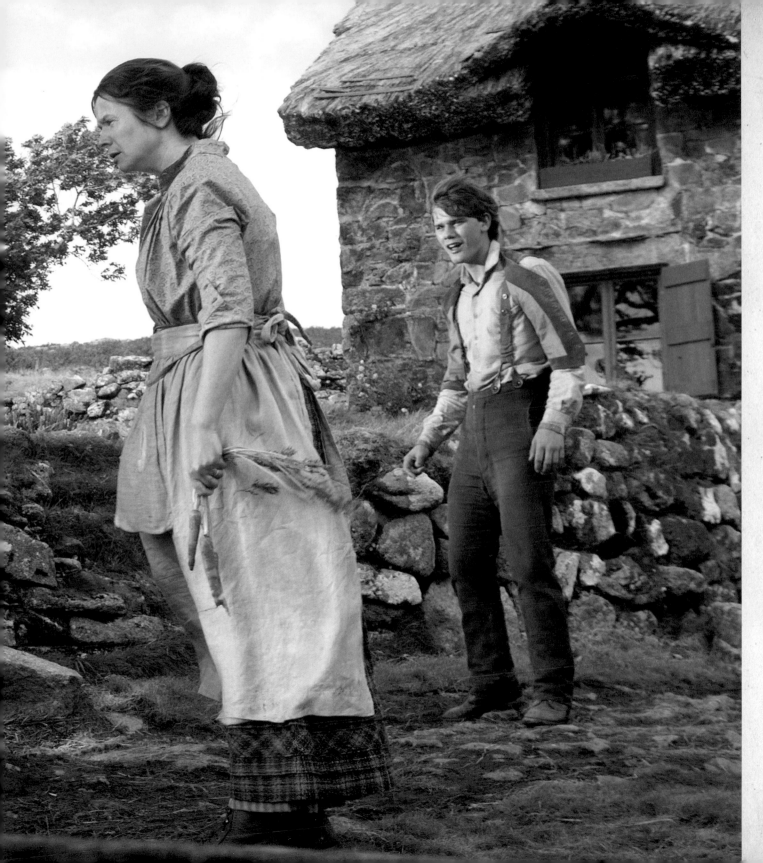

Salt of the Earth

I was not prepared for the moors in Dartmoor, Devon. I wasn't prepared for the kind of beautiful desolation they have to offer. It used to be a forested area of tall, proud trees, but was deforested hundreds of years ago so now it's just desolate, rocky hills.

This movie is as much about the land as it is about the people. The land was everything, it meant everything. This family could not survive without the land. They were devoted to it even if it wasn't always devoted to them. So the story is about the salt of the earth.

—STEVEN SPIELBERG, DIRECTOR

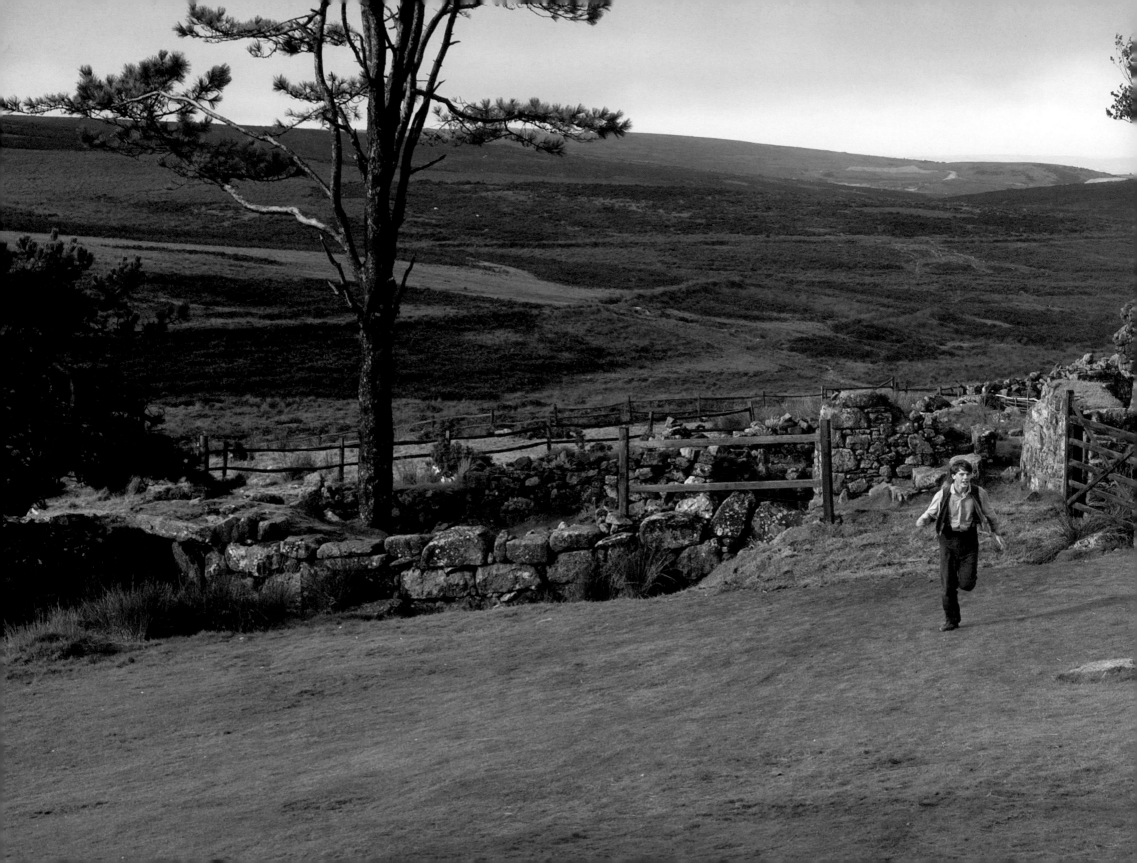

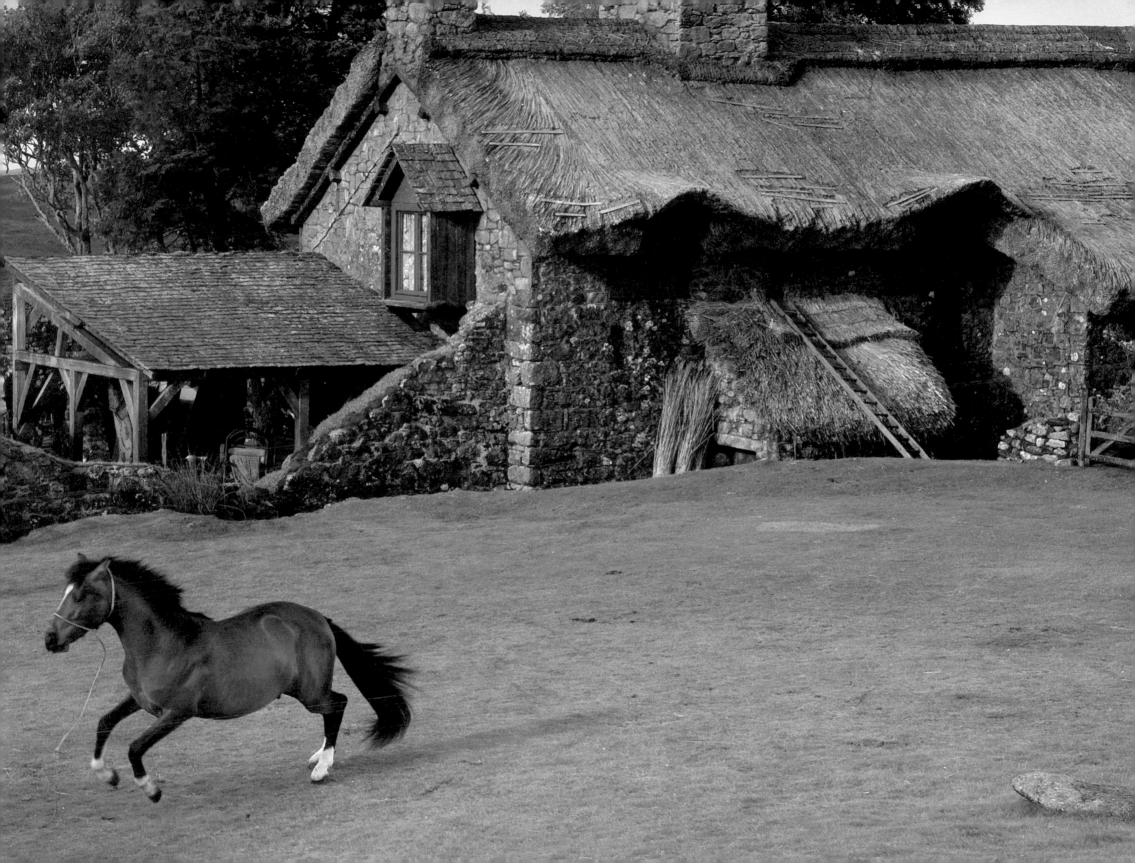

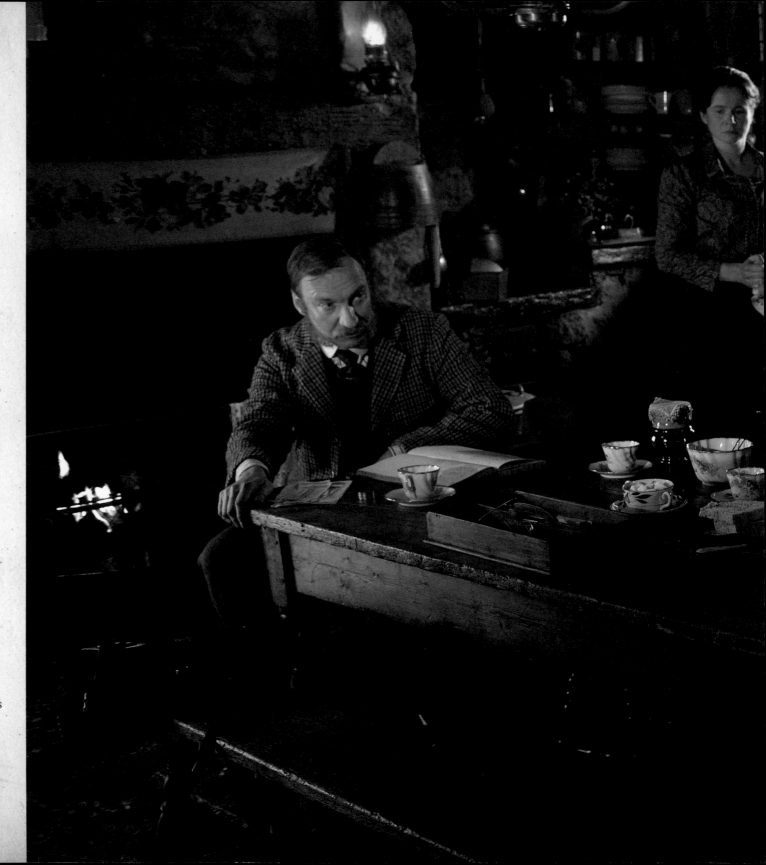

The Evil Landlord

I always liked playing bad guys better than playing good guys. It just seems more interesting. Lyons is a classic character. Steven told me at the outset that this character—the evil landlord—goes back to silent films. And I was glad to have a go at recreating that in a different way.

—David Thewlis, Lyons

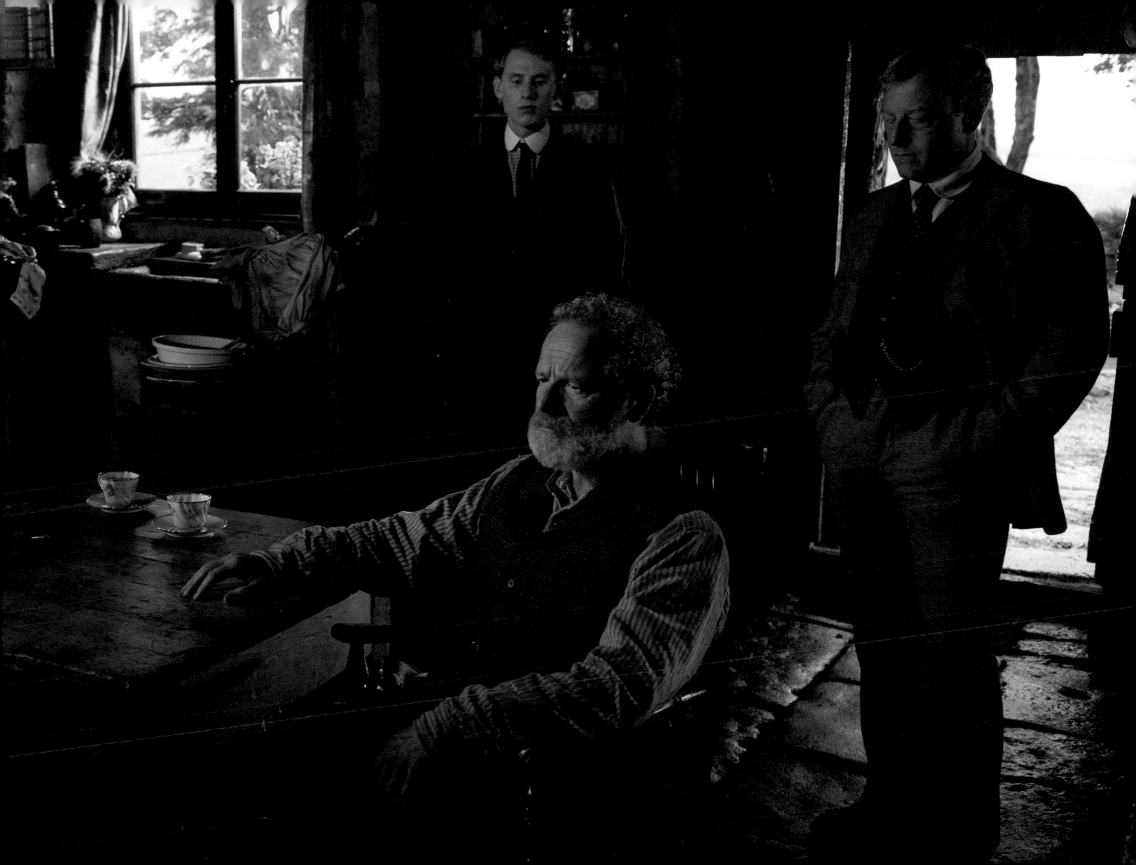

He's worth nothing to me!
If he won't take the collar,
he's not worth a damn thing!

—DAD

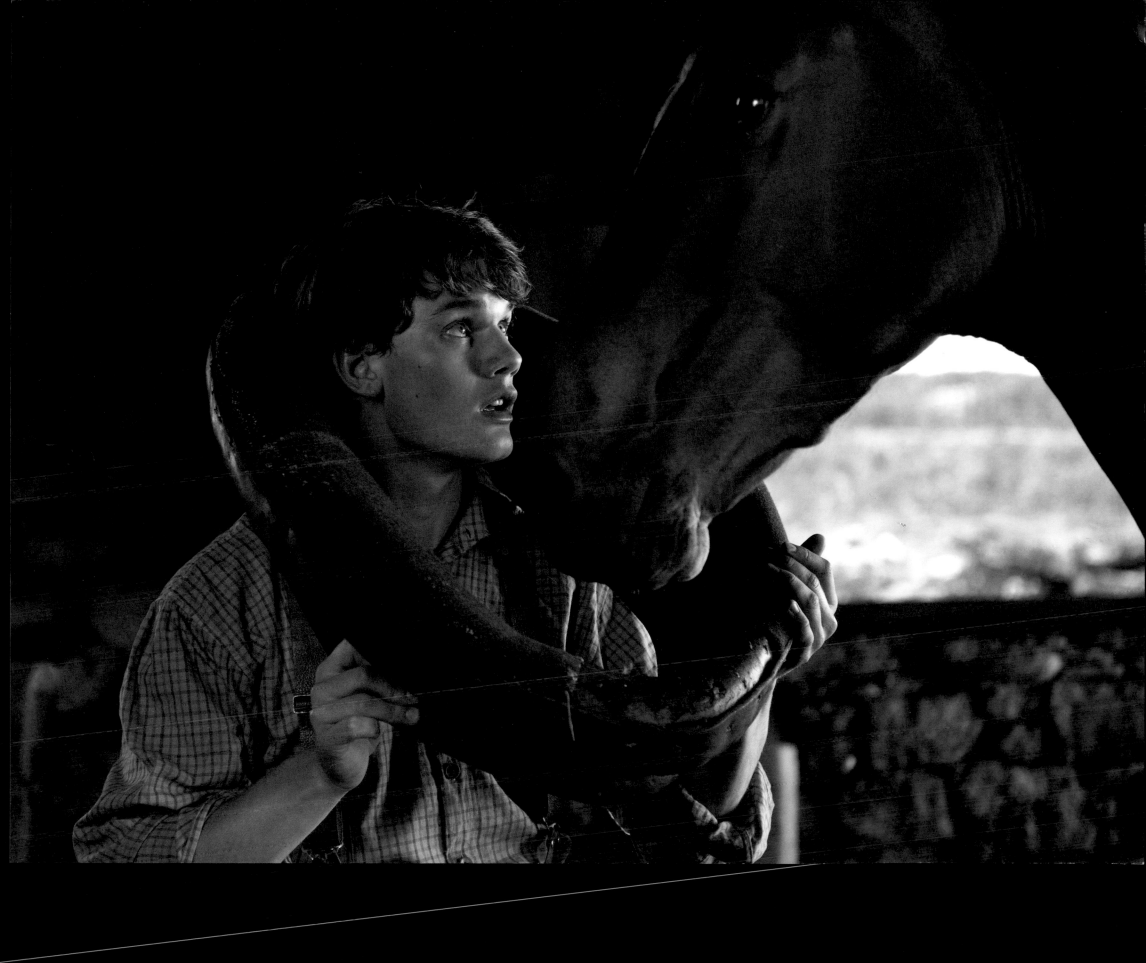

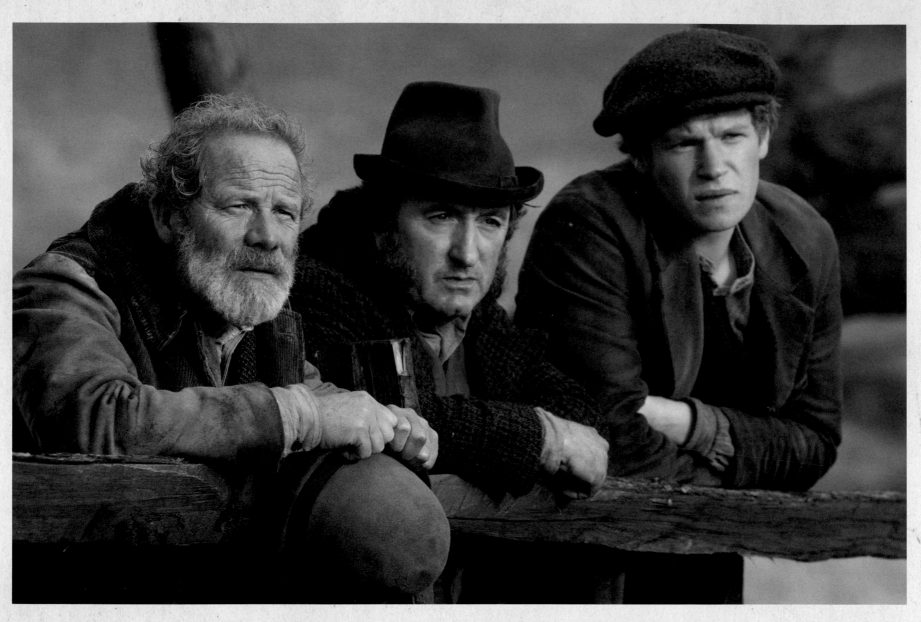

Now I am going to teach you to plough and you are going to learn, understood?
Then we can be together, which is how I believe things are meant to be.

—ALBERT

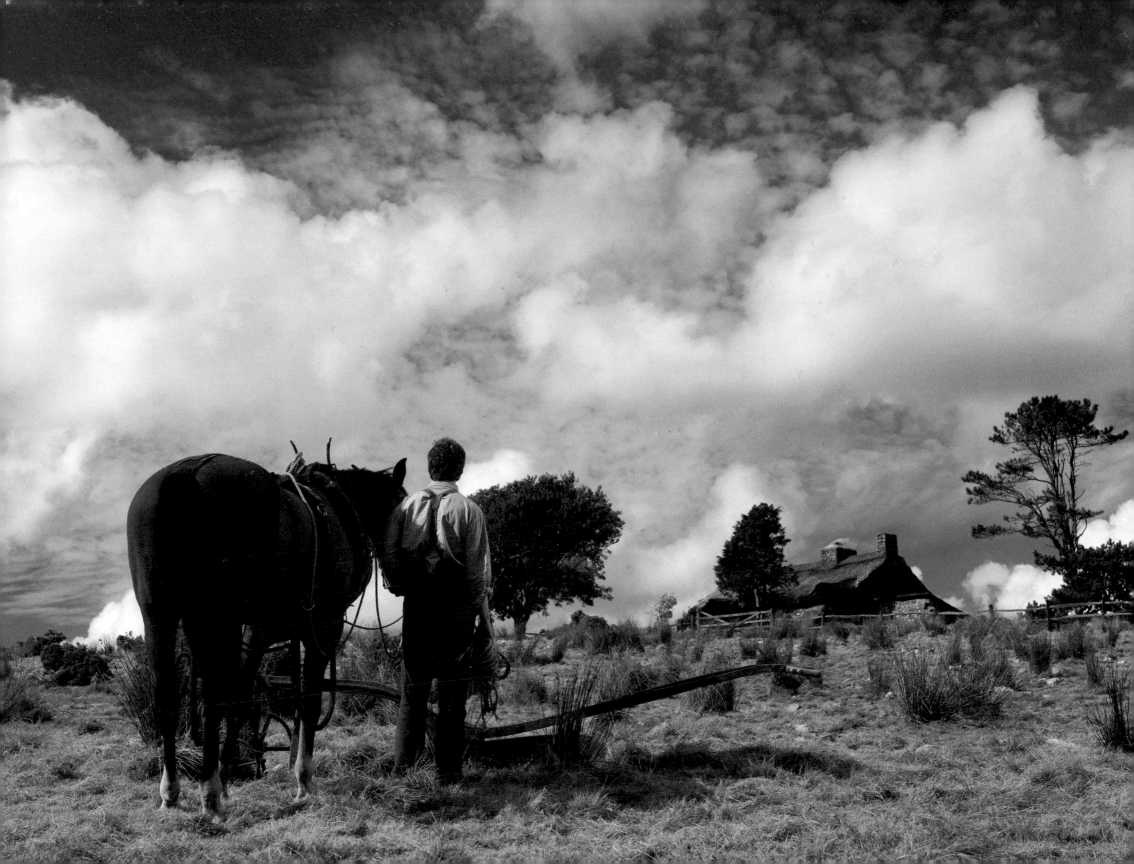

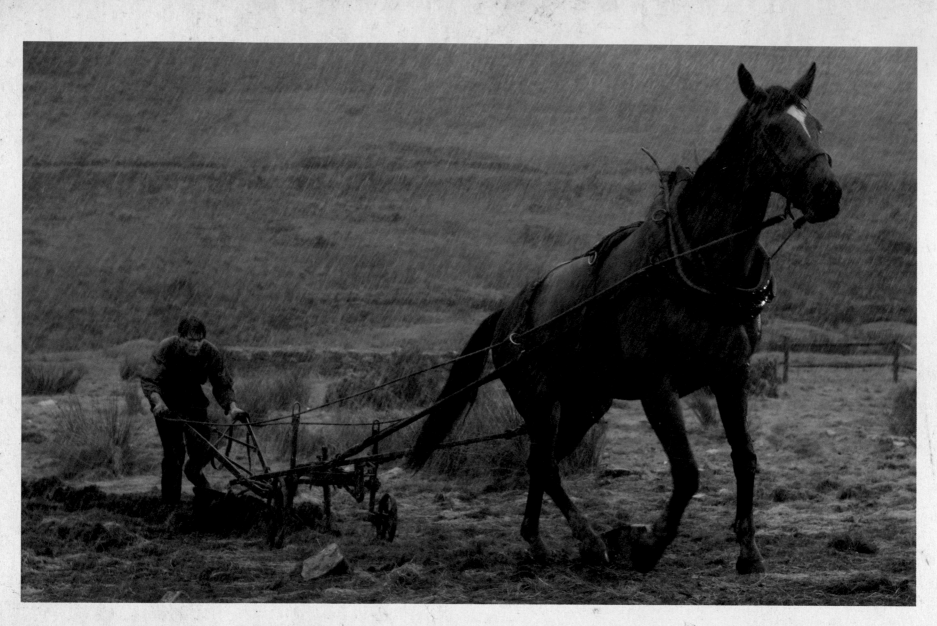

Now boy! This is it. You've got to do it, Joey. You don't know, so I'll have to do the knowing for you. The rest of our lives depend on this! Now get set to pull—and pull straight! And pull hard!

—ALBERT

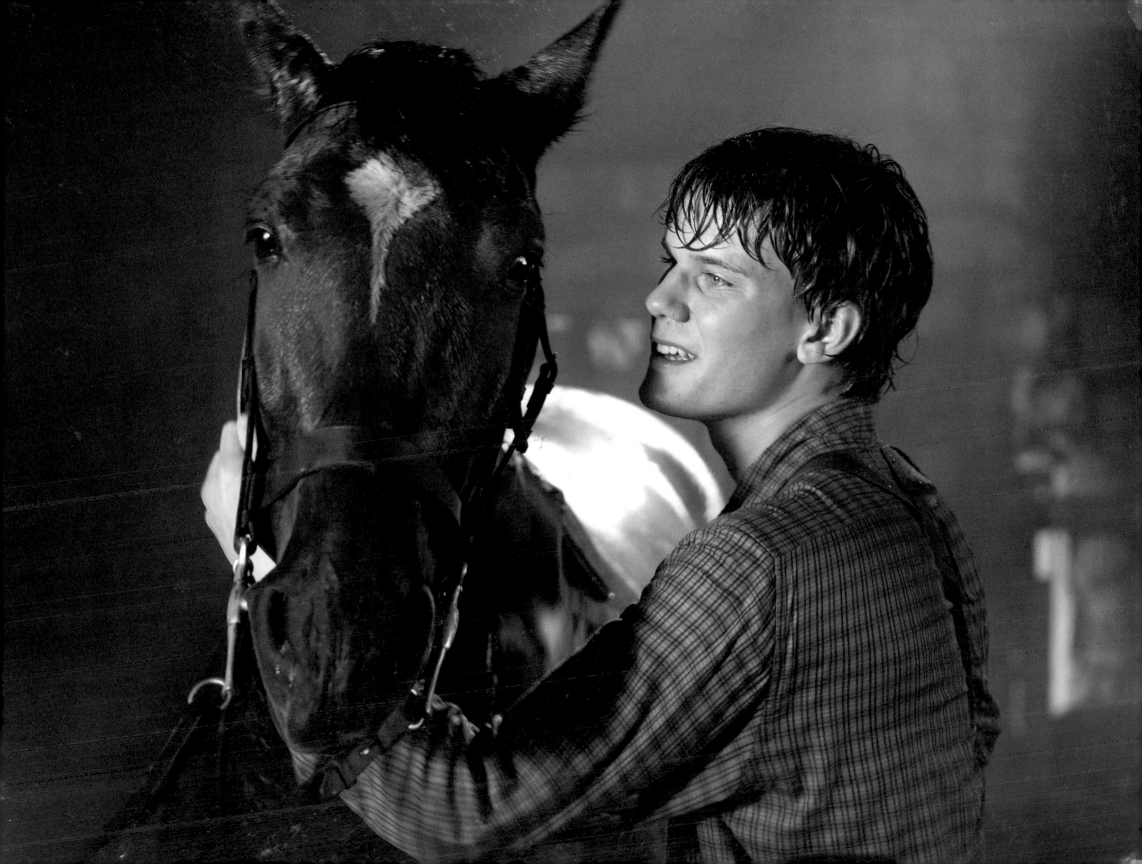

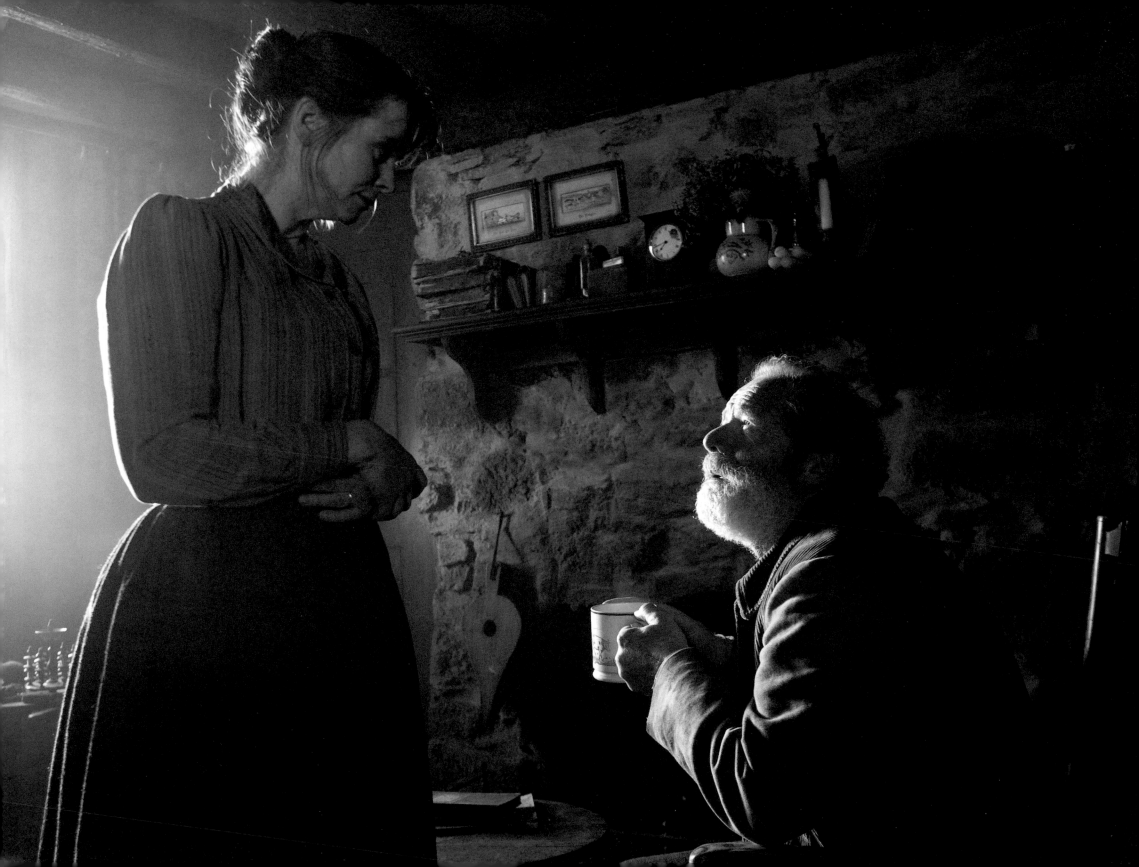

Distinguished Conduct

She hands Albert the Distinguished Conduct Medal. He takes it, astonished.

> **ROSIE** (*cont'd*)
> They gave him that after the fighting at Transvaal. After he'd been hurt, and he'd saved other lads, and . . . I don't know, he won't tell me either. He just . . . tossed them out, all this, after he got home, the first day he could walk, he put these in the bin, and wouldn't hear a word I said not to.

Albert nods, looking at the medal and campaign pennant.

> **ROSIE** (*cont'd*)
> What you did today, you and Joey, you're chuffed up now, and so you should be. My splendid boy.

She takes the medal back, puts it in the sash, and begins to wrap it again. Then, she gives Albert Ted's red and tan pennant, closing his hand around it.

> **ROSIE** (*cont'd*)
> It's good to be proud when you've done something good. What he done, in Africa, whatever it was, he takes no pride in it. Hard as it surely was, for all the pain it's cost him, he refuses to be proud of . . . of killing, I suppose.

> **ALBERT**
> (*confused*) I'd be proud. If I'd saved my mates, if I'd—

> **ROSIE**
> Whether or not you think you'd do the same as him . . . Think how brave he is, refusing to be proud.

She puts the things in the footlocker, closes it, piles the junk back on it.

> **ROSIE** (*cont'd*)
> Your dad makes mistakes. He drinks to make him forget the mistakes he's made—but he never gave up and he does it for us. And today, ya showed the world its all been worth it. You keep looking after Joey and he'll always be looking after you.

Albert opens his hand and looks again at the pennant.

> **ALBERT**
> (*softly, to Joey*) Distinguished Conduct. (*shaking his head, amazed*) Just one step below the Victoria Cross, that is.

Joey shakes his head.

> **ALBERT** (*cont'd*)
> I'm not stealing it. I'll give it back to him, someday.

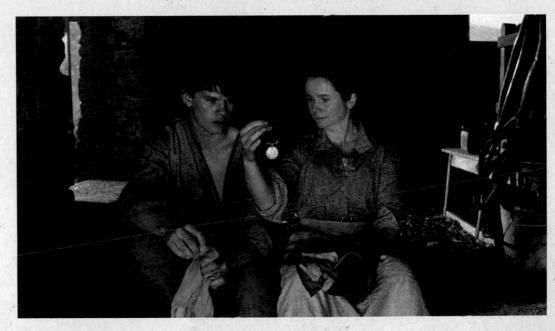

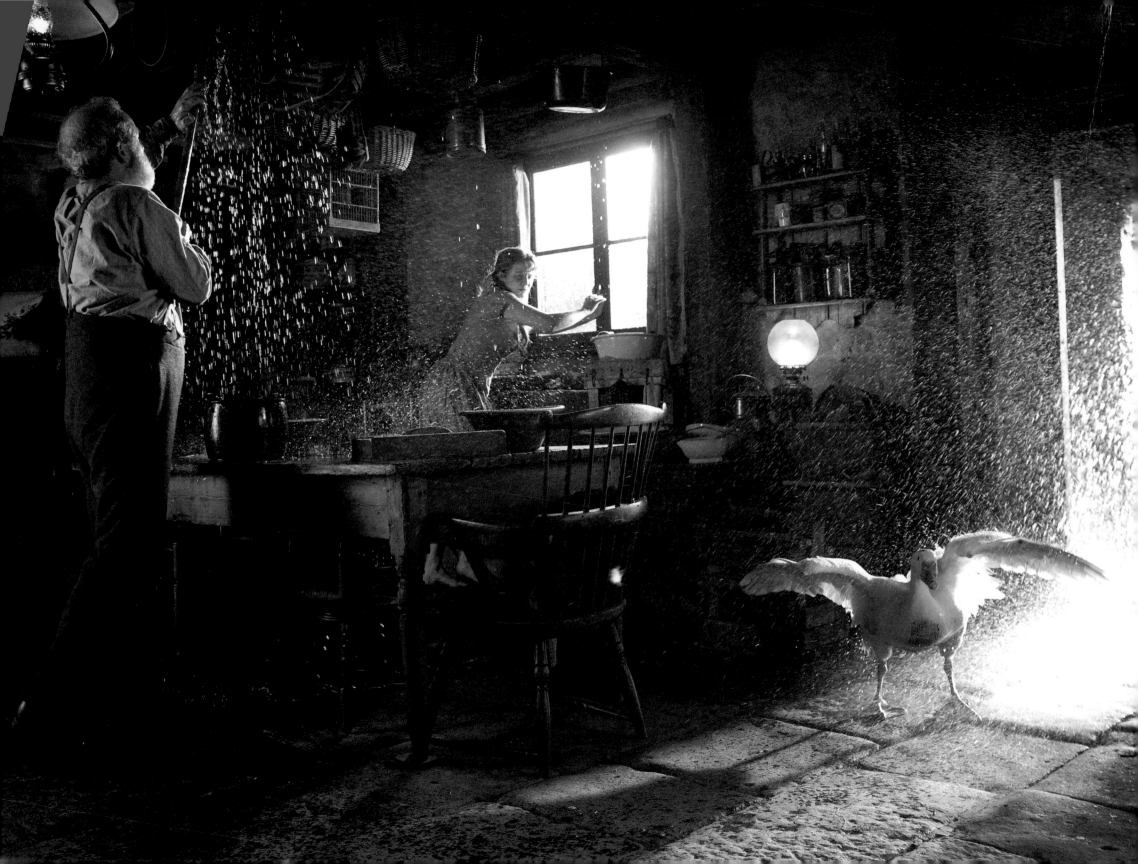

Harold

EXT. NARRACOTT FARM. NIGHT.
Lightning blasts across an angry sky.
The rain is falling in torrents.

INT. STABLES. NIGHT.
Albert rubs Joey down. Water is leaking
through the roof. Albert is finished and
starts to leave. Suddenly the thunder
cracks right over-head. Joey leaps up in
terror. Albert fights to keep control of
him.

Back in the house, another crack of
thunder—and a piece of wood in the
roof gives way—water gushes in—Dad
and Rosie rush to clear the furniture
away from under it . . .

> **DAD**
> What's going on out there?! Give me
> a chair—I'll try and block it from
> under . . .

At that moment, the door suddenly
swings open with the violence of the
storm, smashing against the wall—Dad
and Rosie turn—and there is Harold the
goose, who scuttles in without his usual
arrogance and hides himself in a corner.

He's Sold My Brother

I've got two younger brothers, and I used them a lot in the development of my character.

When doing the scene where Joey is sold, for example, I was thinking, he's sold my brother. I thought it's just how you would feel if a brother or your best friend or the person that you love gets taken away. It was hugely emotional.

—JEREMY IRVINE, ALBERT

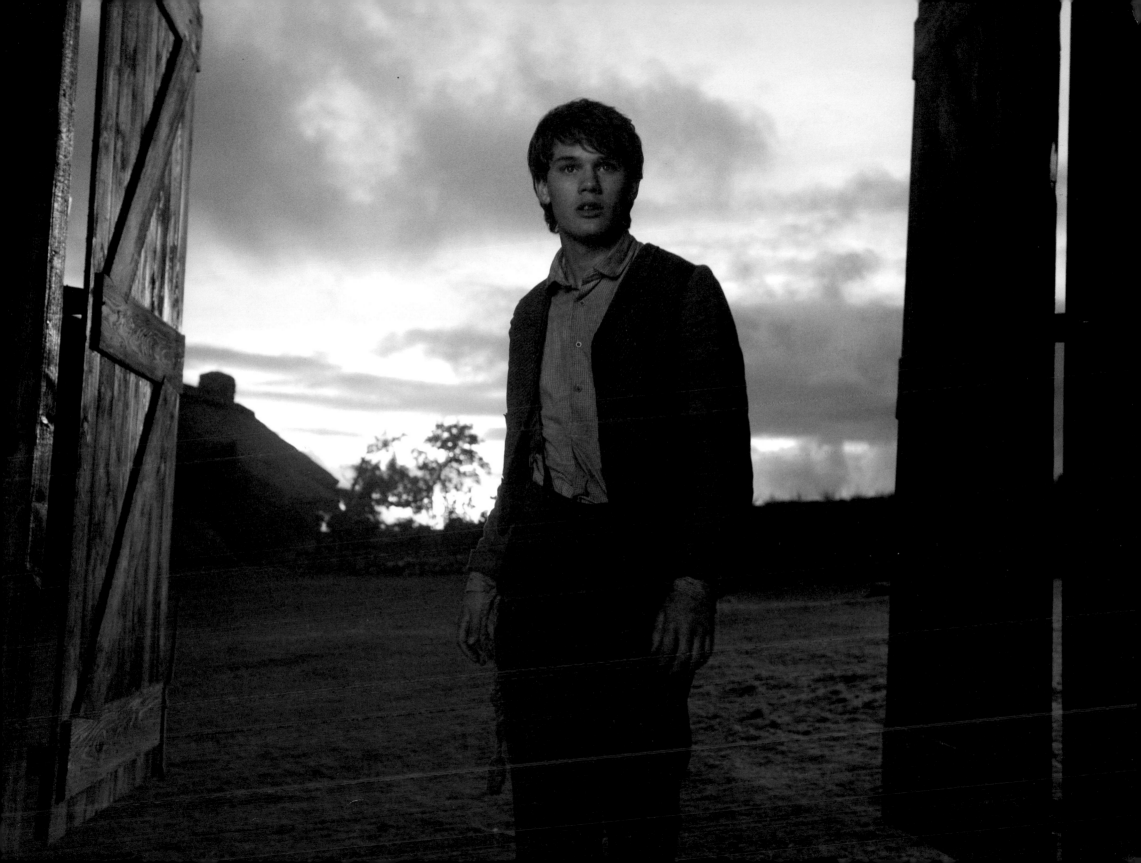

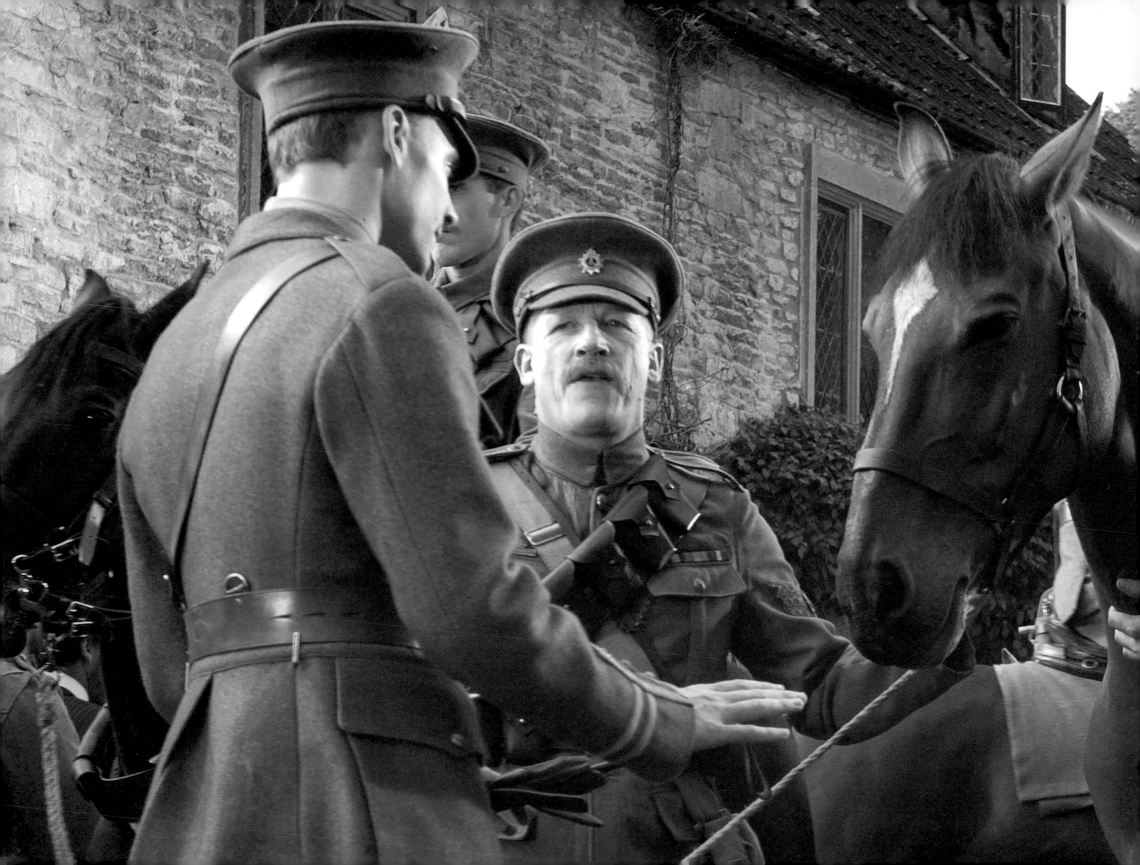

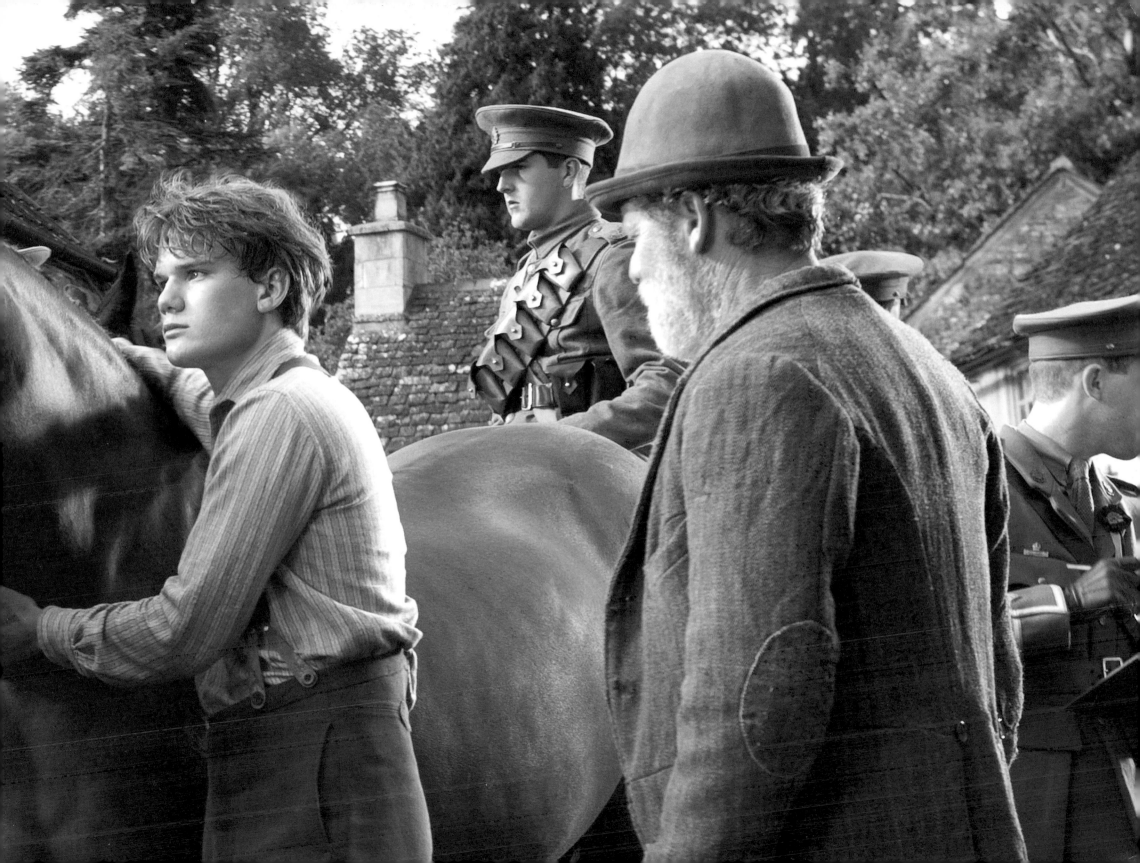

Soldiers and Horses

All three of us, Ben Cumberbatch (Stewart), Tom Hiddleston (Nicholls) and I became incredibly attached to our horses. Learning to ride for the film was one of the greatest privileges I've ever had.

—PATRICK KENNEDY, WAVERLY

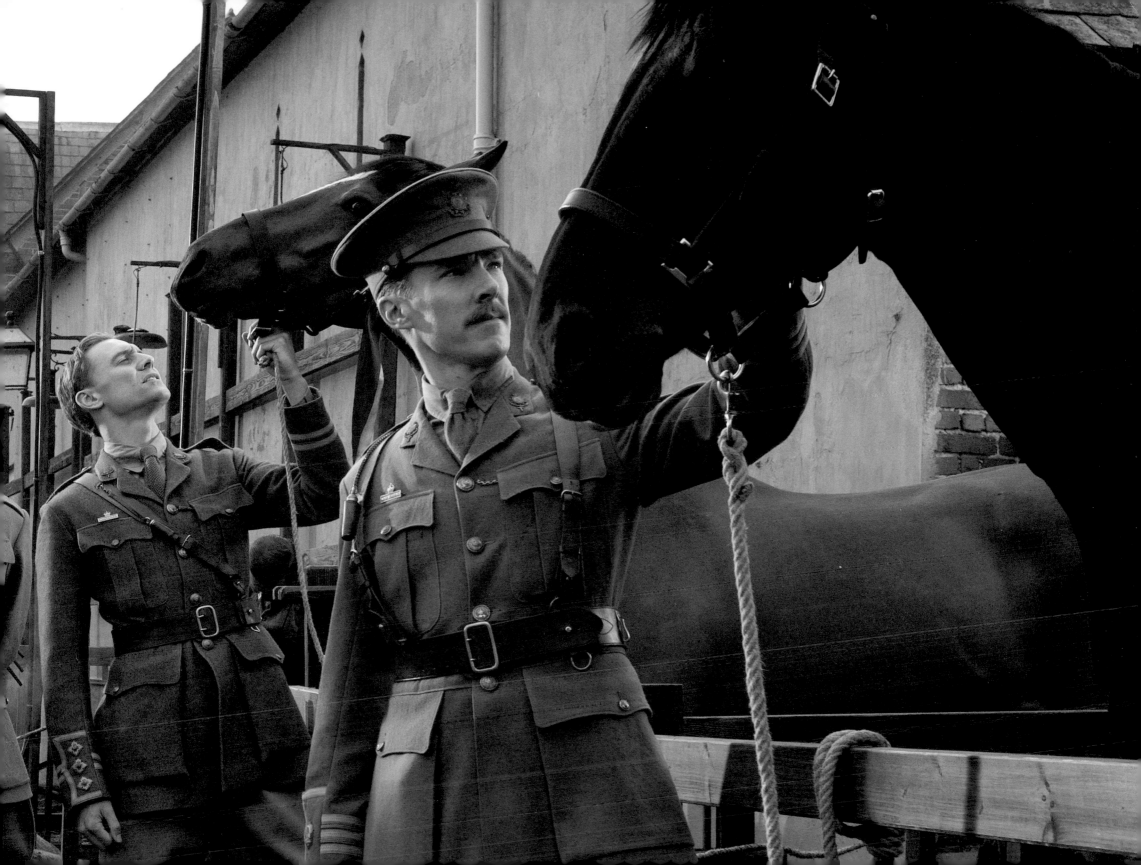

A Dashing British Hero

And then he takes out a worn piece of paper—he unfolds it—it is the little sketch that Captain Nicholls drew of Joey the night before they left for France.

I saw Tom Hiddleston in a couple of smaller parts in films and saw him as a kind of reincarnation of Errol Flynn. I thought it would be great to have the first person that purchases Joey from the father be a dashing, classy, classic British hero. And so instead of casting against type, I went directly on the nose and found a very suave and sophisticated and very, very mindful young soldier.

—Steven Spielberg, Director

Nicholls has a sense of how awful the war with Germany in Northern France is going to be, and his way of coping with his own fear is to sketch. He draws these beautiful sketches of Joey, which is obviously a talent and a passion that he had before the war.

—Tom Hiddleston, Nicholls

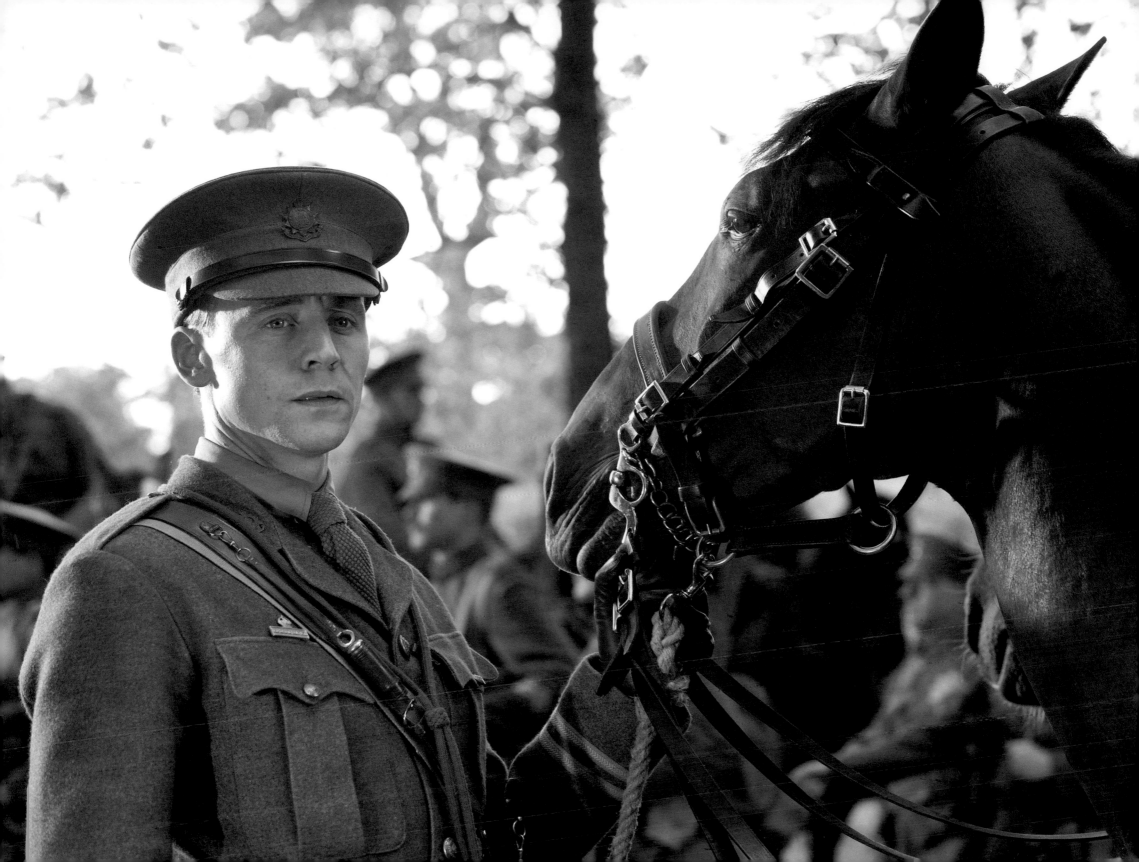

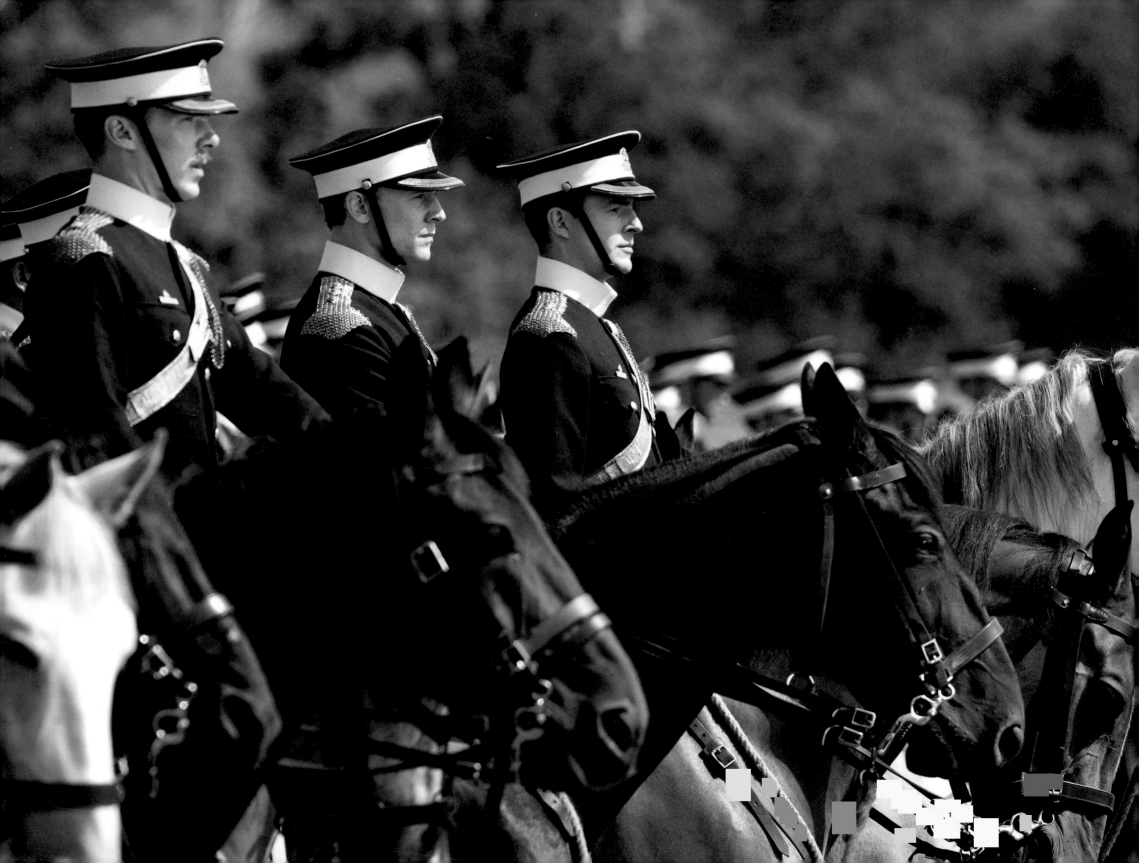

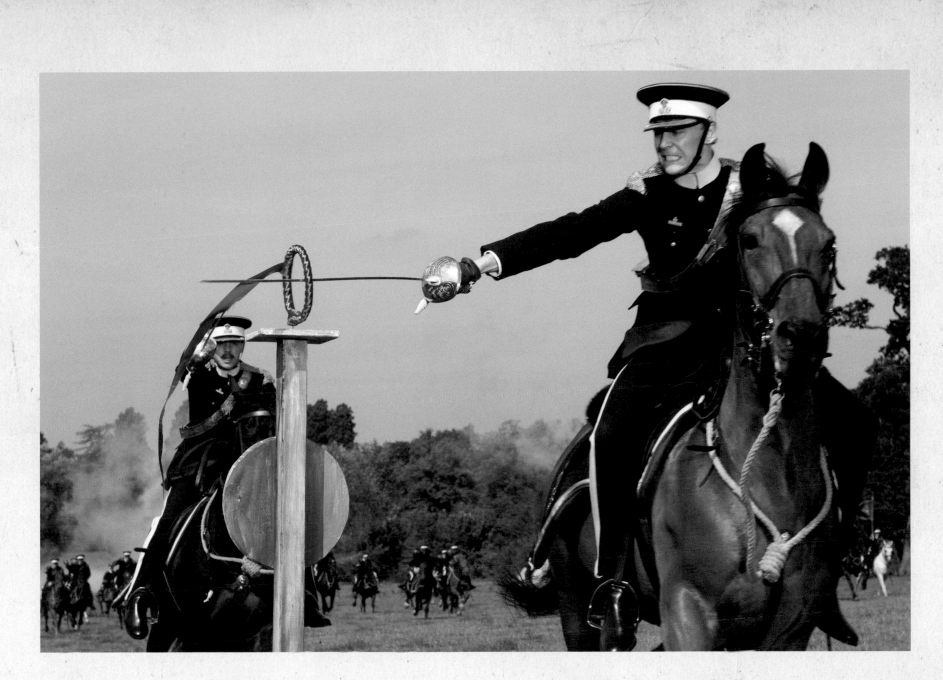

There is something quite heroic and extraordinary about
men riding into battle on horses.
—Benedict Cumberbatch, Stewart

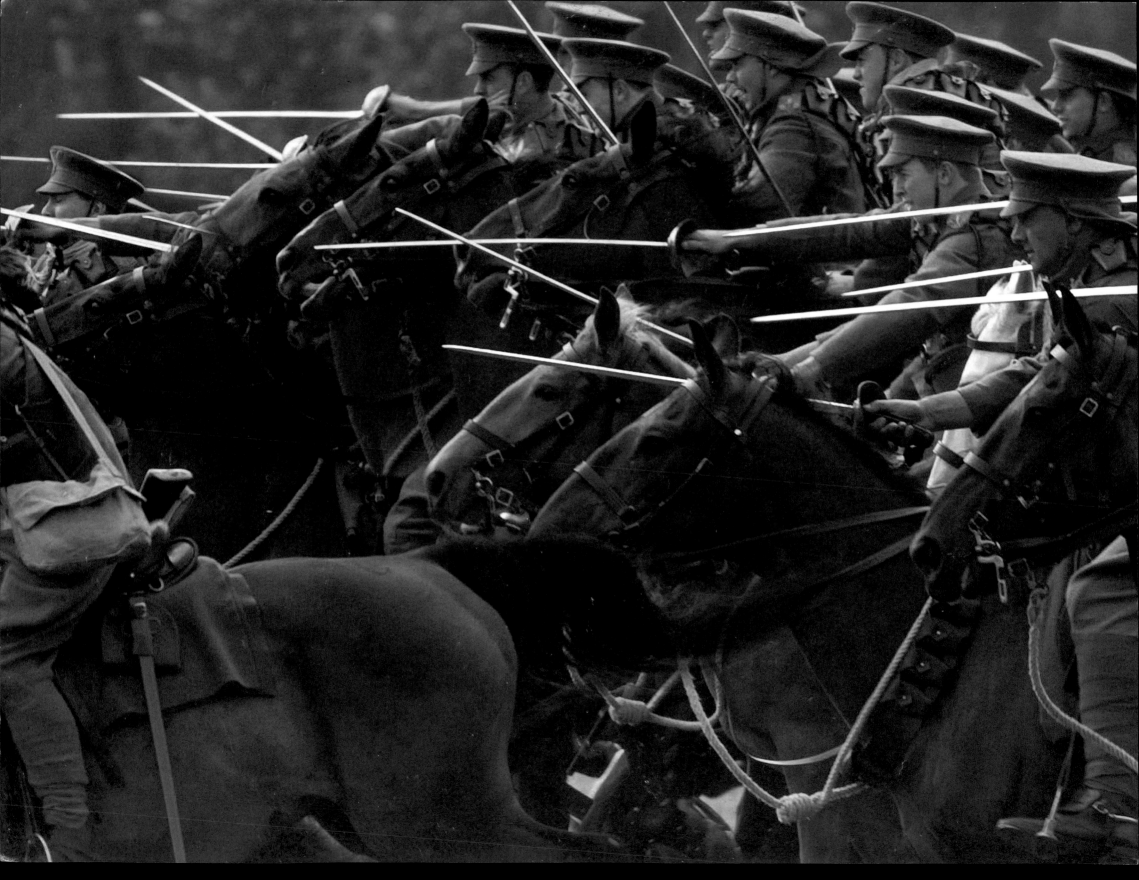

Into the Somme

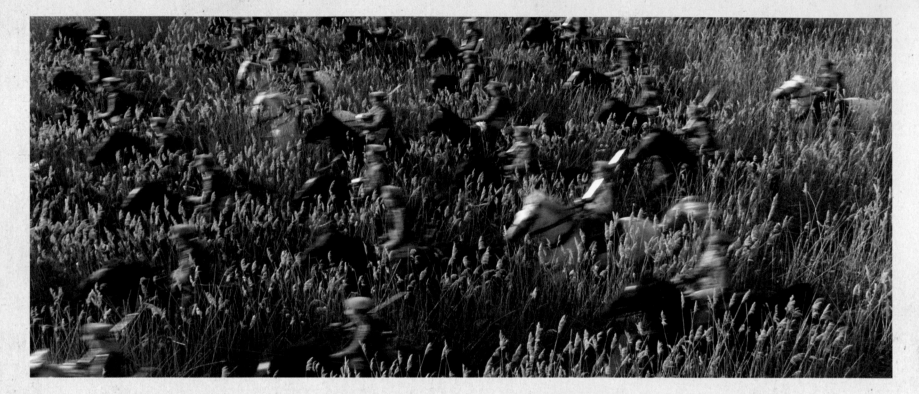

Men and Their Horses

I have the idea that Stewart and Nicholls knew each other before the war. Maybe they went to school together, their families knew each other and they joined up together. Stewart probably took the military more seriously and so he achieved a higher rank than Nicholls. But Joey is in good hands the second you see how well he sketches Joey.

—STEVEN SPIELBERG, DIRECTOR

There are many wonderful stories about men and their horses in war, about the lengths that men will go to save their horses and the length that horses will go to save their riders and the men that they love. It's a wonderful subject.

—ARTHUR MORNINGTON, GRANDSON OF THE DUKE OF WELLINGSON

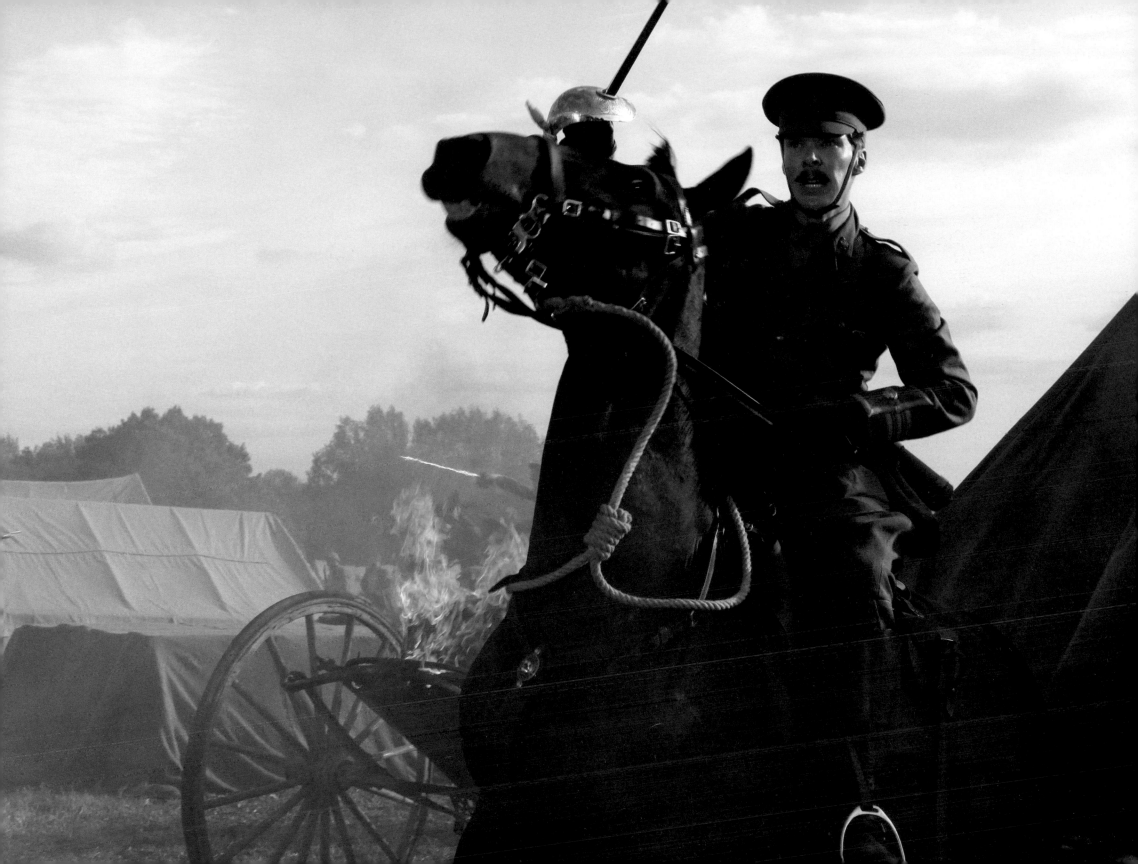

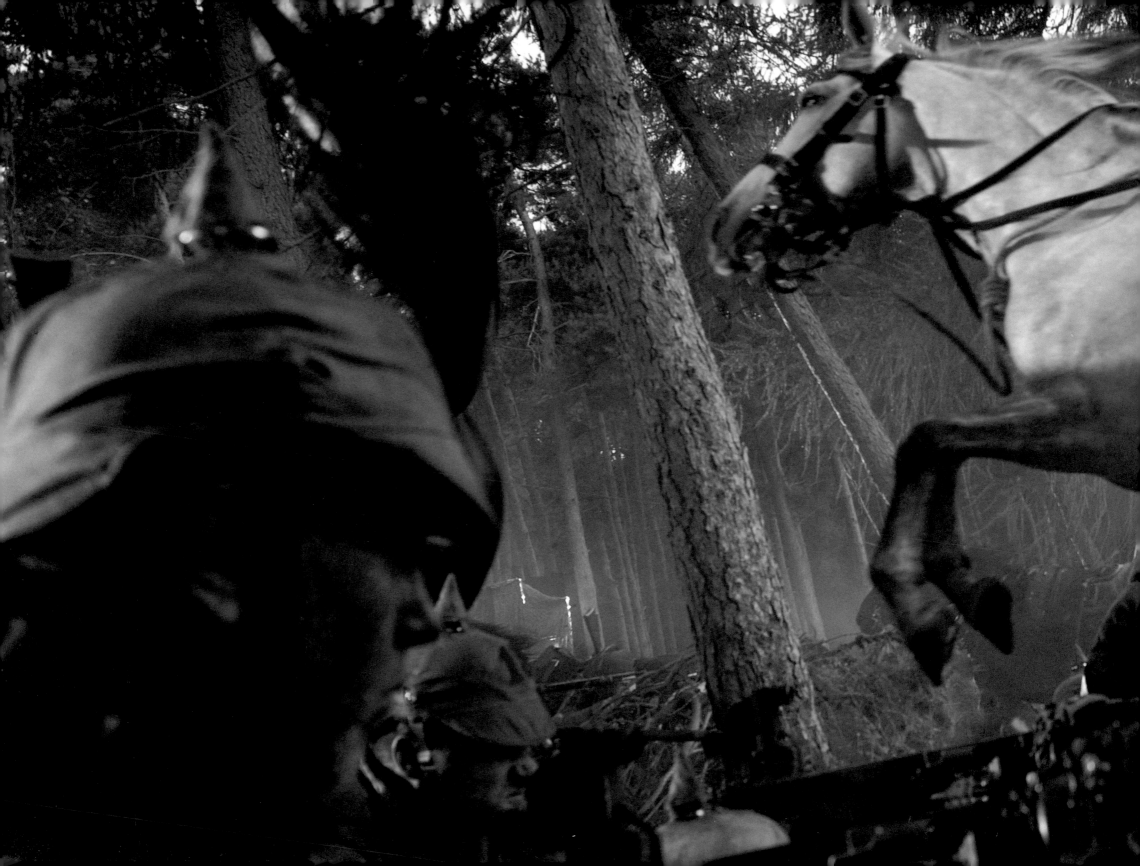

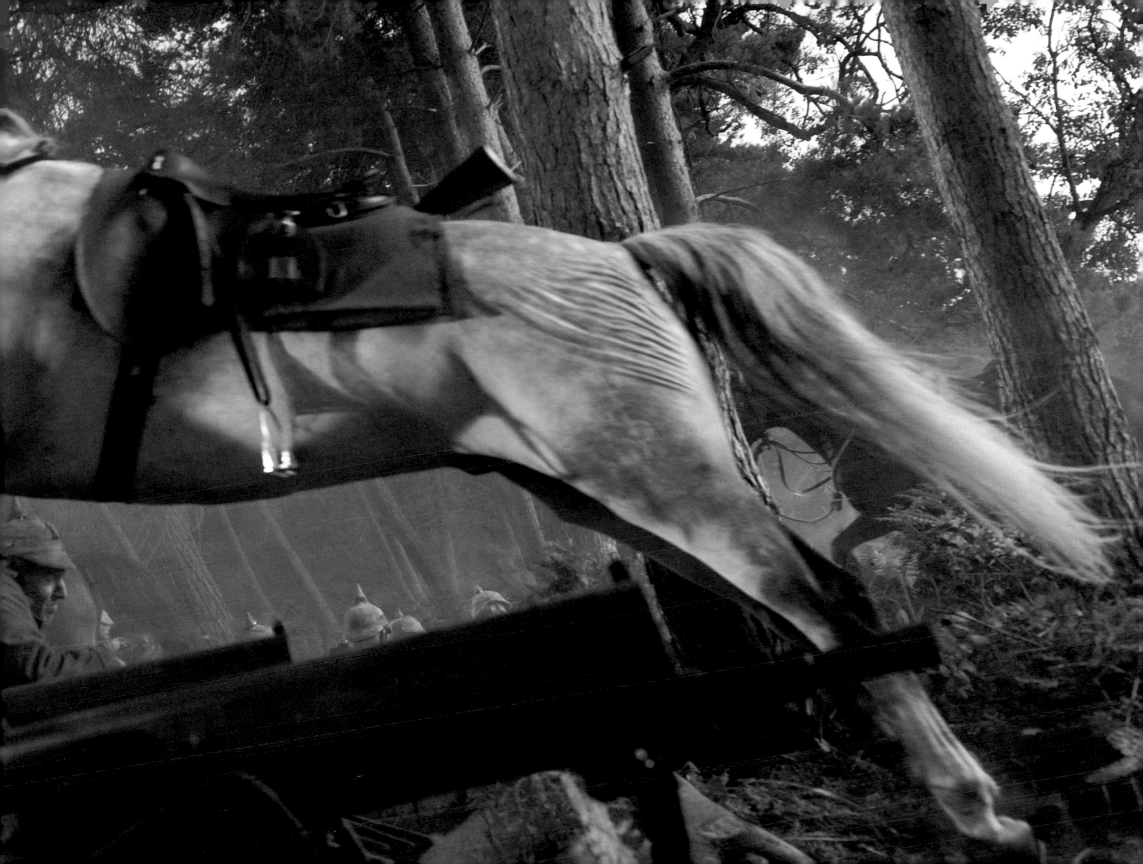

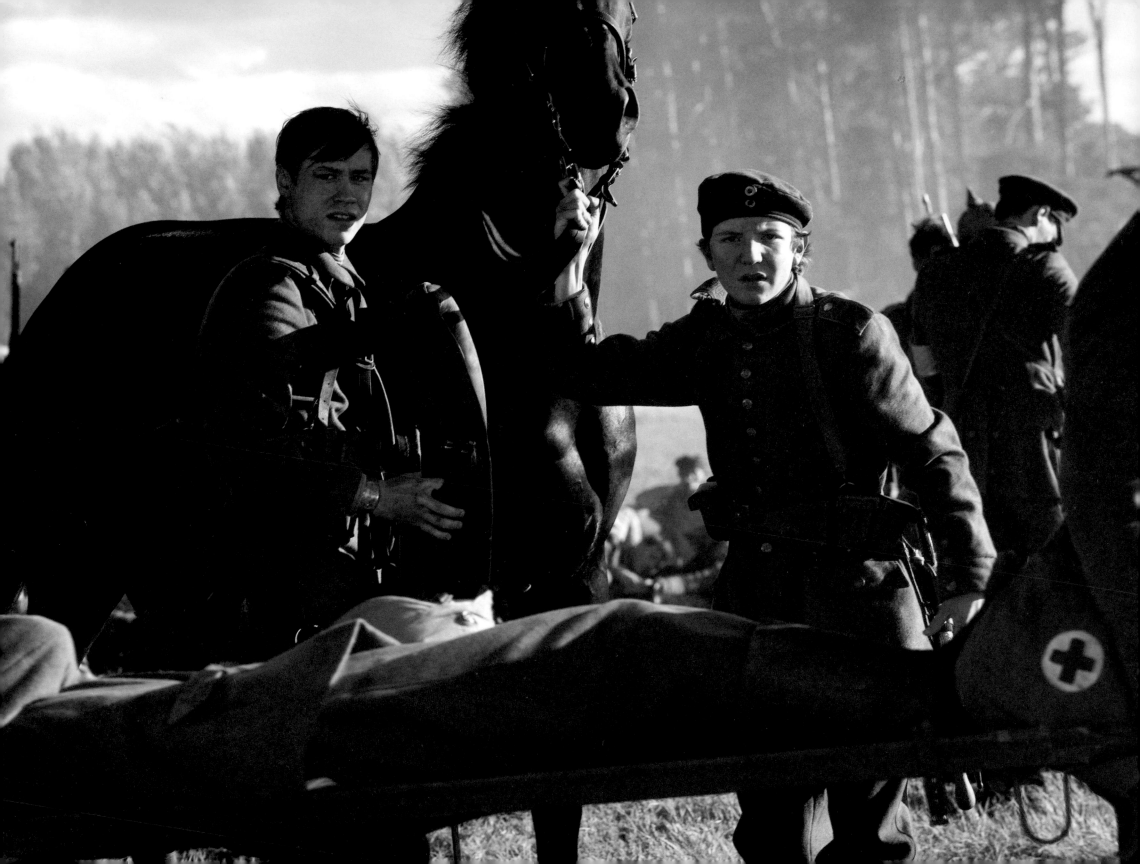

Easy, now, easy Englishman . . .

—GUNTHER

Like a Ferrari

My character, Gunther, a working-class farm boy forced into war, made a promise to his mother that his younger brother, Michael, would always be safe with him. So when he sees Joey—a really beautiful and strong charger who's like a Ferrari to him—he falls in love with him.

—DAVID KROSS, GUNTHER

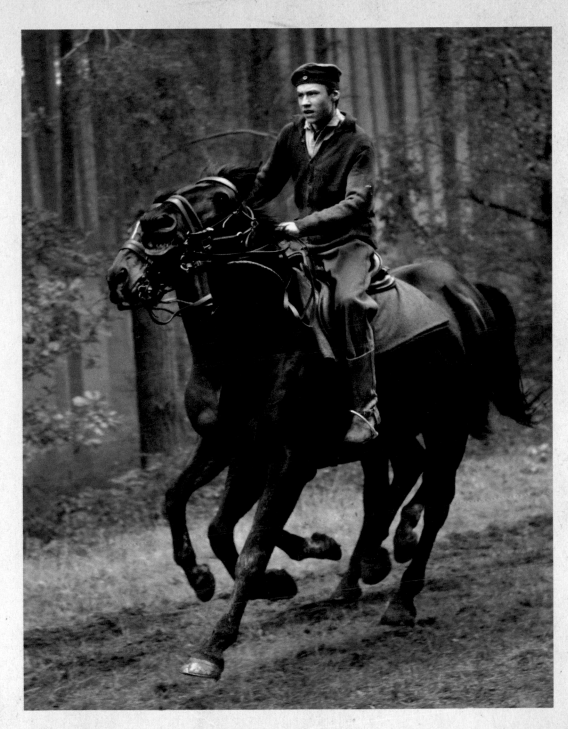

The trickiest moment in the movie is when the horses go to the German side because Joey has already had two relationships and suddenly there is a third. So when we reach the German side we very quickly get into the adventure of two very young German soldiers meeting the horses and escaping.
—RICHARD CURTIS, C0-SCREENWRITER

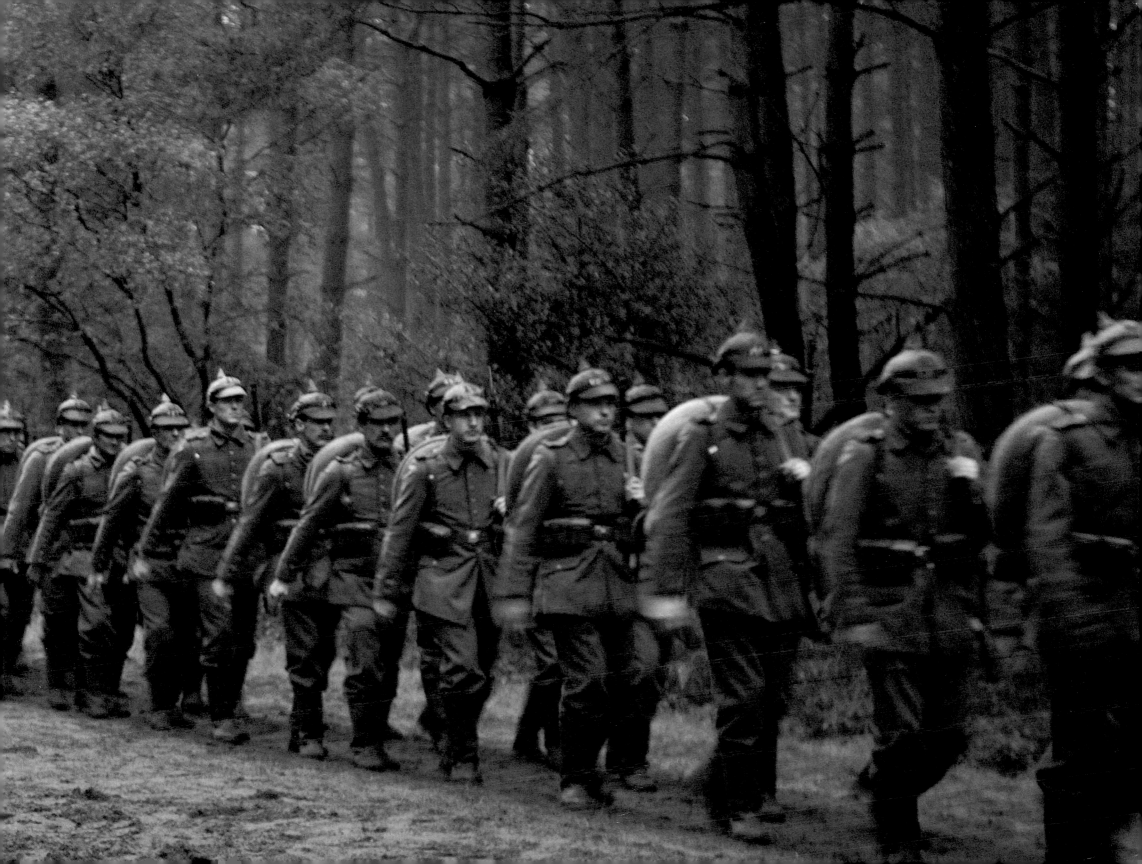

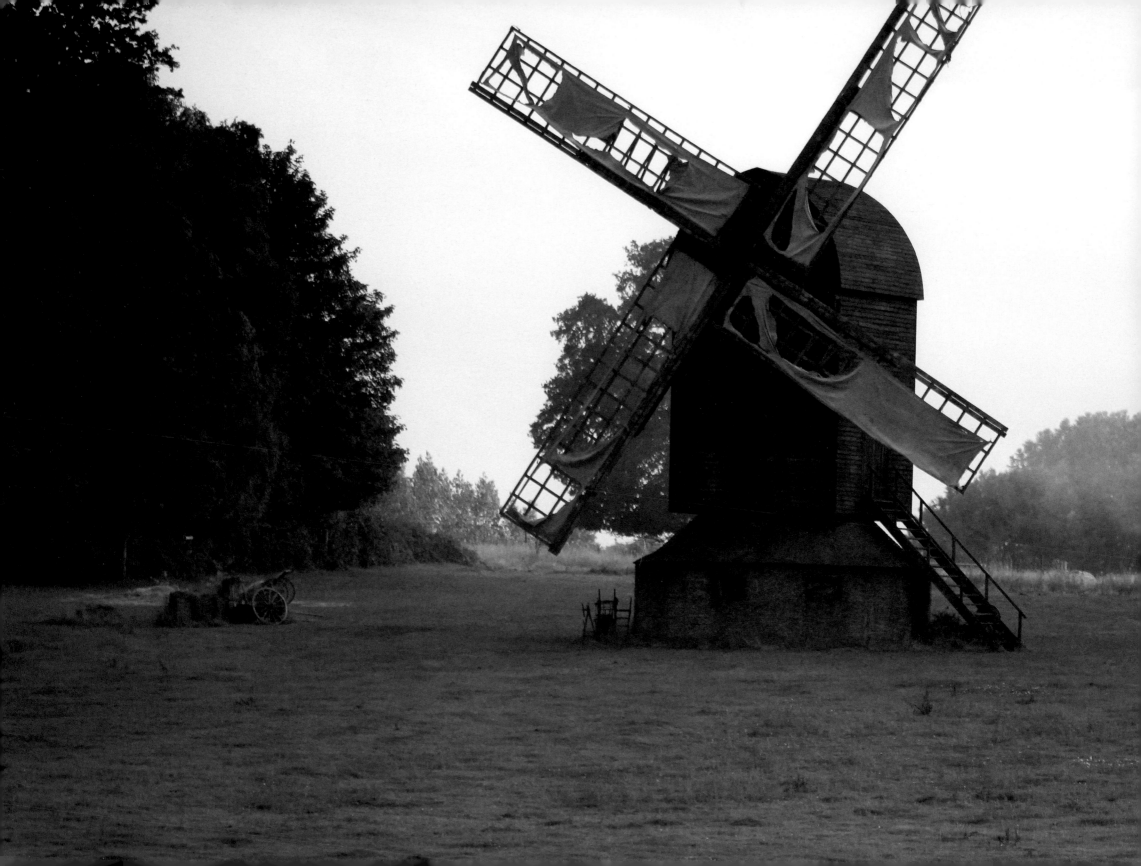

One More Mile

And on they ride—though all too soon day starts to break in the far distance. Gunther leans over and speaks to Topthorn.

GUNTHER
Ride on, Kaiser. One more mile,
then we rest.

One last riding moment—and then they see a very dilapidated windmill. They aim for it as the sun begins to seriously break over the horizon.

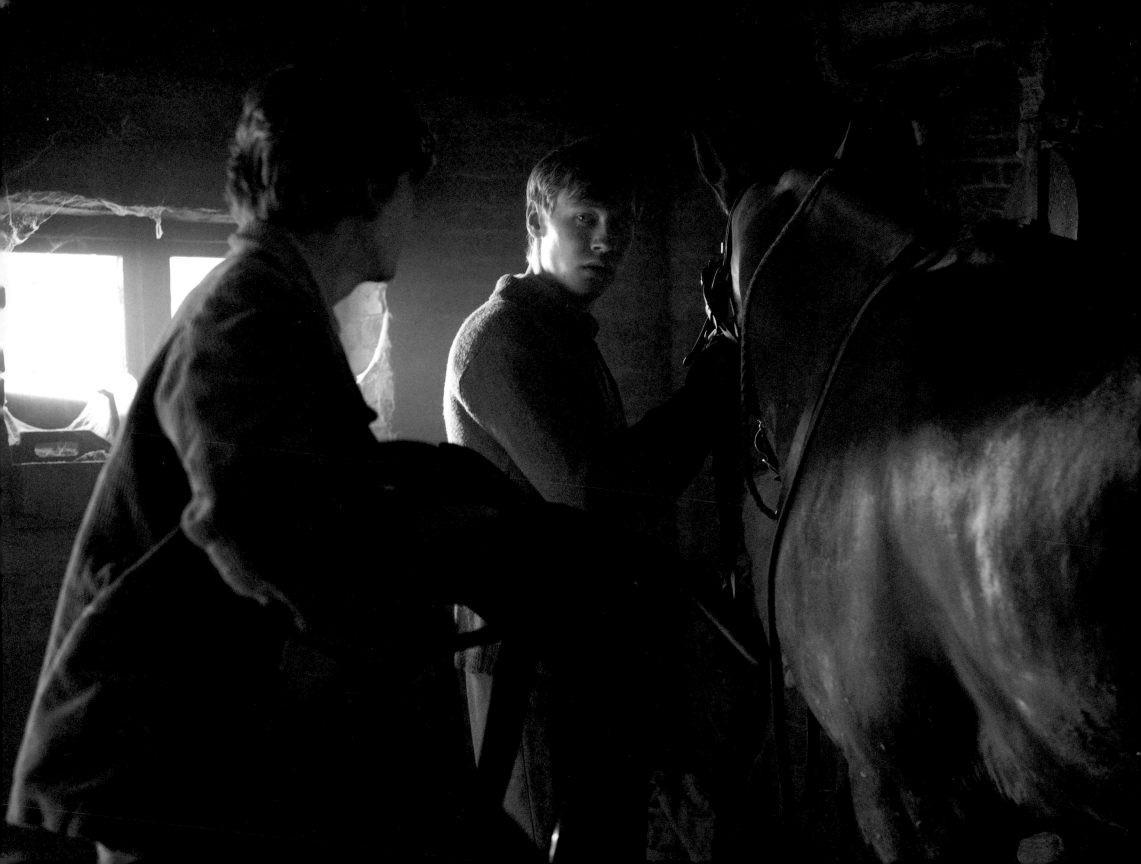

The Brothers Awake

EXT. WINDMILL. NIGHT
Gunther and Michael are still asleep. Camera moves onto Topthorn, who is now off his feet and sleeping soundly on his side, Joey lying next to him. Suddenly something awakens Joey. He stirs and then rises.

Hear the sound of engines and see lights through the slats sweeping across Joey's face. Michael and Gunther are stirring in their sleep as we hear a car and several motorcycles approaching. Headlamps filter through the cracks in the windmill walls stabbing the brothers awake. The windmill doors are thrown open. And then we see what they see. A German car—two motorcycles. Six Germans, including the officer who was in charge of them.

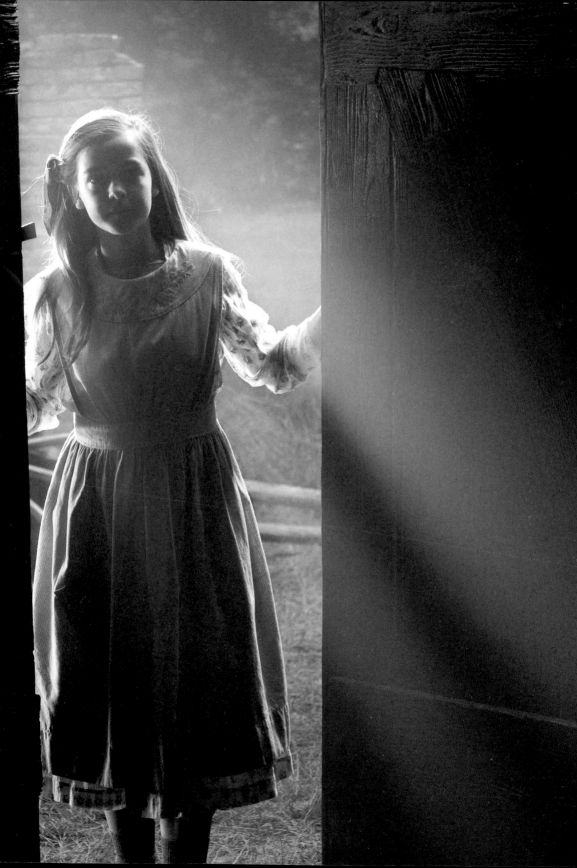

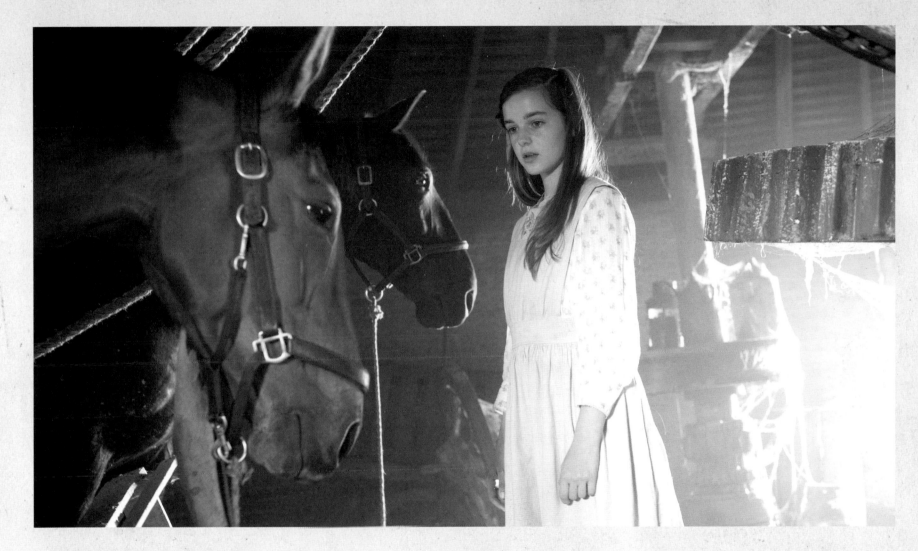

Timeout from War

The French farm, for me, is a vacation from the horrors of war. It is a little bit of a timeout. The war is close but not so close that for a while the audience as well as the horses can breathe again. And the bond that the little girl has with Joey is very similar to the one Albert had with him. Joey remembers Albert through this girl who is taking such good care of him. And as Joey passes through all these lives we see how the horse affects them. And we certainly see how the characters imprint themselves on Joey.

—STEVEN SPIELBERG, DIRECTOR

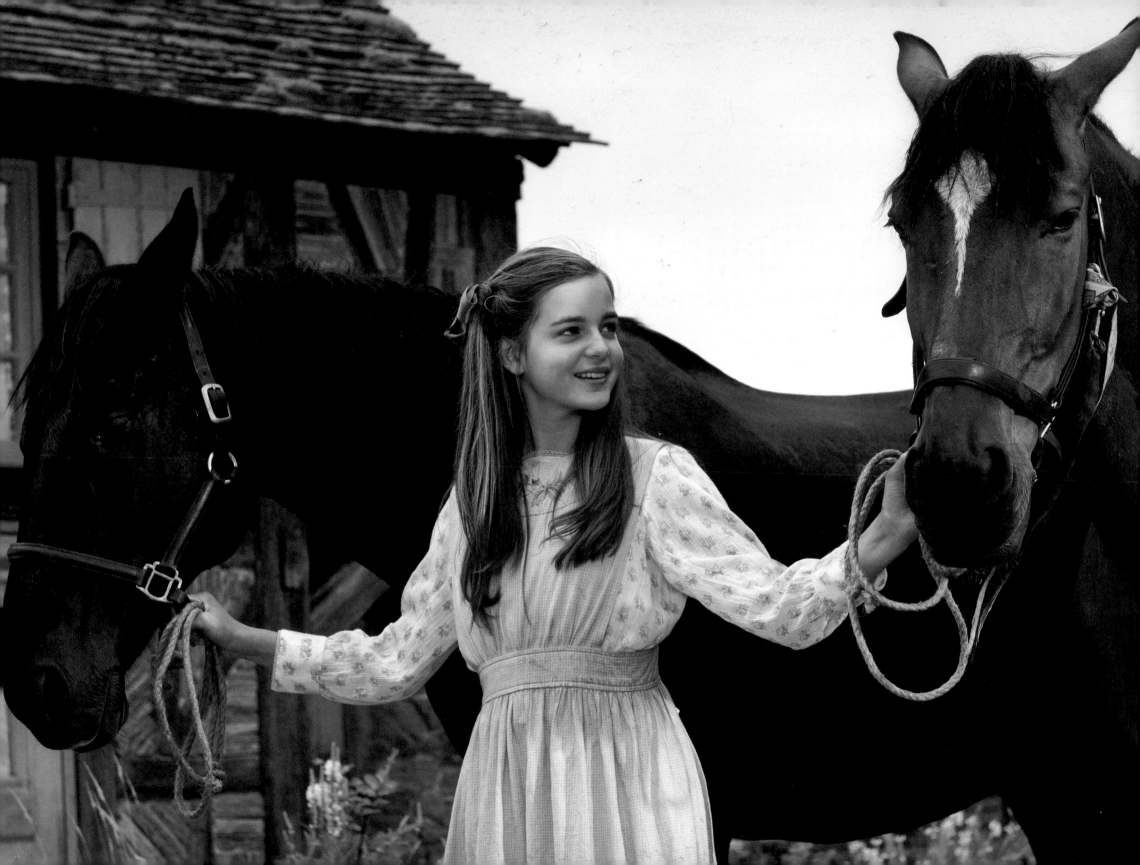

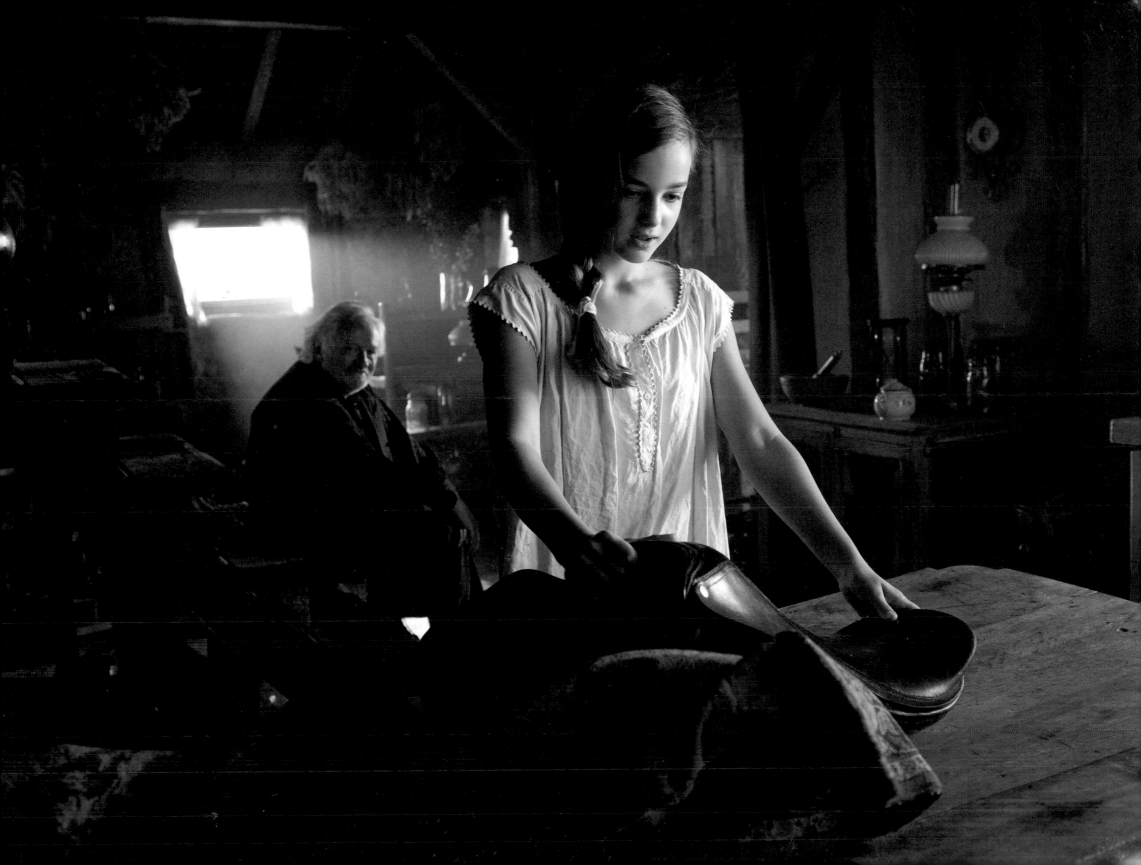

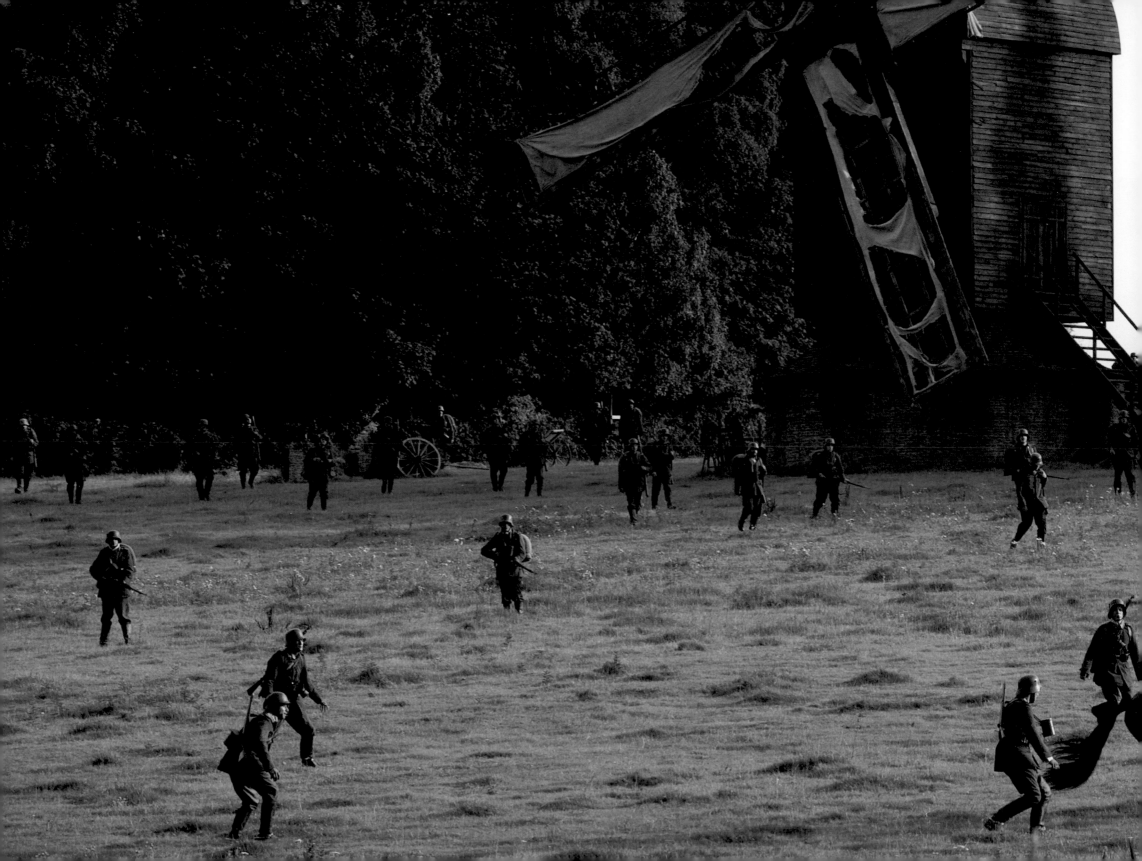

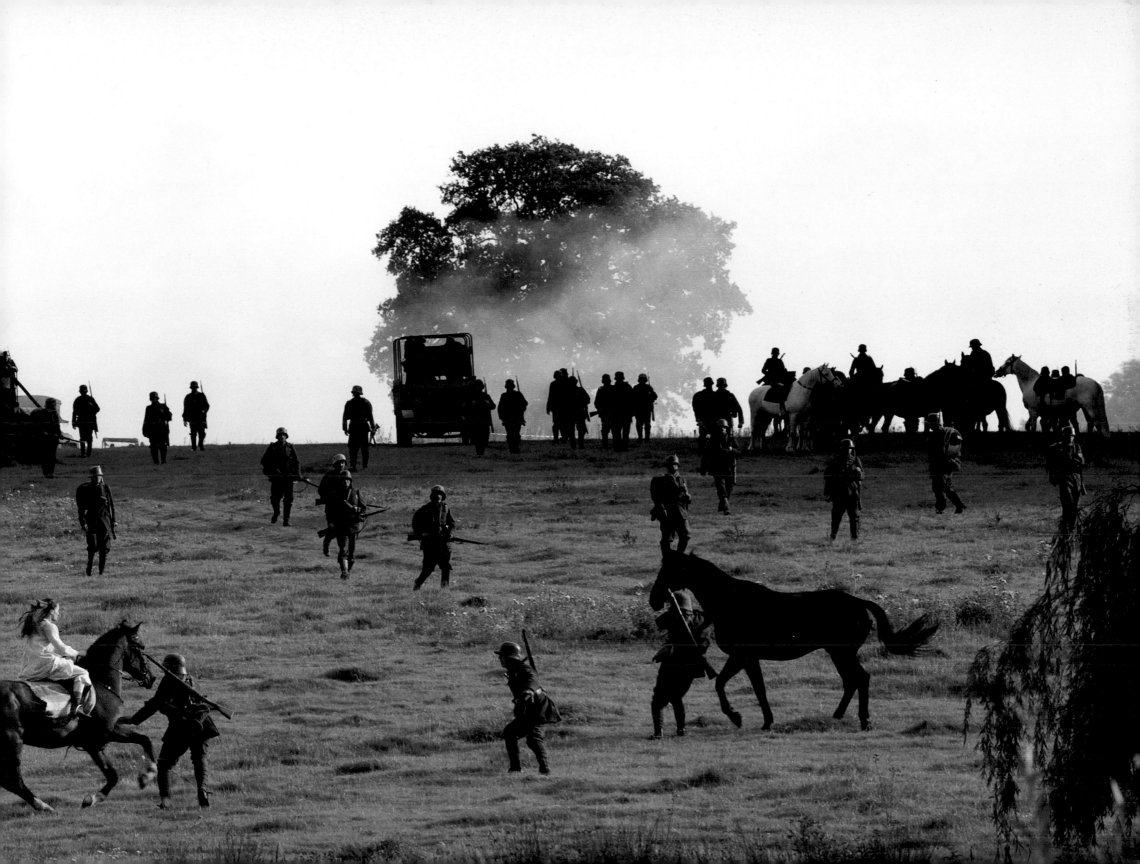

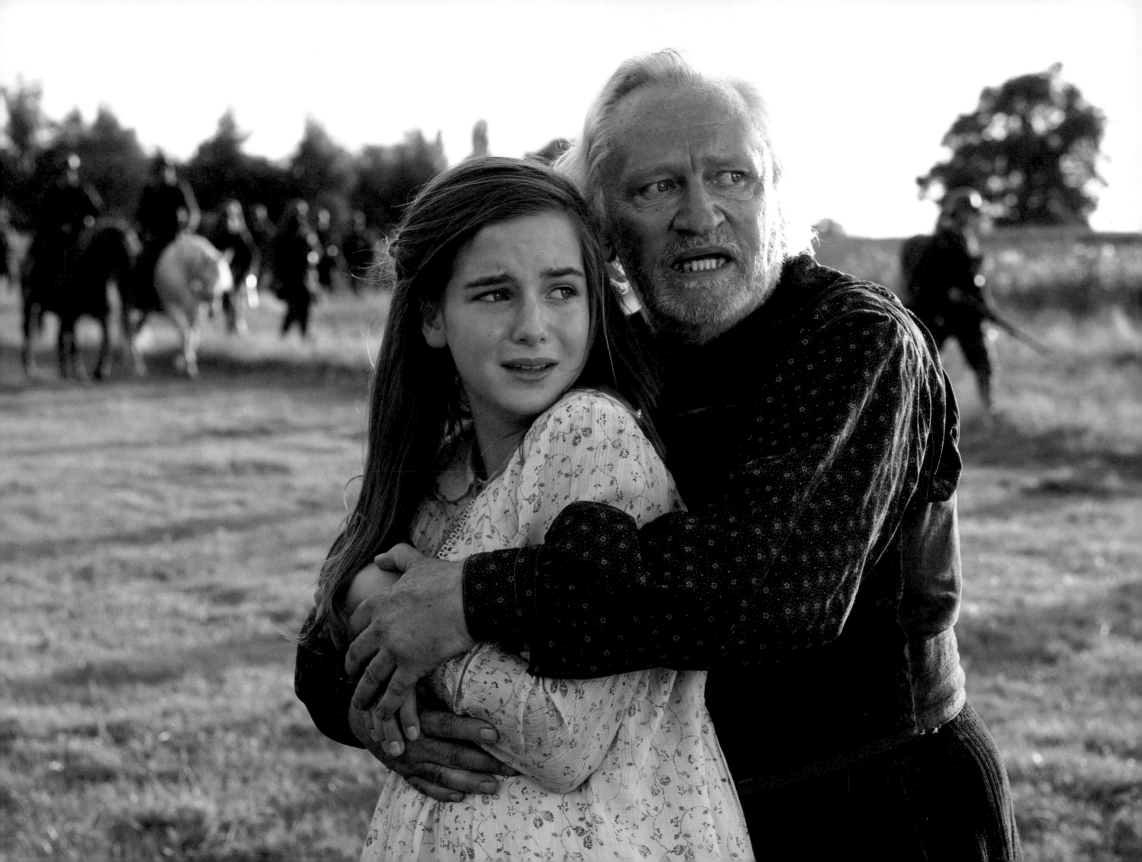

Kicking and Screaming

EXT. GERMAN COLUMN NEAR THE WINDMILL
Harsh cut—the Germans are moving through the horses they have gathered. Emilie tries to get to Joey, who is being roughly led away by a German soldier. Grandfather grabs her. She is screaming. He tries to calm her down. Joey is tied up as is Topthorn. Emilie is kicking and screaming—but also desperately short of breath. A clinical German Officer, Brandt, comes over to her Grandfather.

BRANDT
Only the two?

GRANDFATHER
Of course there are only two. We're not millionaires.

BRANDT
We will leave you then.

The horses are now being led away. Emilie is still sobbing; now so upset that she has a coughing fit. The grandfather hugs her—in horror that she is now struggling so hard for breath.

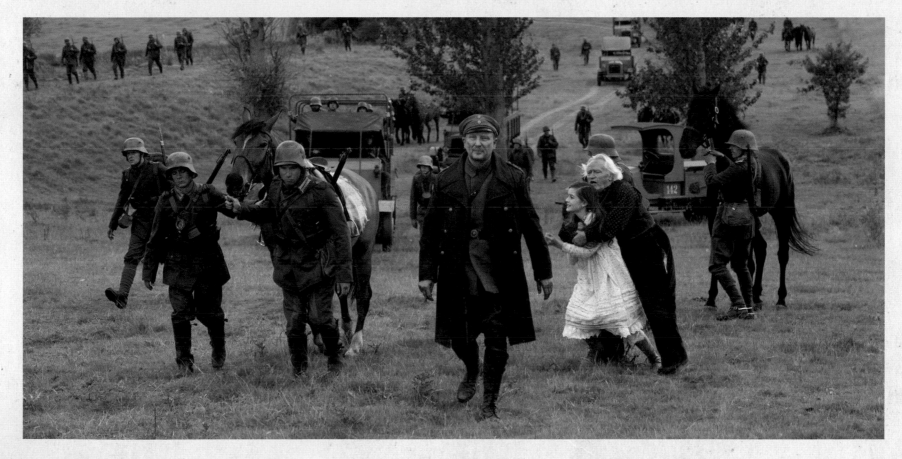

Work Horse

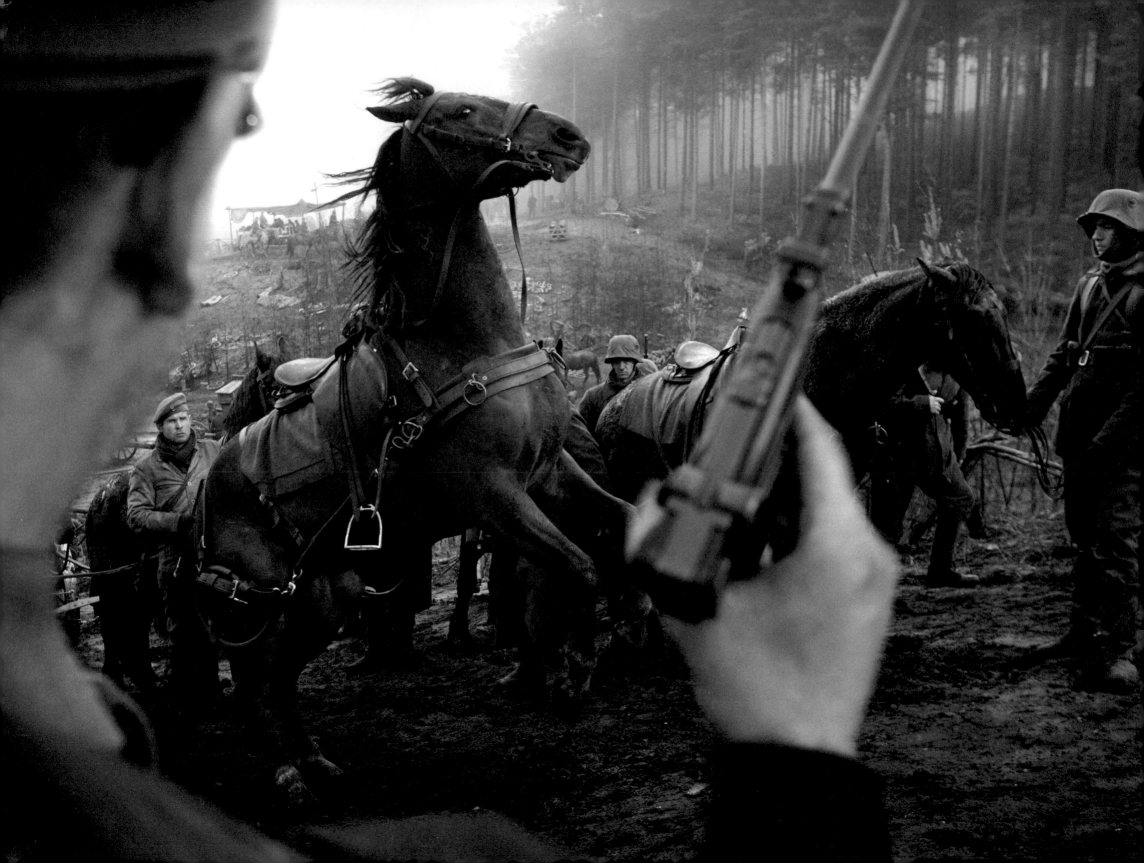

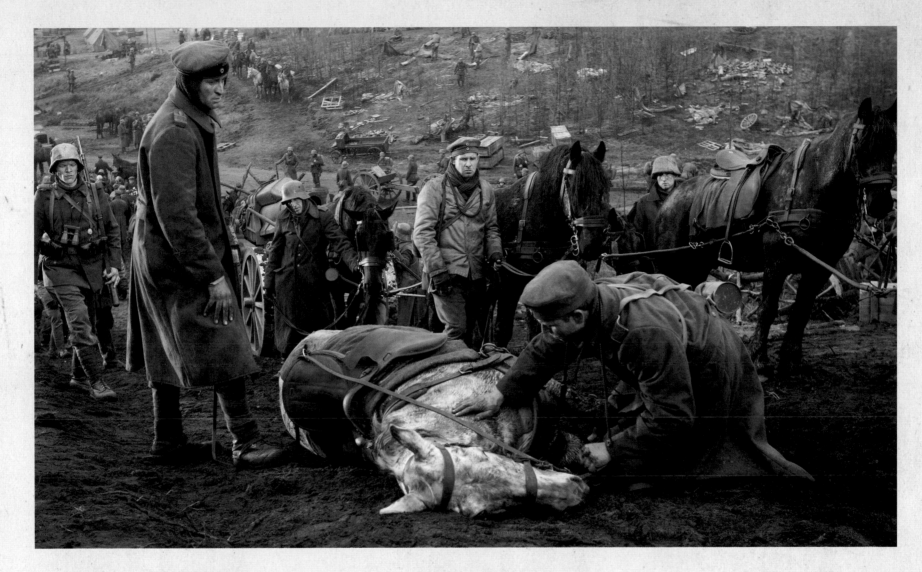

Beasts of Burden

Somewhere in Steven's mind is that great moment in American Westerns when someone goes over the hill and sees the Indians. You think it's all going to go horribly wrong, and this is one of those moments. Suddenly you realize when the horses are taken by the German army that they're not meant to survive. They are beasts of burden that are going to be dragging guns till they die.

—Richard Curtis, Co-Screenwriter

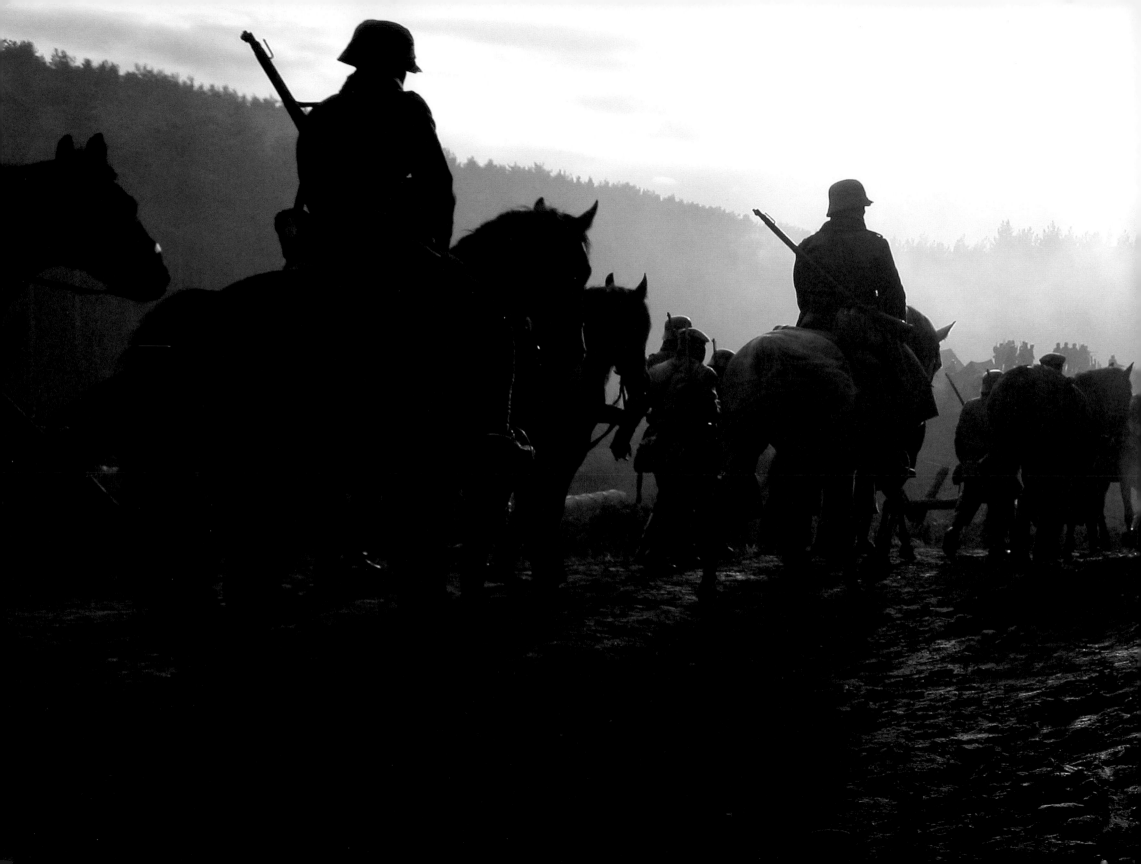

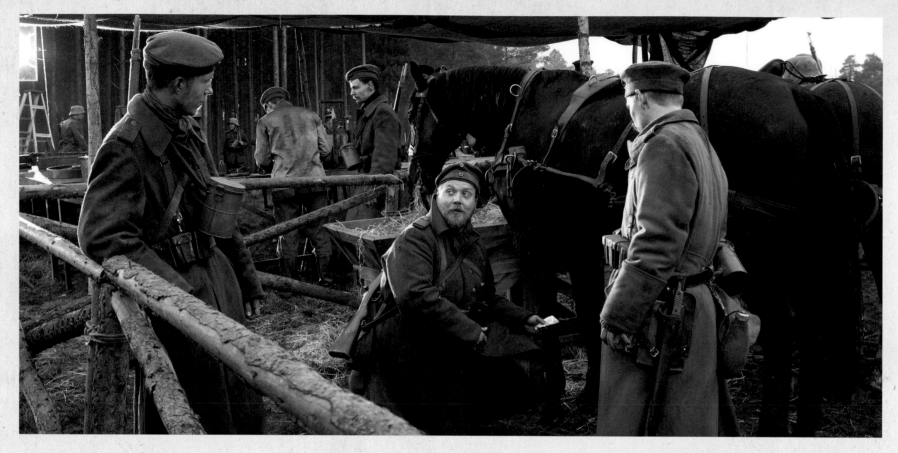

They're Only Horses!

FRIEDRICH
"You over there move that thing over here and you over here move *that* thing over there. No, not that thing, the other thing that looks just like that thing, and then the one that's next to that one by the whatsit, yes, that's right, I mean, no, wrong, move the whatsit next to the one next to the thing, the first thing not the second thing, then wiggle your ears and drop your britches and I'll be right over to kiss your . . ."

A group of soldiers are passing the stables. One calls out.

CURIOUS SOLDIER
Heiglemann!

FRIEDRICH
Yes?

CURIOUS SOLDIER
You are talking to the horses.

Other soldiers laugh.

FRIEDRICH
I'm explaining to them the new strategic plans for achieving the revised ultimate objectives.

SOLDIER 2
Do they talk back?

FRIEDRICH
Of course. Why wouldn't they?

CURIOUS SOLDIER
What do they say?

FRIEDRICH
What do you think they say? "Stop telling us stories you fat useless bastard and get us the hell out of France!" *(he shrugs)* They're only horses! What do you expect?

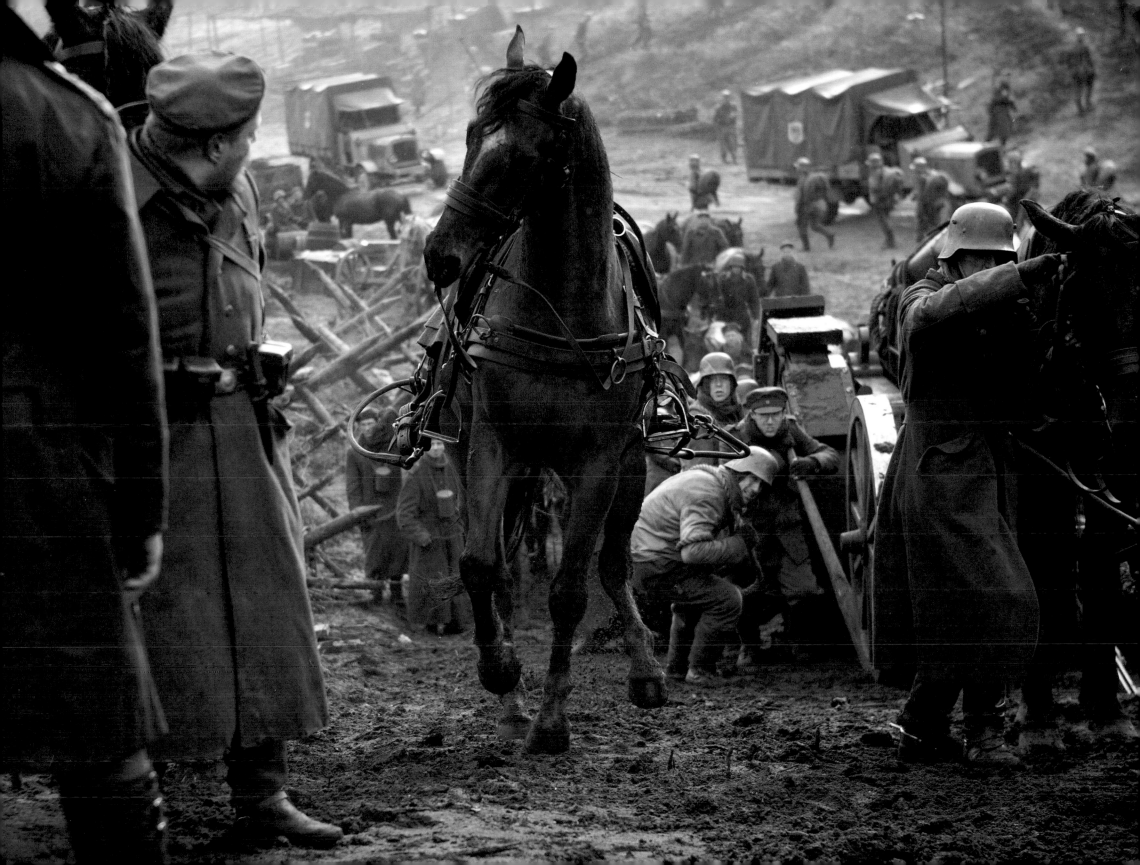

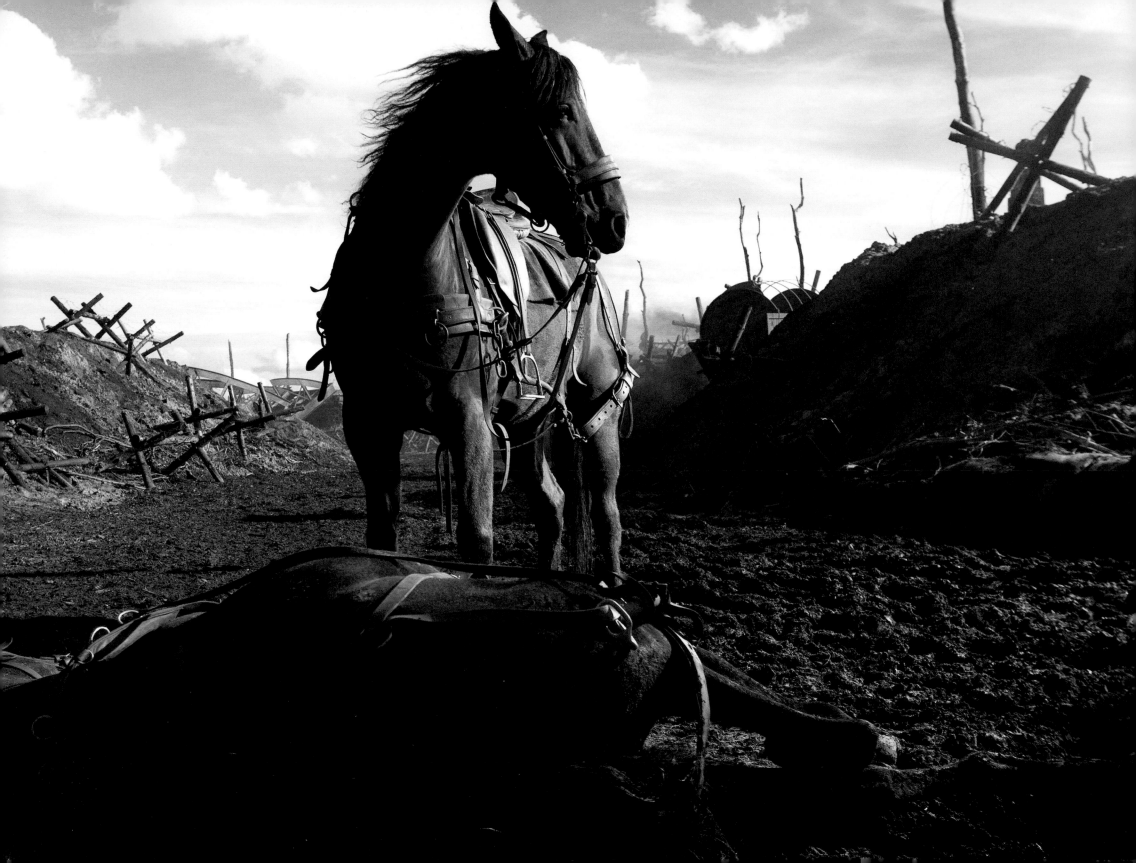

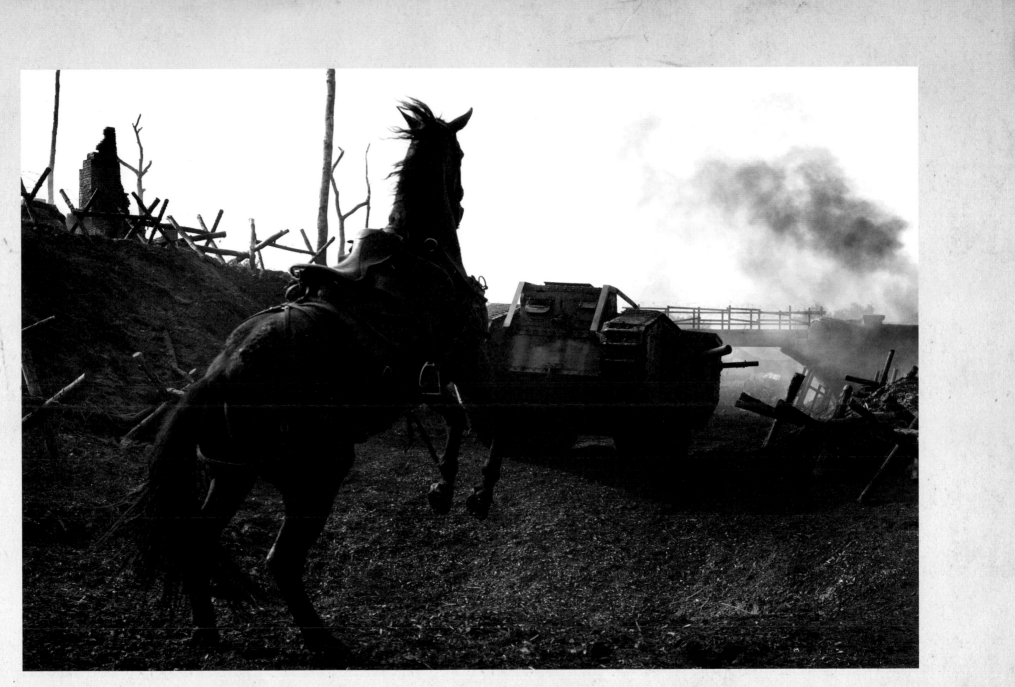

Joey is now in the direct line of the tank, but still stands completely inert beside Topthorn's body. The tank is about to crush Joey. He has left it too late. He is about to die. But then, counter-intuitively, he runs straight toward the tank . . .

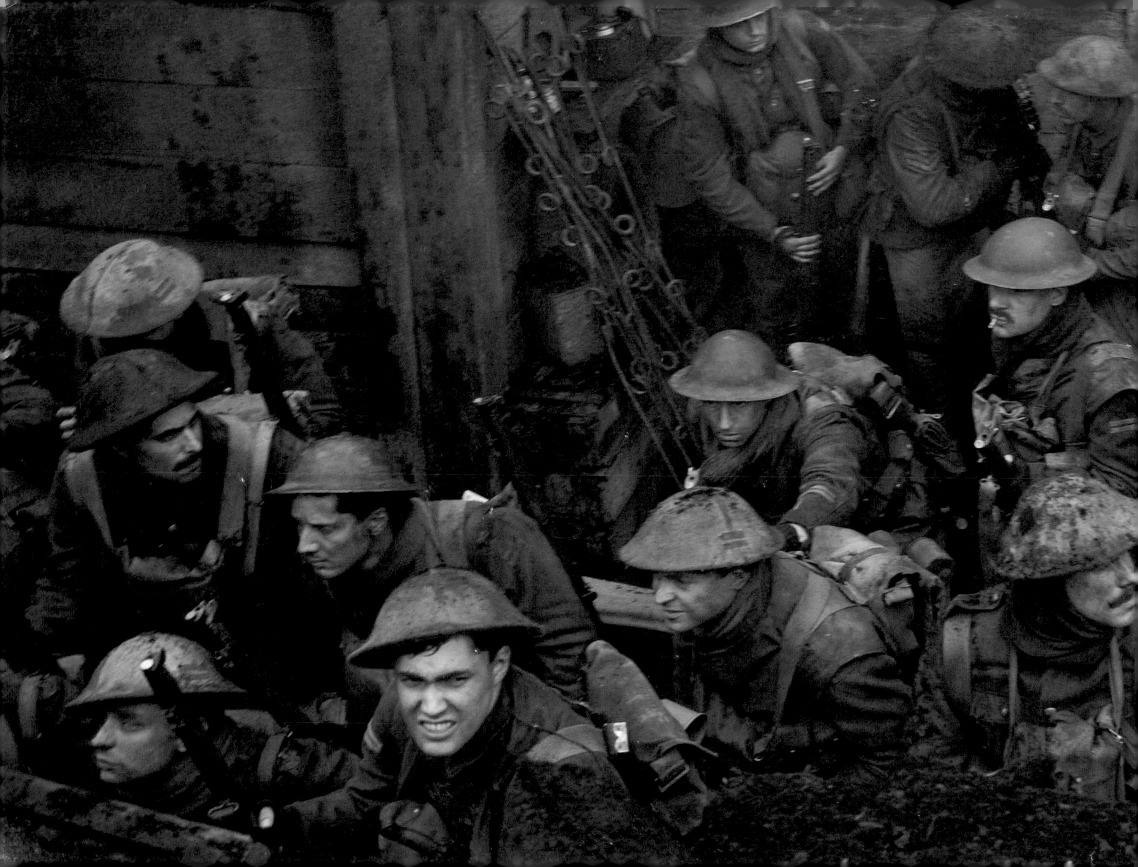

The Trenches

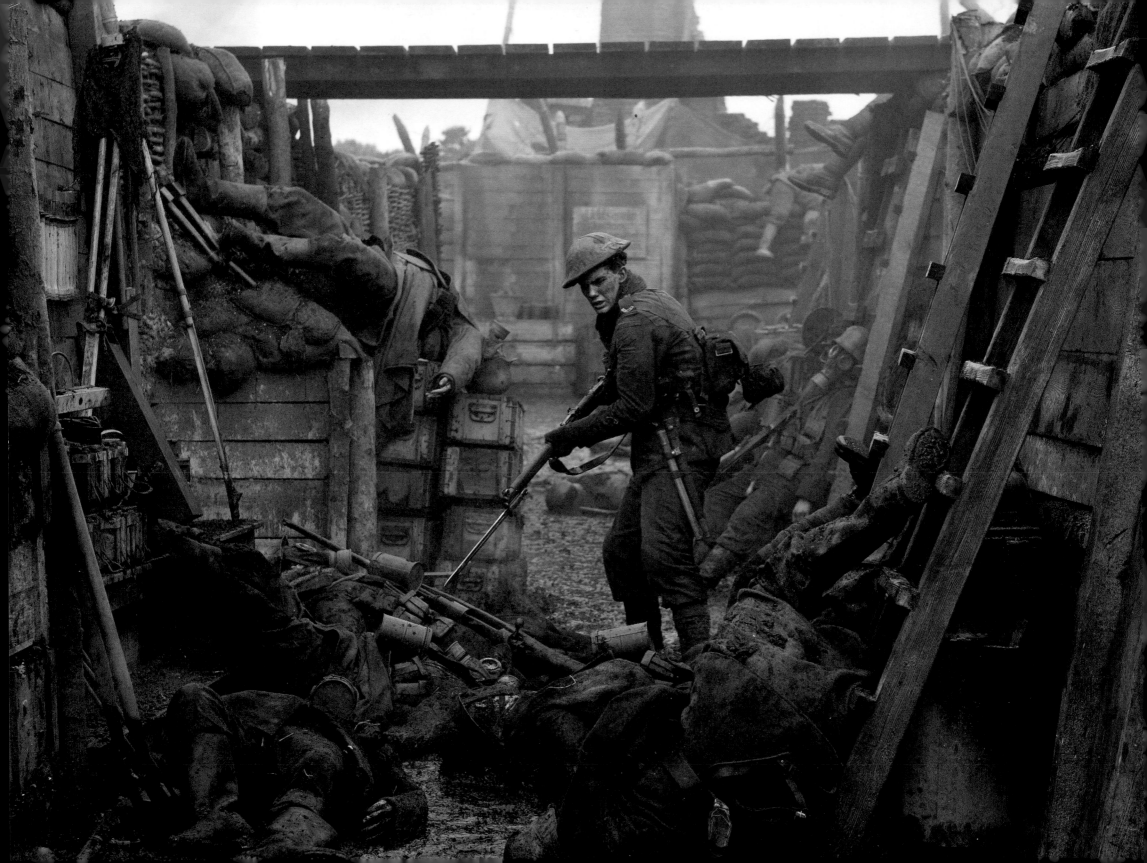

A Letter from the Trenches

When my grandmother was twelve her older brother was seventeen. She adored him; worshiped the ground he walked on. He lied about his age, signed up, and was killed. When she told me this she sobbed as if it had been yesterday. She slept every day of her life with his letter from the trenches by her bed.

—Emily Watson, Mum

When I got the role I started looking into my family history and my auntie told me about my great-grandfather who had a horse during the First World War. He was a doctor and became very attached to this horse. And after the war, he bought the horse off the army, for exactly the same amount that Albert tries to buy Joey for at the auction.

—Jeremy Irvine, Albert

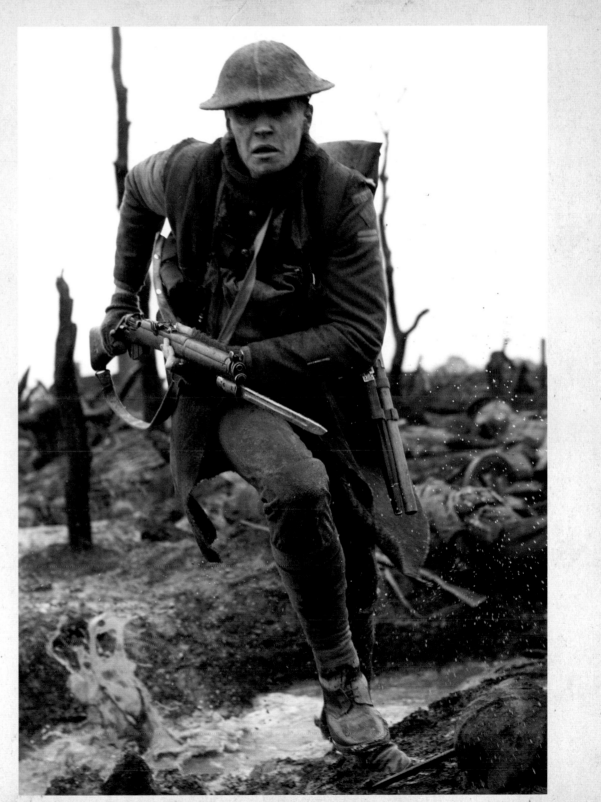

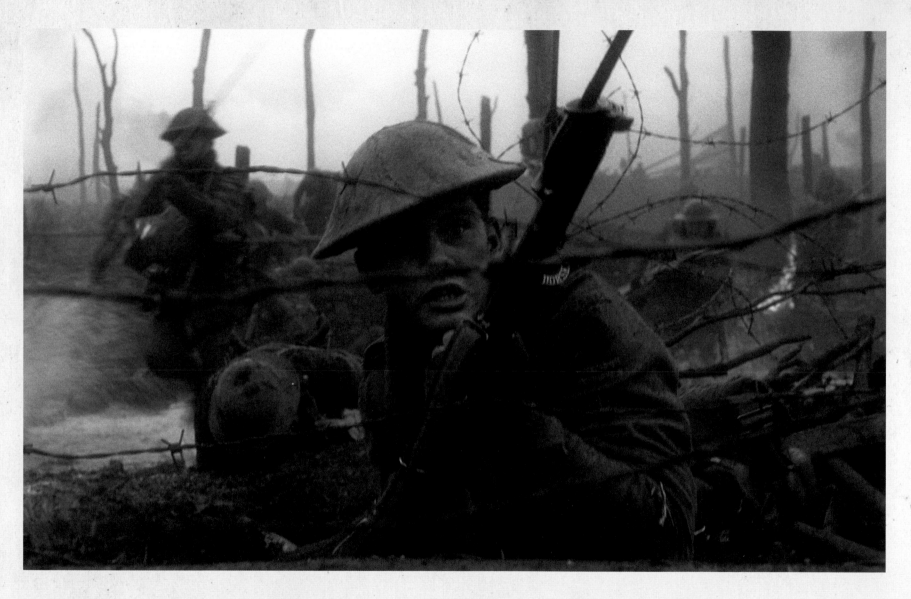

Explosions light the dirty faces of British boys in uniform, one after the next.
Each light fading out before the next great blast illuminates another
anonymous face—then another—and then another—

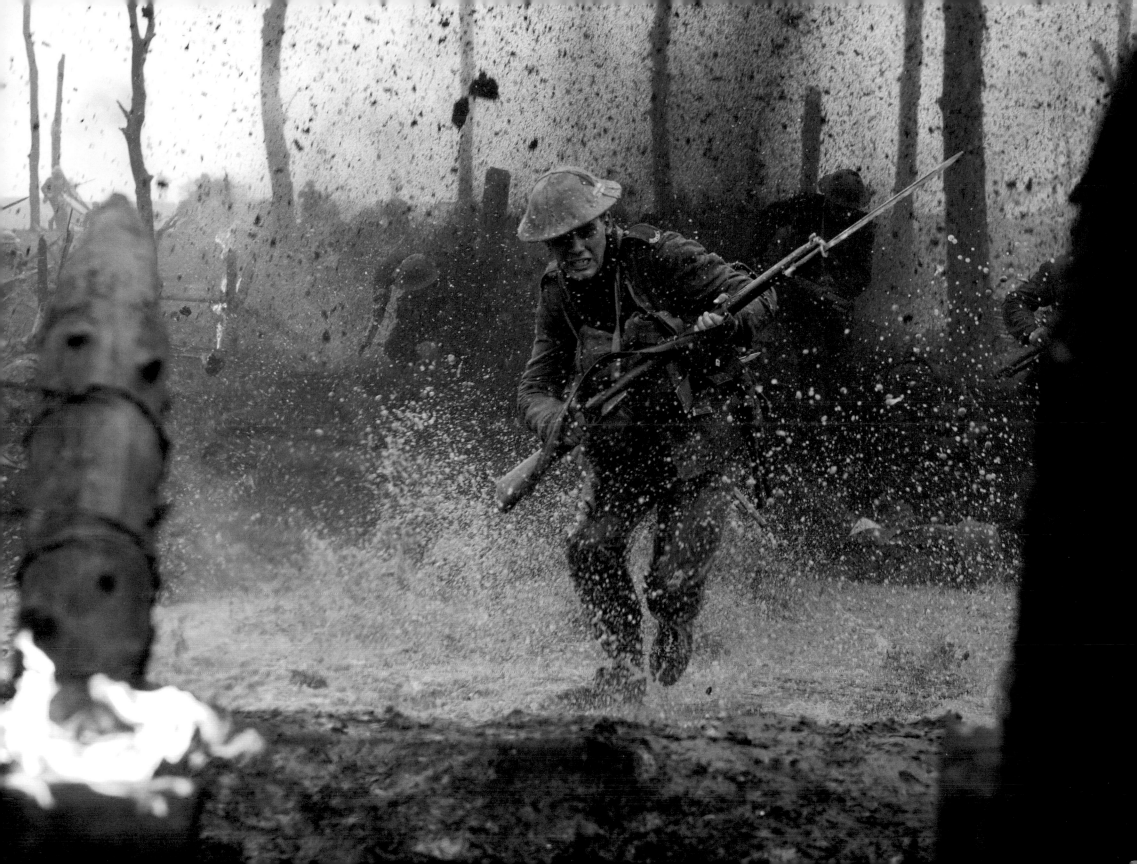

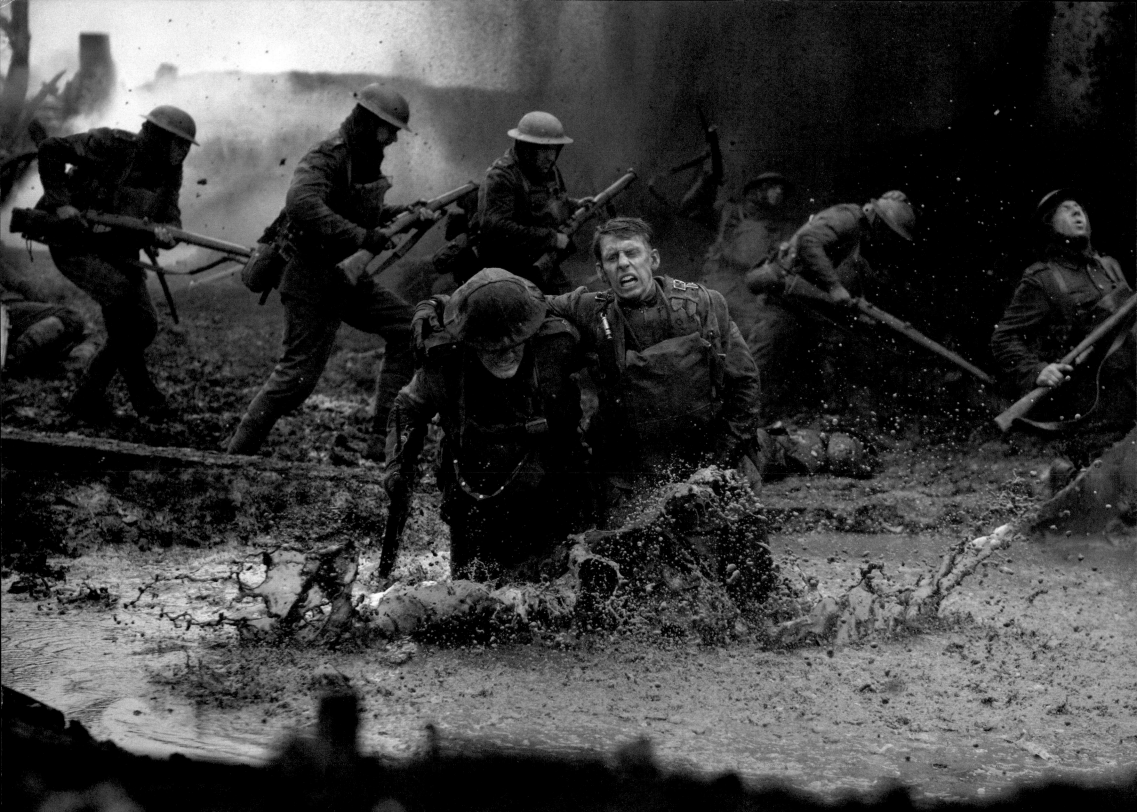

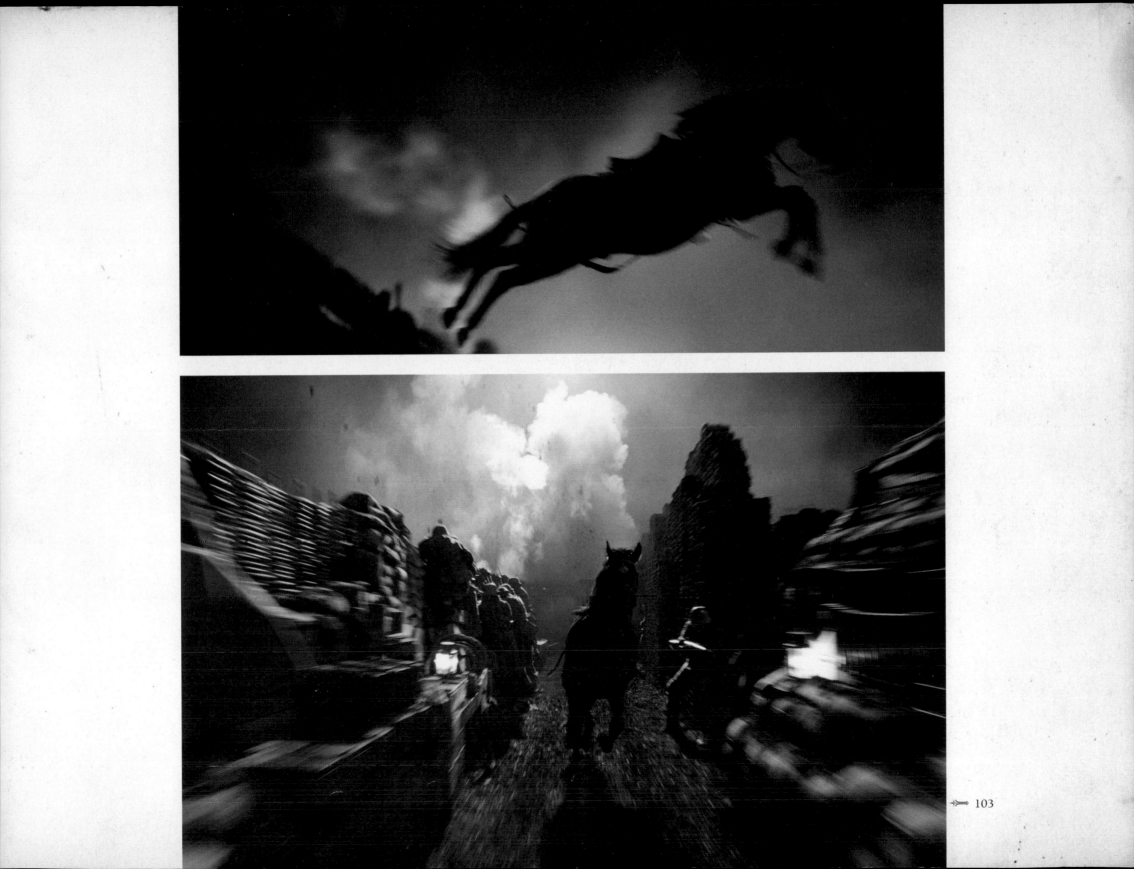

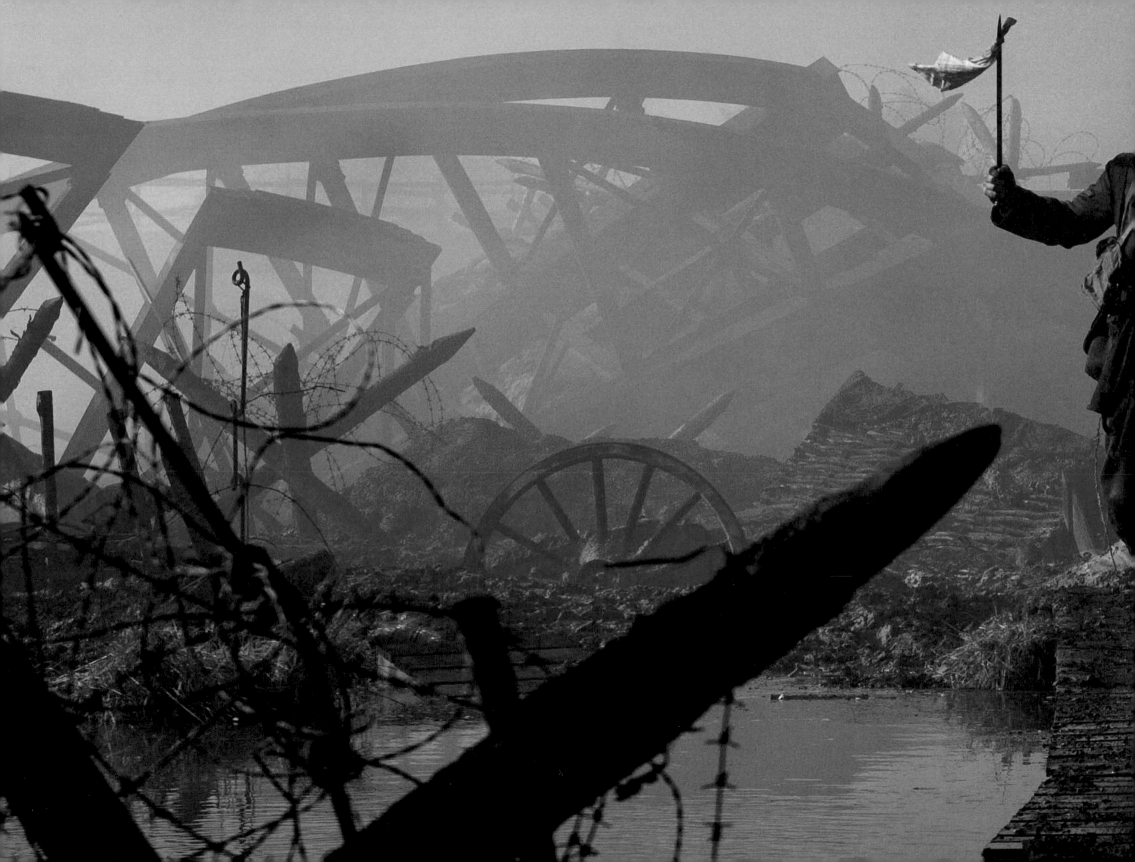

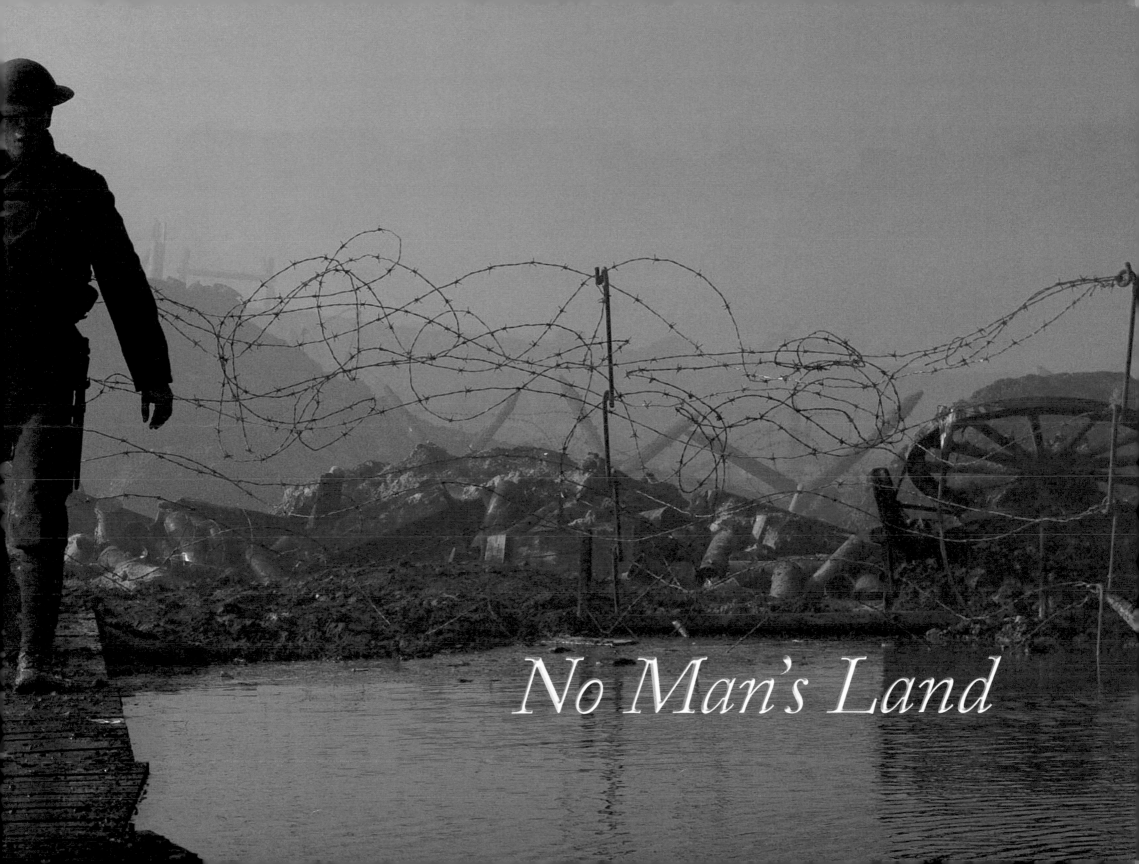

No Man's Land

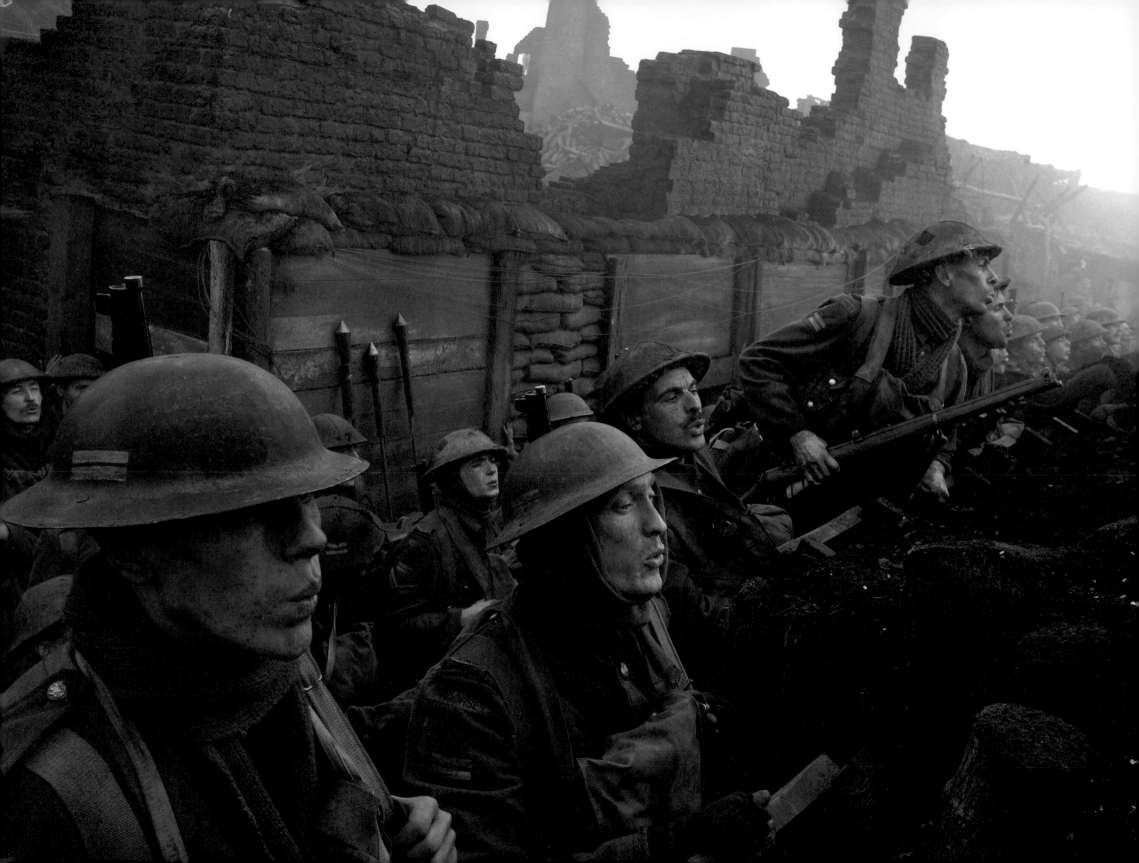

Out There

And there, in the middle of this strange, muddy, huge, empty hell, is Joey. Entirely alone. Trapped in the wire. Surrounded by huge bomb craters—and dead centre between the two opposing trenches.

EXT. BRITISH TRENCH. THE SAME.
Now a flurry of excitement in the trench. The men are gathered to look at the strange spectacle, straining to see. The sergeant major grabs the periscope.

> **CAPTAIN**
> Blow me! It's a horse!

EXT. GERMAN TRENCH. THE SAME.
We see an almost identical scene of several German soldiers looking out at Joey just as the British soldiers had done. A German is looking through a periscope as others are gathered.

> **GERMAN SOLDIER**
> A horse!?

> **SECOND GERMAN**
> It can't be a horse. Nothing alive could be out there.

> **THIRD GERMAN**
> It isn't a horse.

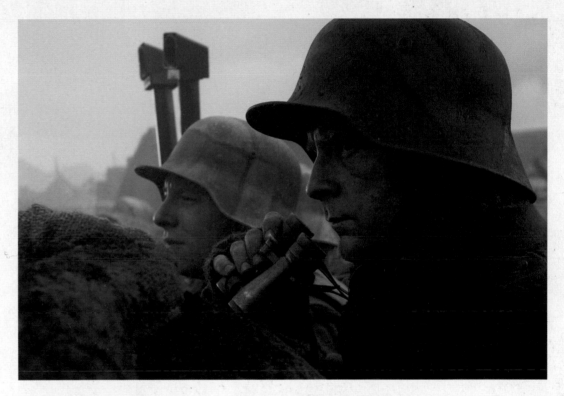

> **GERMAN SOLDIER**
> Look. Look.

He looks.

> **SECOND GERMAN**
> Yes— it's a horse.

EXT. BRITISH TRENCHES. THE SAME.
Now all the soldiers are gathering to look out at Joey.

> **GEORDIE SOLDIER**
> We should call him.

> **SOLDIER 2**
> *(Calling)* Here, boy, come on boy.

> **GEORDIE SOLDIER**
> He's a horse not a dog!

They try to attract his attention with tongue clicks and whistles.

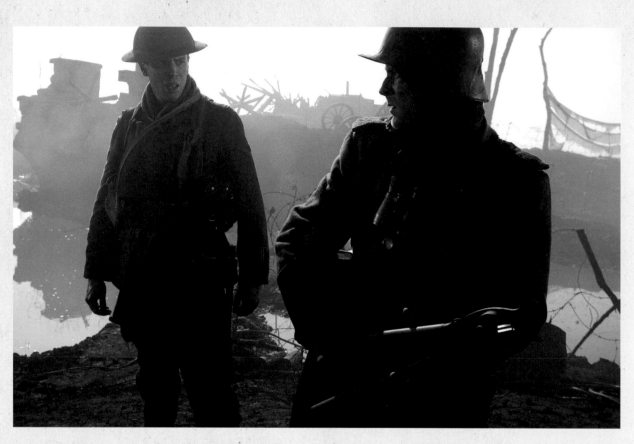

Both men smile at this while Joey is completely still; they work quickly, in concert, cutting the horse's head free of the wire.

Joey raises his head, gives it a shake, neighs and then stirs a little. The two soldiers smile at one another. Then they set about cutting the rest of the wire; it's much easier now.

The Geordie cuts through the last wire binding Joey's legs. The two soldiers help as the horse staggers upright.

GEORDIE
Look at this animal! Them muscles he's got, them long legs. They're meant for running, horses. Runnin' away. From danger.

GERMAN SOLDIER
Running away is all they have.

GEORDIE
Yet we taught 'em opposite. Running into the fray.

GERMAN SOLDIER
A war horse.

GEORDIE
And here you are, eh, fella? A war horse. Bloody odd, that.

Bloody Odd, That

GEORDIE
So how's doings over yonder in your trench?

GERMAN SOLDIER
Oh, delightful. We read, we knit sweaters, we train our rats to perform circus tricks.

GEORDIE
If you need more rats, we'll send ours over. We've more rats than we need,

strictly speaking. And they frighten off the pretty girls.

GERMAN SOLDIER
Our girls aren't afraid of rats.

GEORDIE
Great strapping German girls, eh? Kind what gives robust massages?

GERMAN SOLDIER
Every Thursday! And they bring rum cake on your birthday.

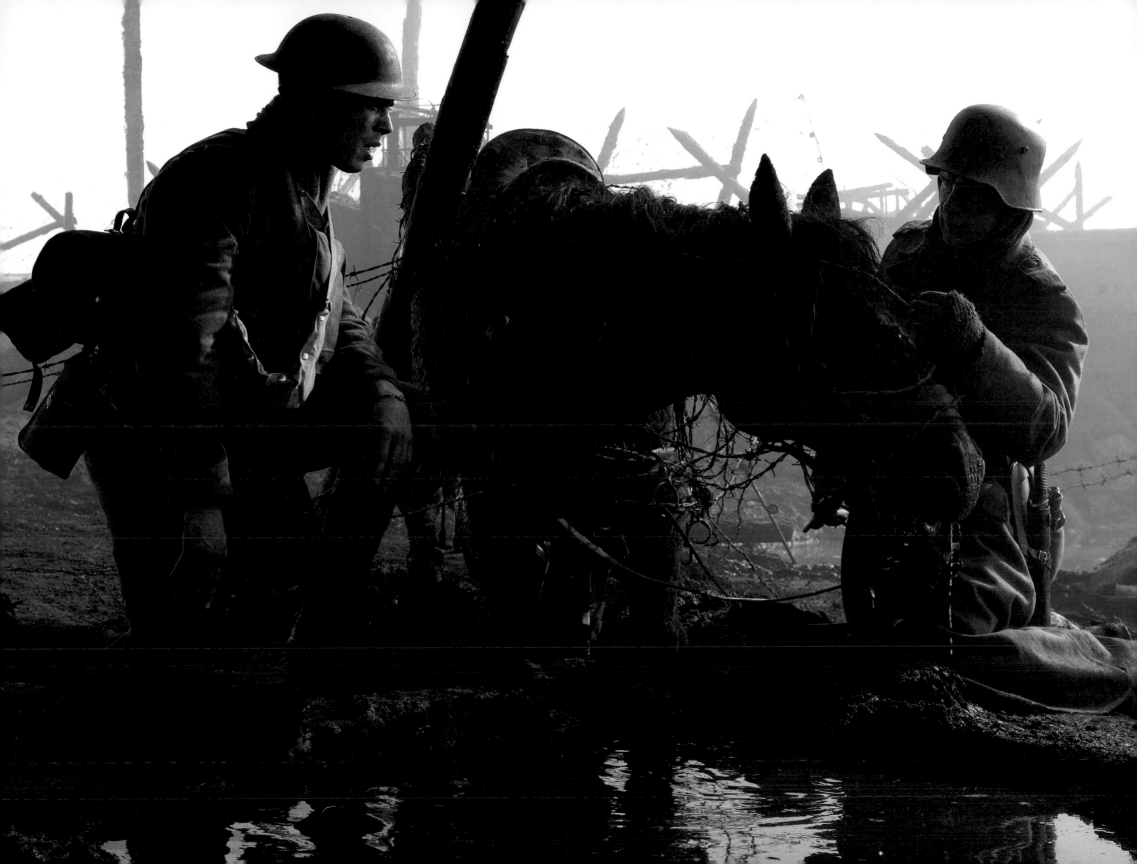

Part 2
The Making
of *War Horse*

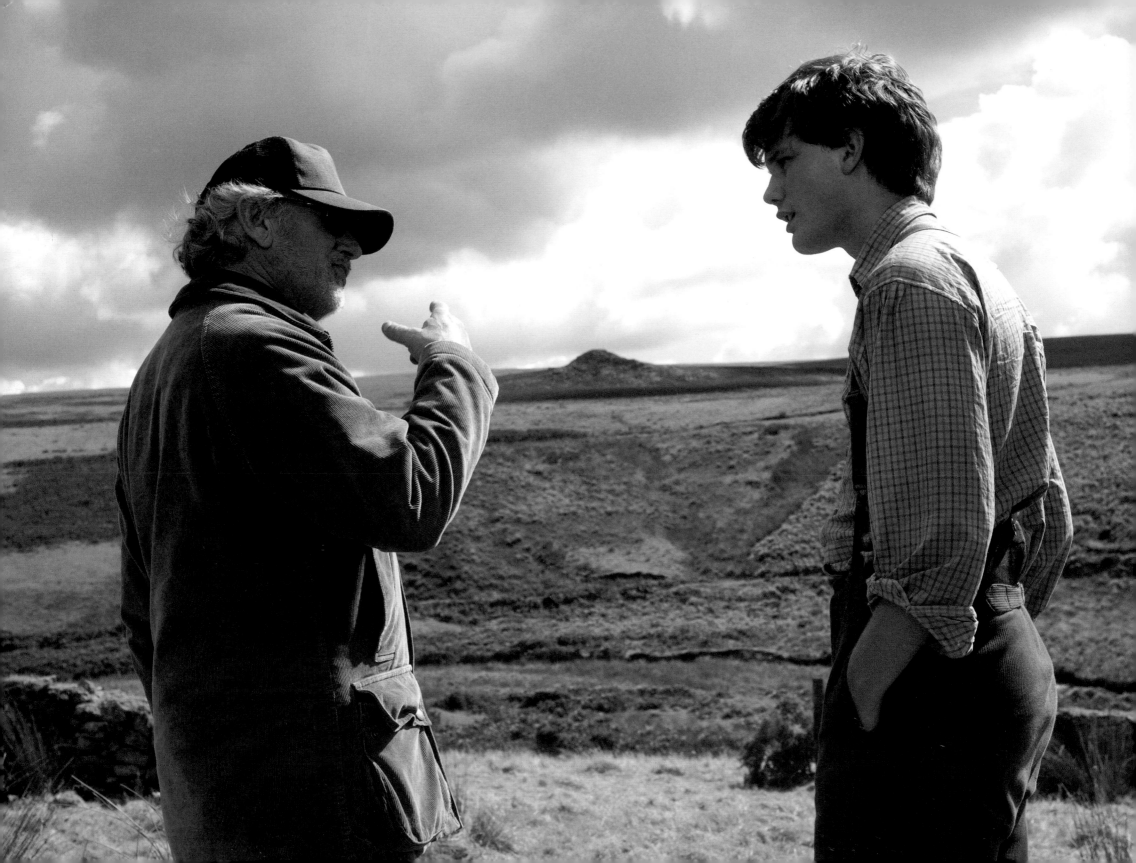

I really wanted to make *War Horse* because it says a lot about courage; the courage of this boy, what he endures, what he overcomes both for himself and his best friend Joey. It's also about the courage and tenacity of this extraordinary animal. So the theme of courage kept coming back—from the play, from Michael Morpurgo's book, and from Lee Hall and Richard Curtis's screenplay. And that underlying, subliminal theme informs every frame of *War Horse*.
—STEVEN SPIELBERG, DIRECTOR

I live in the heart of Devon, which is very rural even now, so you get to know everyone in the village.

I was in the pub one day and saw this old bloke that I knew had been in the war so I asked him about it. He told me he had been with the Devon Regiment with horses. Then he started talking about his experience of being a soldier, of leaving the land, of the fear that was in his heart every day. He told me that the horses weren't just what you rode to go into action or to pull a gun carriage, they became personal to you. They mattered to you.

And I thought, well here's an opportunity to tell a story which crosses over the boundaries, the nationalities, cultures, the divides, the enmities.
—MICHAEL MORPURGO, AUTHOR

This was a very difficult movie to make. Our philosophy was, "do the best you can with what you have, and if it can't be done then it's not meant to be." Of course it doesn't hurt to have the likes of Steven Spielberg on your team. He is extraordinary at taking what is a relatively limited number of resources and making it look huge. It was a real lesson in recognizing that what's important in the process of making a movie like this, one with historical reference, is to capture the reality and not rely on creating it artificially.
—KATHLEEN KENNEDY, PRODUCER

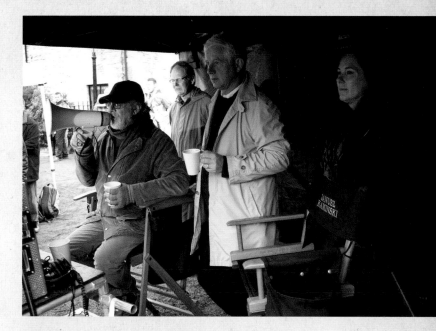

OPPOSITE: Steven Spielberg and actor Jeremy Irvine. ABOVE RIGHT: Co-Screenwriter Richard Curtis (center foreground), with Steven Spielberg and producer Kathleen Kennedy. BELOW RIGHT: Author Michael Morpurgo and wife Clare with Steven Spielberg on set. The Morpurgos are extras in the auction scene.

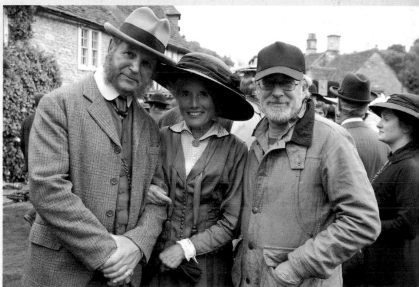

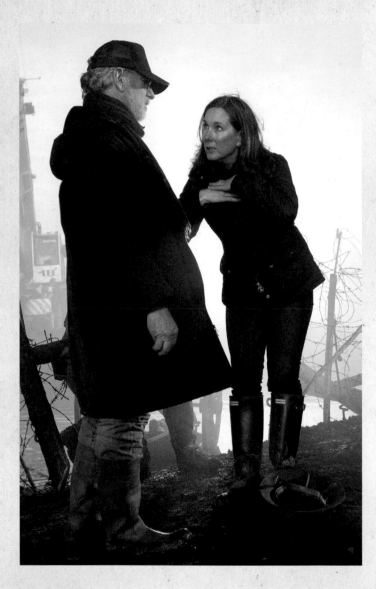

It's rare with large studio pictures to shoot a movie with essentially all exteriors. Being outside every single day is kind of an old-fashioned way of movie making, but we were trying to tell a story in Devon. We were quite surprised at the extraordinary beauty, and to capture that on film was really quite amazing.

—KATHLEEN KENNEDY, PRODUCER

We don't take sides in terms of who's right and who's wrong in this conflict. It's really about how these characters relate to the horses. The characters that do relate to the horses have no political agenda, their main concern is for the safety and the care of their charges. That's what gives a little more humanity to this particular kind of war story.

—STEVEN SPIELBERG, DIRECTOR

England is one of my favorite countries to work in for various reasons. One is the beauty of the landscape—it's very, very visually stimulating. Another is the unpredictability of the weather. But instead of fighting the weather or waiting for it to change, we used the rain, clouds, and sun we would get thorough the course of the day to make the movie better. Sometimes we started with a beautiful sunrise which turned to rain, then to clouds that would roll in leaving you with beautiful patches of sunlight and clouds.

—JANUSZ KAMINSKI, CINEMATOGRAPHER

LEFT: Steven Spielberg and producer Kathleen Kennedy on the No Man's Land set. OPPOSITE: Steven Spielberg directs actors Peter Mullan (Dad, Ted Narracott) and Emily Watson (Mum, Rosie Narracott).

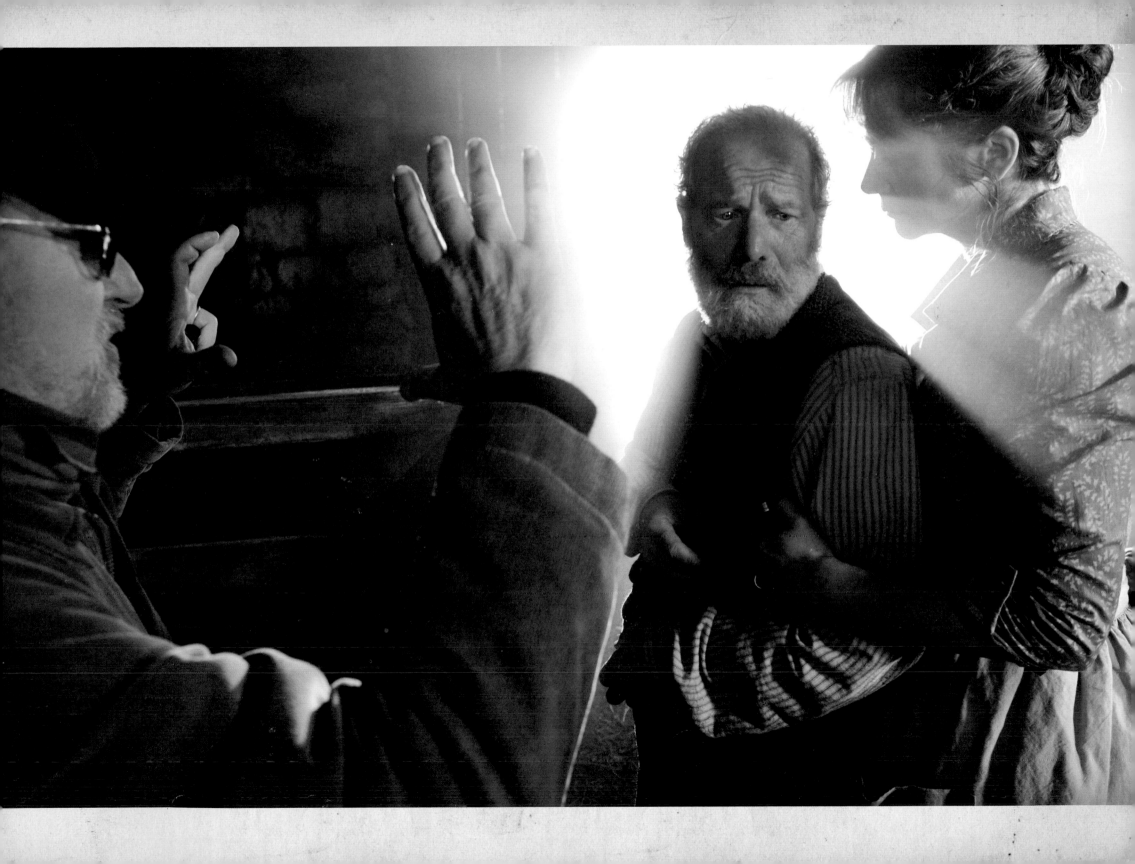

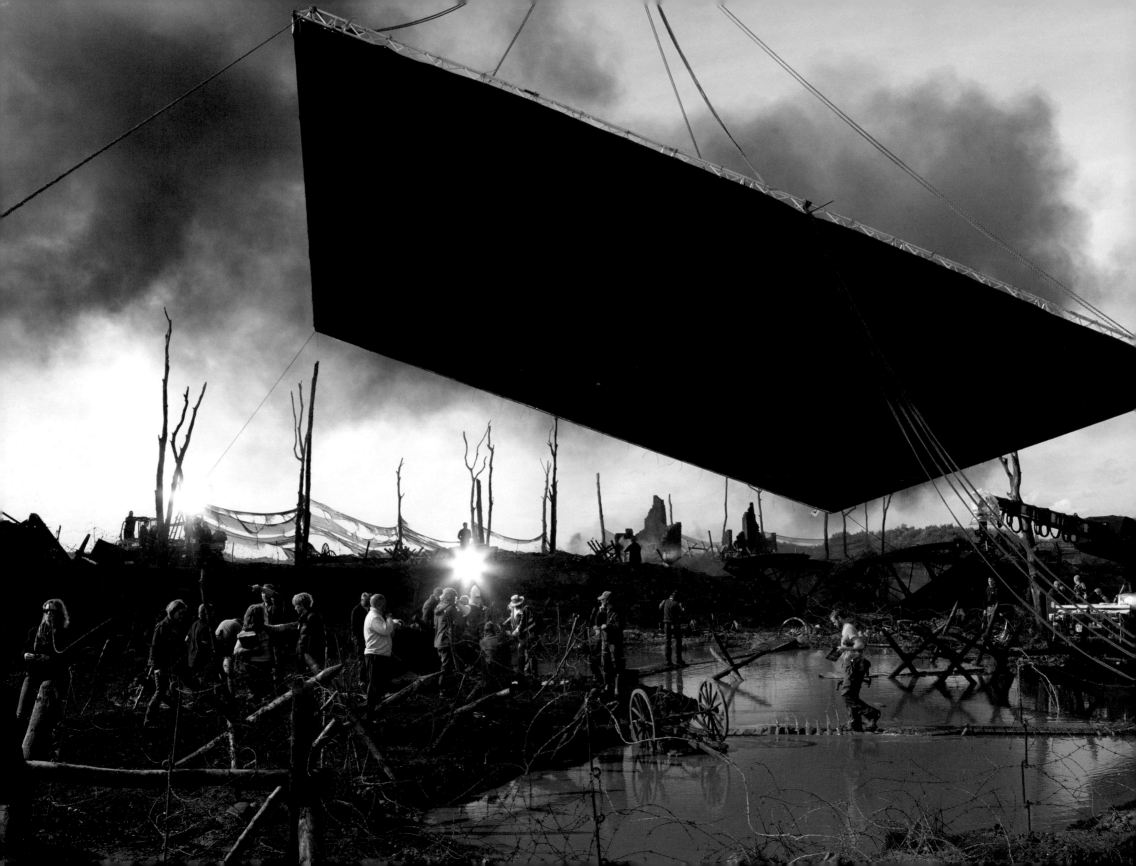

War *Horse* is a quintessential Steven Spielberg movie. He was able to take all its elements—great emotions, great action, great characters—and combine them to tell a very intimate story.

For this movie we talked about certain visuals. We spoke about John Ford and his composition and about the importance of the characters standing out from the land rather than blending in. The movie takes place in an amazing English landscape so I used many very big, very strong lights because I wanted to see the blue skies and puffy clouds and I wanted the characters to stand out from the land.

This is very much old-fashioned filmmaking. We are dealing with the First World War and its beautiful costumes. We're dealing with really beautiful composition and great performances; there are soldiers, the spectacular landscape, and hundreds of extras. Nobody makes movies like this anymore but Steven Spielberg.

—Janusz Kaminski, Cinematographer

Opposite: Filming on the No Man's Land set.

Right: Cinematographer Janusz Kaminski (in white).

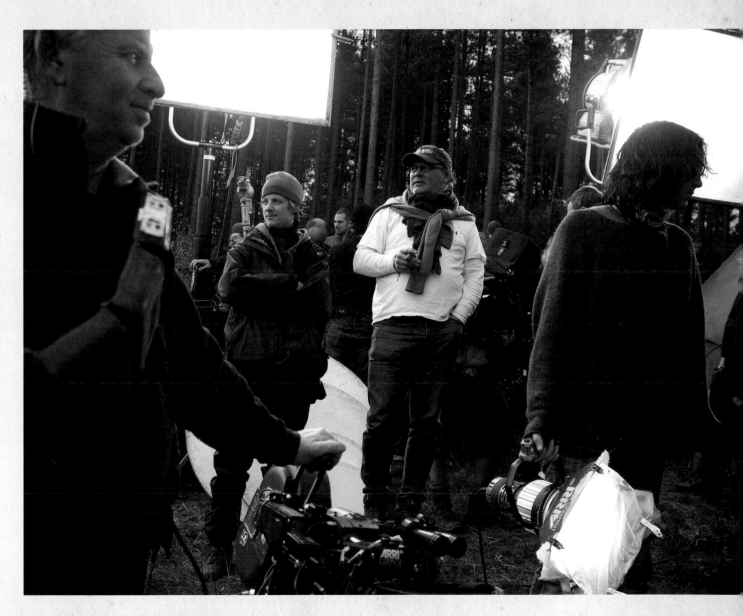

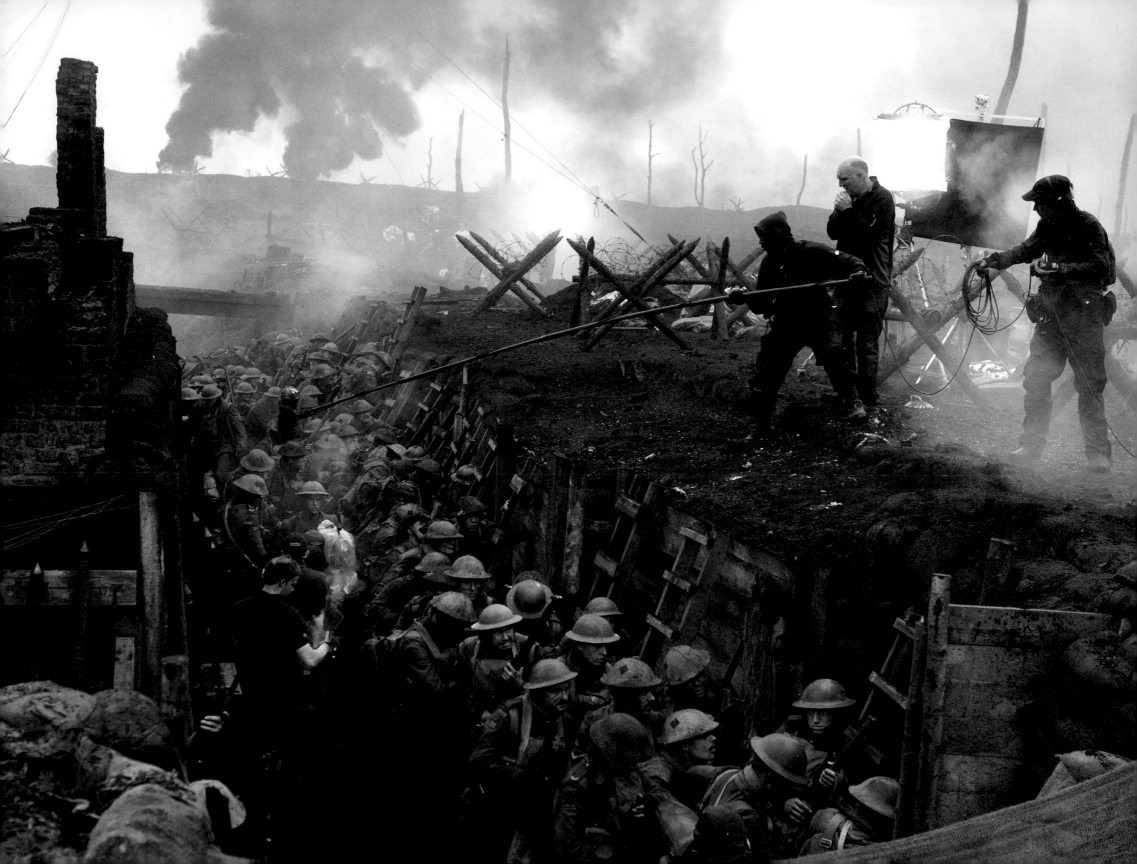

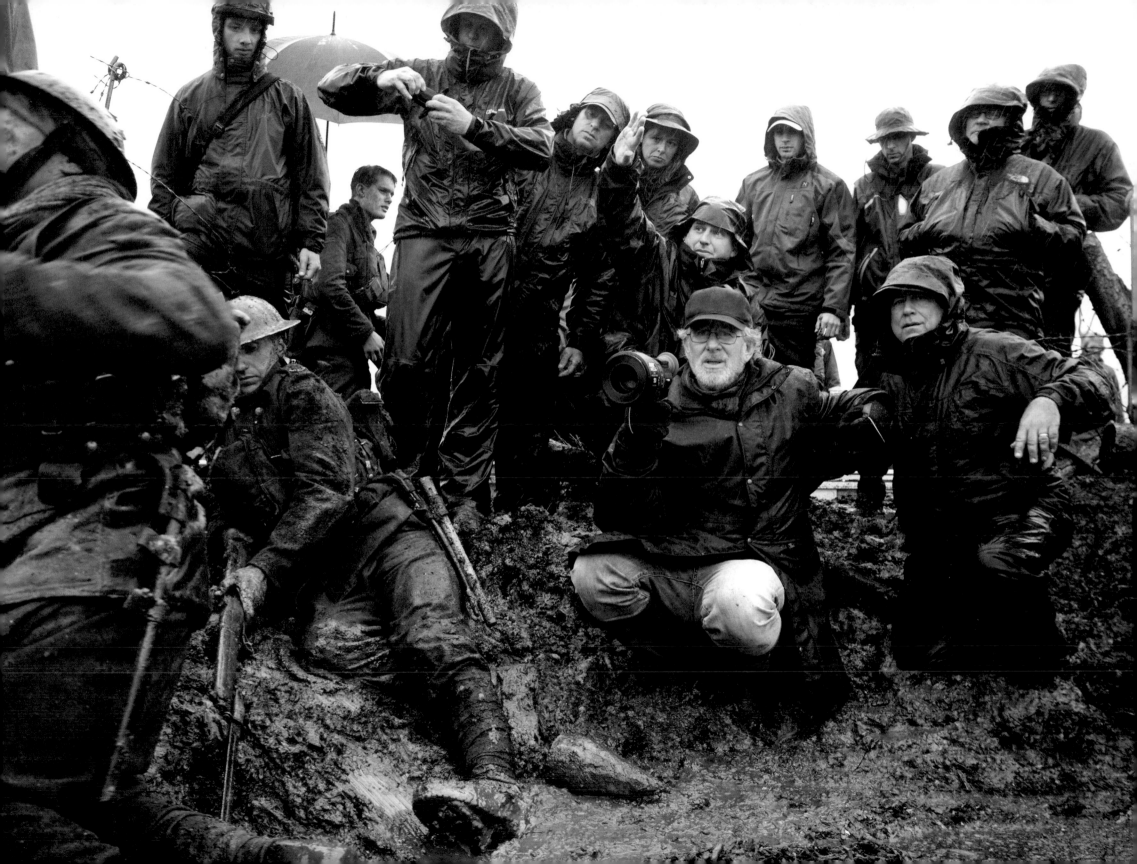

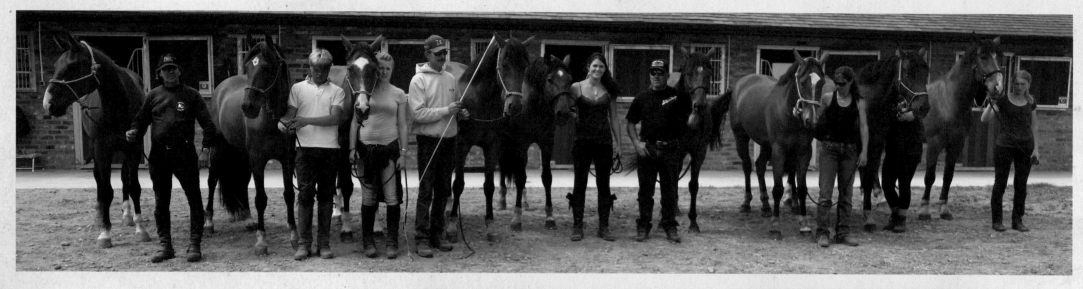

We've got eight hero adult Joeys, two teenagers, one mingling, and a folk, and they all have to be identical. Each horse was cast specifically for different actions and each has his own temperament. They must all have four white socks and a star on the forehead, and, on average, it takes forty-five minutes to get a Joey to look like a hero Joey. This job has taught me a lot of patience.

—CHARLIE ROGERS,
EQUINE MAKE-UP SUPERVISOR

ABOVE: Hero and stunt Joeys (left to right) Generoso, Lincoln, Roger, Sultan, Diego, Finder, Abraham, Sueno, and Civilon, with their handlers. RIGHT: Make-up artist Sarah Nuth working on "Joey," with trainer Zelie Bullen. OPPOSITE: Make-up artist Lois Burwell touching up actor Jeremy Irvine.

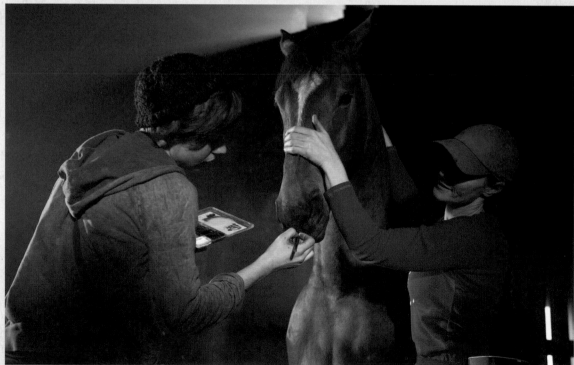

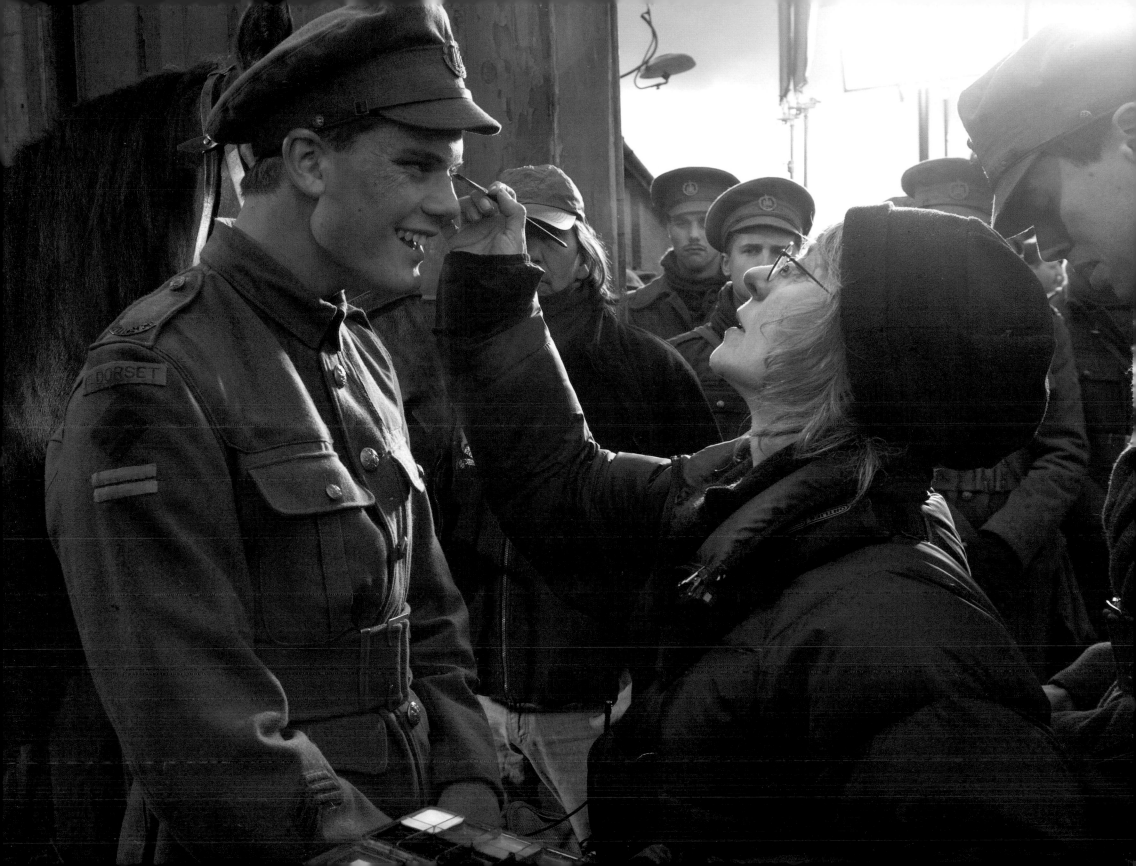

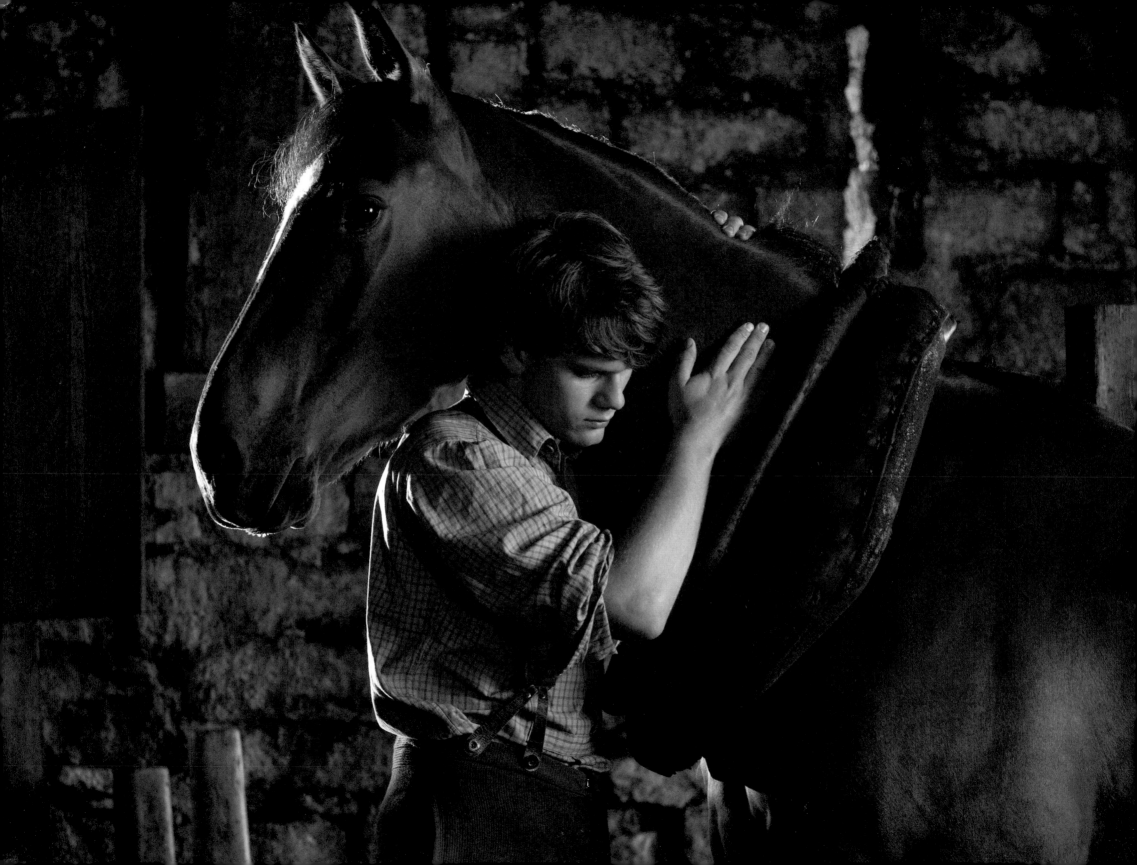

What is very difficult is getting an emotion from the horses that you can read. I'm very lucky with Finder. He has a personality that shows some of that emotion. I trained him for *Seabiscuit* and bought him afterwards. We did an awesome scene when Topthorn dies and Joey picks up the reins and pulls Topthorn's head up. It was very emotional.

—Bobby Lovgren,
Horse Whisperer

The first time we had the actors on the field fully uniformed, equipped correctly, and looking exactly as they would have on the day, a shiver went down my spine. I've spent so long studying it in books and looking at photographs that bringing it to life was just fantastic. Our horses were very similar to the types that would have been used at the time, and how they interact with each other and their riders hasn't changed, so when they set off from the bottom of the field in that charge, the horses felt and acted exactly the way they would have in real life. The sad thing is that the outcome of it was so often tragic. But in memoirs they say that it was the greatest thrill around. Horses weren't just a tool of the war, but they were participants in it and served with an equal kind of honor and heroism as the men who rode them. The animal combatants did their bit just as much as everybody else.

—Dr. David Kenyon,
Advisor/Cavalry

The first time we did the cavalry charge I was so breathless with excitement I nearly fell off the horse. I actually saw stars in front of my eyes and thought I was going to faint. The second time I had a bit more control but was still giddy with excitement. And the third time I was an emotional wreck. I had to really try hard not to cry.

—Benedict Cumberbatch,
Major Stewart

We had all these quick releases and bungee rigs inside tents so that as the horse runs past we collapse the tent in the right direction. We also had some really lightweight break-away tables and chairs made from foam that the horses ran through.

—Neil Corbould,
Special Effects Supervisor

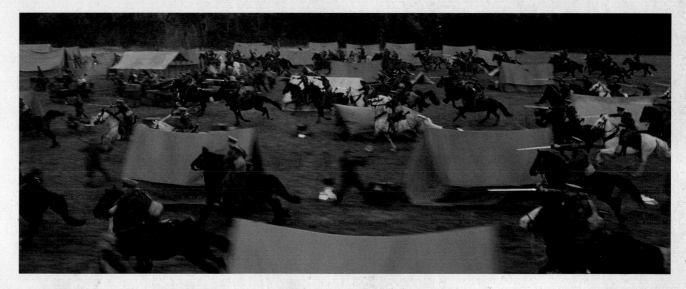

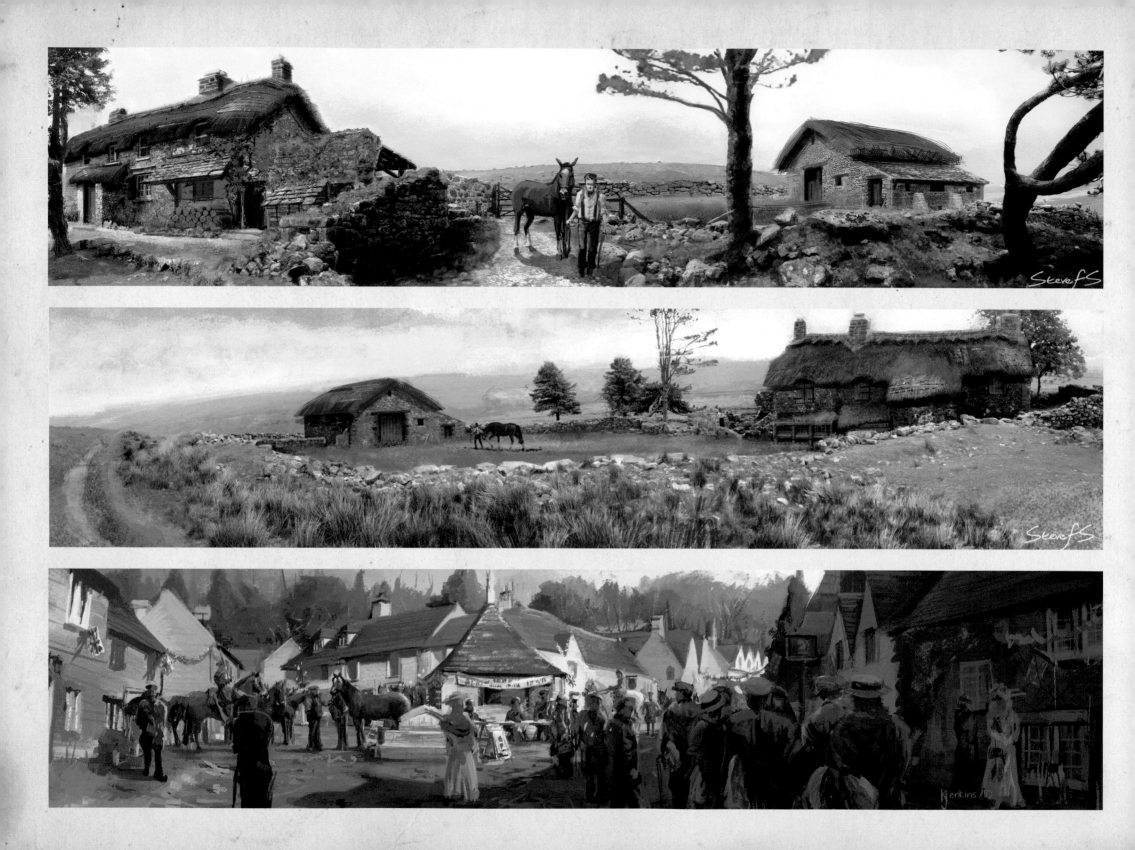

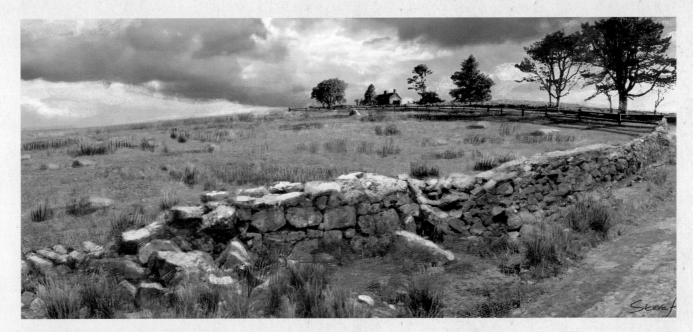

When we were down in Devon scouting—where the story is actually set—I saw all the elements that I was looking for with the thatched roofs and the rock walls and the houses that looked right. But none of them actually fit the bill because we had to have space around for the field to plow. So I got into a helicopter and after hours crossing a barren moor landscape that had nothing in it, in the middle of nowhere, I saw an old ruin that had been there for a long, long time. It's one of those places where the landscape just speaks to you.

—RICK CARTER,
PRODUCTION DESIGNER

The skies over the moors are as dramatic as our story, and every variety of sky you can imagine came pouring over.

—STEVEN SPIELBERG, DIRECTOR

Devon concept art by Kevin Jenkins (opposite bottom) and Stephen Forrest Smith (opposite top and right).

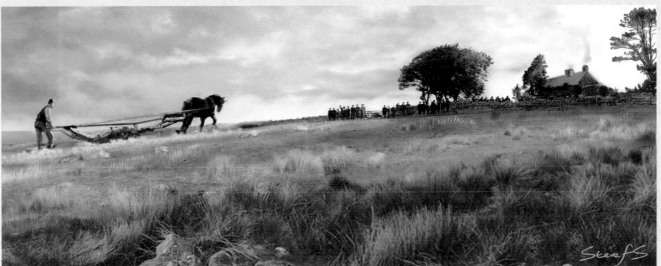

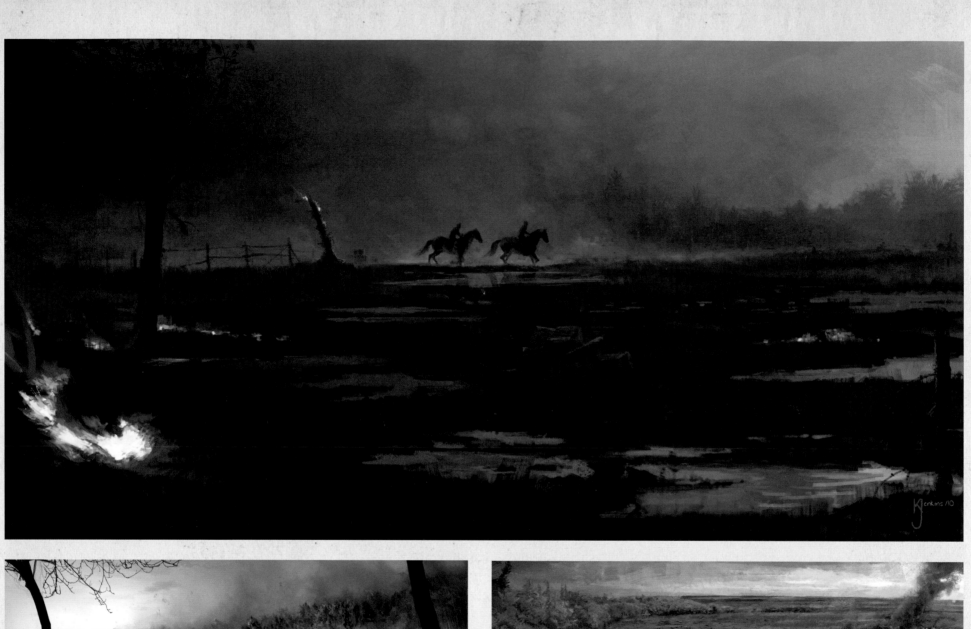
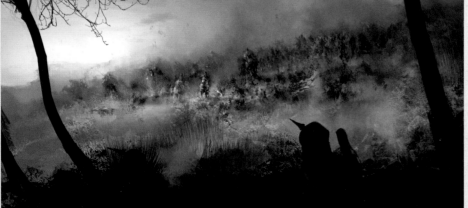
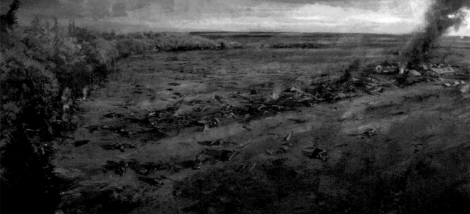

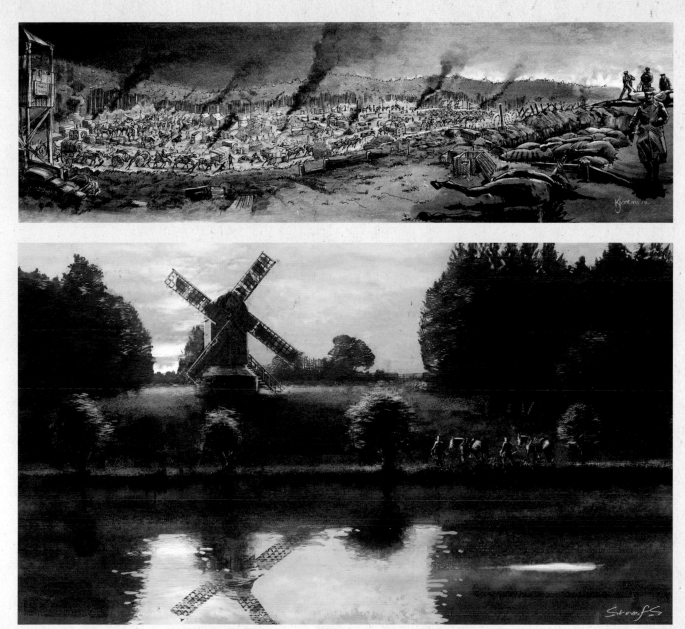

We shot the cavalry charge, the place the troops initially amass to train, and a German camp on the Wellington estate. We also found the "French countryside" there and built a windmill.

—RICK CARTER,
PRODUCTION DESIGNER

My family has lived in Stratfield Saye for the last two hundred years. We have quite a varied topography and terrain here so the crew was able to create interesting sets. In addition, it's got some historical resonance. There's obviously a great deal of military history in my family and a great connection with horses here. Copenhagen, the famous charger ridden by the first Duke of Wellington at Waterloo—and Copenhagen was his favorite—is buried in great splendor and great grandness here.

—ARTHUR MORNINGTON, GRANDSON
OF THE DUKE OF WELLINGTON

Concept art by Kevin Jenkins (opposite and above right) and Stephen Forrest Smith (bottom right).

Past 2 layers of barbed wire as Joey charges toward us...

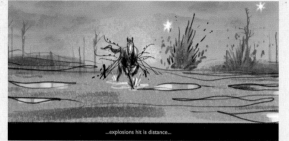

...explosions hit is distance...

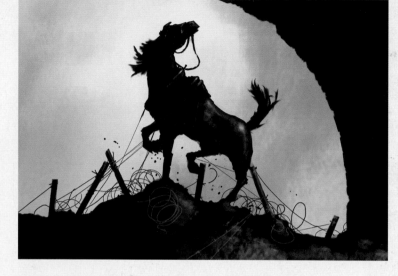

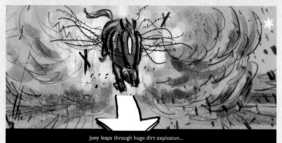

...he crashes through 1st layer of barbed wire...

Joey leaps through huge dirt explosion...

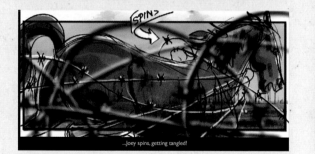

SPIN

...Joey spins, getting tangled!

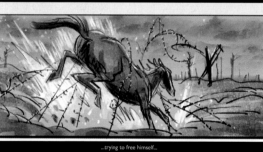

...trying to free himself...

We go from this bucolic, beautiful, lush landscape into the horror of the war and all sense of color and life dissipates. Finding a way to do that in a subtle nuanced way in combination with what Joanna Johnston was doing with the costumes and Rick Carter was doing with the set design really gives the movie quite an amazing look. It was a combination of extraordinary talents.

—KATHLEEN KENNEDY, PRODUCER

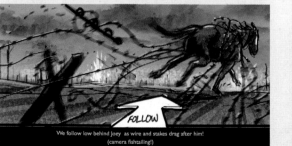

FOLLOW

We follow low behind Joey as wire and stakes drag after him!
(camera fishtailing!)

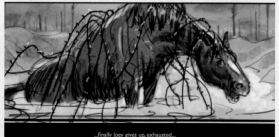

...finally Joey gives up, exhausted...

LEFT: Storyboards by Josh Sheppard showing Joey in No Man's Land. ABOVE: Joey caught in the barbed wire of No Man's Land. OPPOSITE: No Man's Land set.

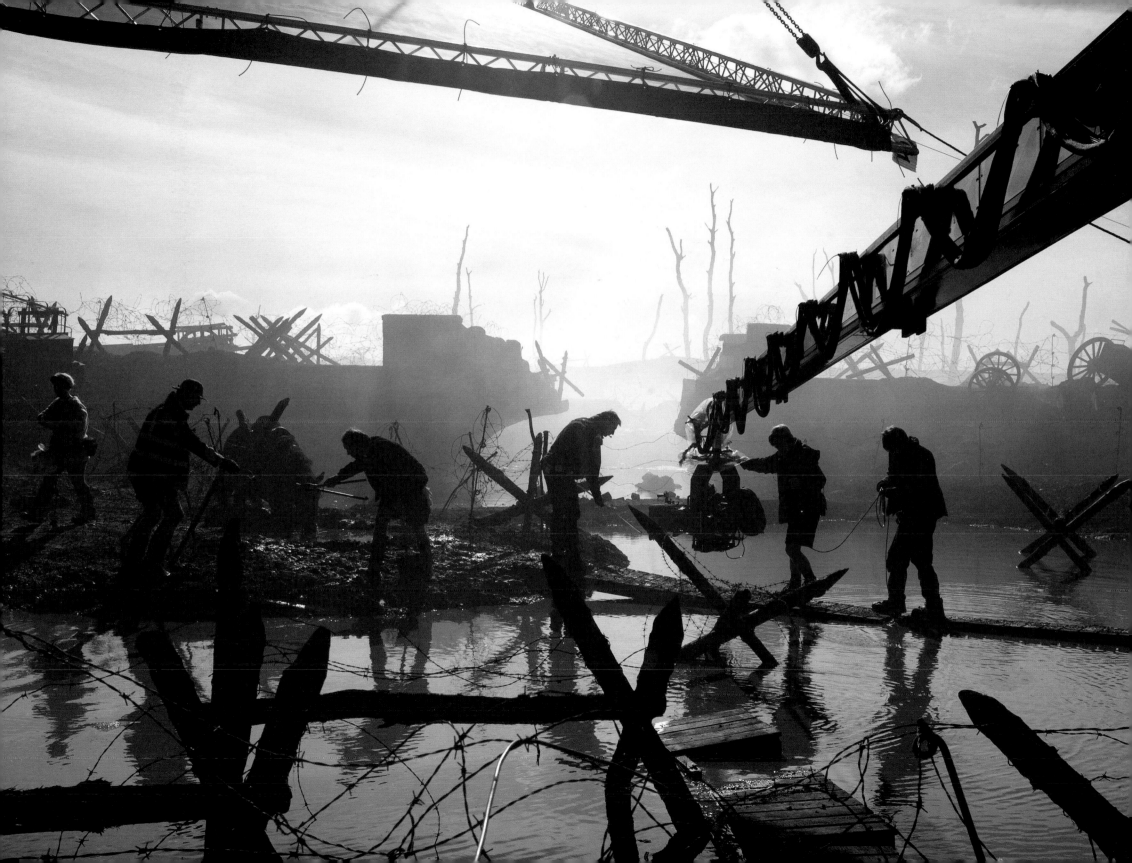

Part 3
The History
of War Horses

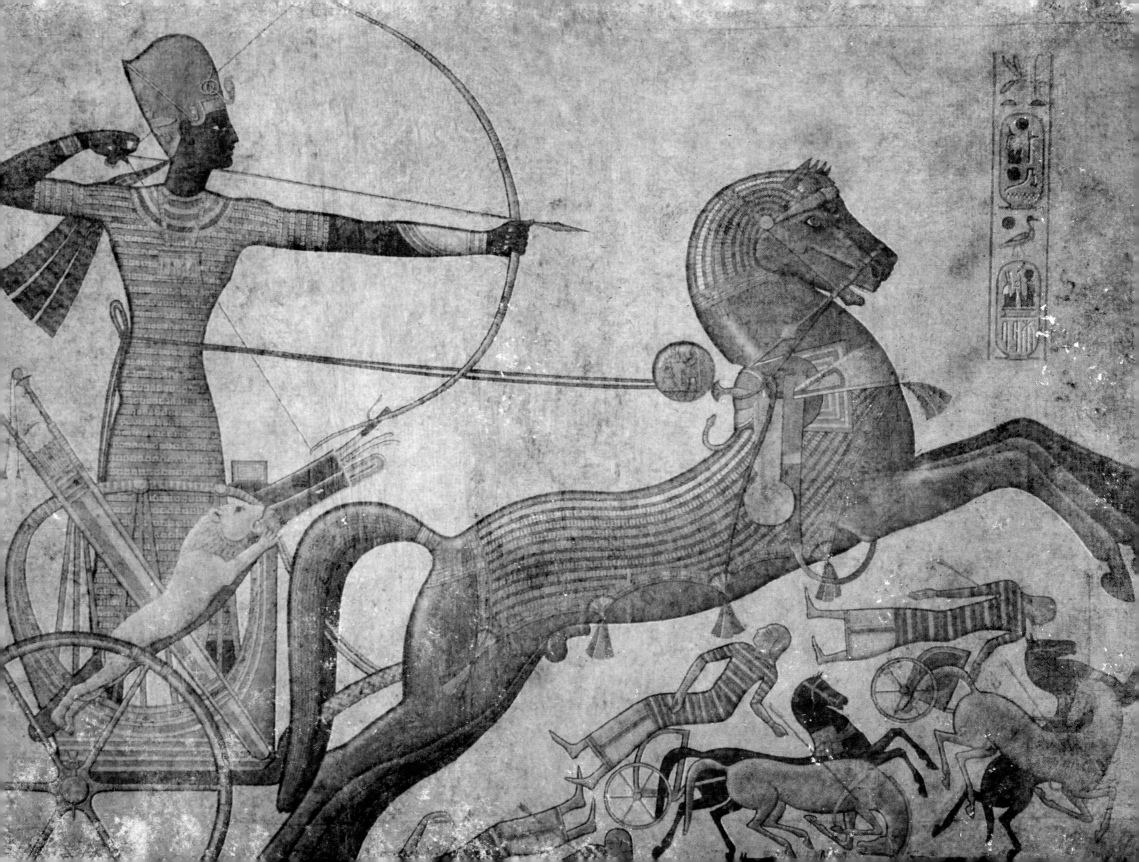

An Ancient Beast

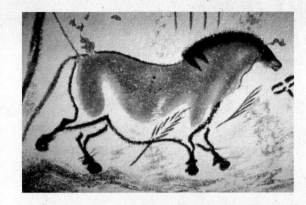

Abbout 34,000 years ago someone thought enough about horses to carve a figure of one from a mammoth's tusk to create one of the earliest know pieces of art—*The Vogelherd Horse*. Around the same time images of horses, along with wooly rhinoceroses, started appearing on cave walls in Europe giving evidence that they were being hunted.

Fast forward thirty thousand years or so and the people of the Asian steppe had domesticated the horse, keeping them for milk and meat. But it wasn't for another two thousand years that the horse became a tool of war. Chariot burials—tombs that not only held the dead, but their highly prized chariots, and occasionally even their horses—have been found among the ruins of the Botai people of Kazakhstan. Five hundred years later someone decided to hop on and be the first to ride horseback.

THE WAR HORSE

But while it took thousands of years for horses to go from food source to weapon, soldiers fast figured out that those with horses could easily defeat those without, and if both armies had horsepower, it was training and strategy that counted. So around 1400 B.C. Kikkuli—master horse trainer to the Hittite king Suppiluliuma I —wrote a how-to guide detailing the proper care for war horses that included regimens of weight training, swimming, and specific recipes for feeding. His techniques no doubt helped the Hittite charioteers successfully challenge the all-powerful Egyptians.

Thus—from the steppes of central Asia to medieval Europe, from the Japanese samurai to the American Indian—the horse became an integral part of warfare.

Opposite: Ancient Egyptian image of Ramses II (1292–25 B.C.) at war in his chariot. Top Right: Paleolithic cave painting of a horse from the Lascaux caves in southwestern France, circa 15–18,000 B.C. Below Right: *Alexander Taming Bucephalus* by François Schommer, circa 1895. An image of Alexander the Great taming his beloved warhorse, Bucephalus.

THE CAVALRY'S LAST STAND

But the writing was on the wall for mounted troops even as early as the American Civil War as better, farther-reaching artillery came into use. Fifty years later when trenches, barbed wire, poison gas and machine guns were added to the mix the cavalry—which had dominated warfare for millennia—suddenly became more of a liability than an asset. Where they had once been the fastest, most agile fighters on the battlefield, they were now slow (compared to mechanized vehicles) and they made easy and outstanding targets (for automatic weapons). And—as always—they were expensive and difficult to maintain and transport. By comparison tanks and motorbikes were a breeze.

Still, cavalries were used on the battlefield early in the war, though they were shortly redirected to better use, mostly where vehicles could not go: through the muck, for reconnaissance, to carry messengers, to pull ambulances, and, along with mules, to haul artillery and supplies. The Germans also used horses to pull their field kitchens and, experimentally, as biological weapons, infecting them with anthrax and glanders.

The British Cavalry battled longer than it's foreign counterparts, especially in Palestine where the Turks likewise were still on horse-back. The final mounted charge by the The British Household Cavalry—directly into machine gun fire and barbed wire—occurred in 1917 during an attach on the Hindenburg Line in Arras. It ended in slaughter.

DRAFTED

When the war began in 1914 there were 25,000 horses in the British Army, and the War Office, expecting a short war, but wanting to prepare for worse, gave the order to increase the number to 500,000.

They recruited as many as possible from the English countryside but the main source of horses during the war was the United States where 1,000 horses would cross the Atlantic every day between 1914 and 1917.

FRIEND AND FOE

Having horses in camp, or even on the battlefield, tended to raise morale among the troops. But keeping conditions sanitary—the never-ending job of manure and carcass disposal—for an army on the move was often impossible. Insects and disease—adding yet more misery to life in the combat zone—were the result.

By 1917 there were over one million horses and mules in the British Army. But due to star-vation, falls into artillery ditches, exhaustion, drowning (sometimes in mud), bites by tse-tse flies, and poison gas, nearly half a million were lost during the war. Those that lived suffered from shell shock, bullet wounds, the flu and ringworm, and were left by the thousands along the Western Front.

BEASTLY TOLL

At the end of the war older horses were killed and younger horses sold for meat, mostly in France, which was common even before the war. The loss of horses during World War I—estimated to be eight million worldwide—was a major factor in speeding up the mechanization that began around the turn of the century. Busses, cars, tractors, and trucks all replaced the horse.

Today the British Army has fewer than 450 horses—mostly used to carry supplies across any tough landscape. The Defence Animal Centre's largest focus is now dogs. ∎

OPPOSITE: *The First VC of the European War, 1914* by Richard Caton Woodville. This oil painting depicts the 9th Queen's Royal Lancers at Audregnies, Belgium, in battle on August 24, 1914, where Captain Francis Grenfell won the Victoria Cross medal, the highest military honor awarded for valor in the face of the enemy.

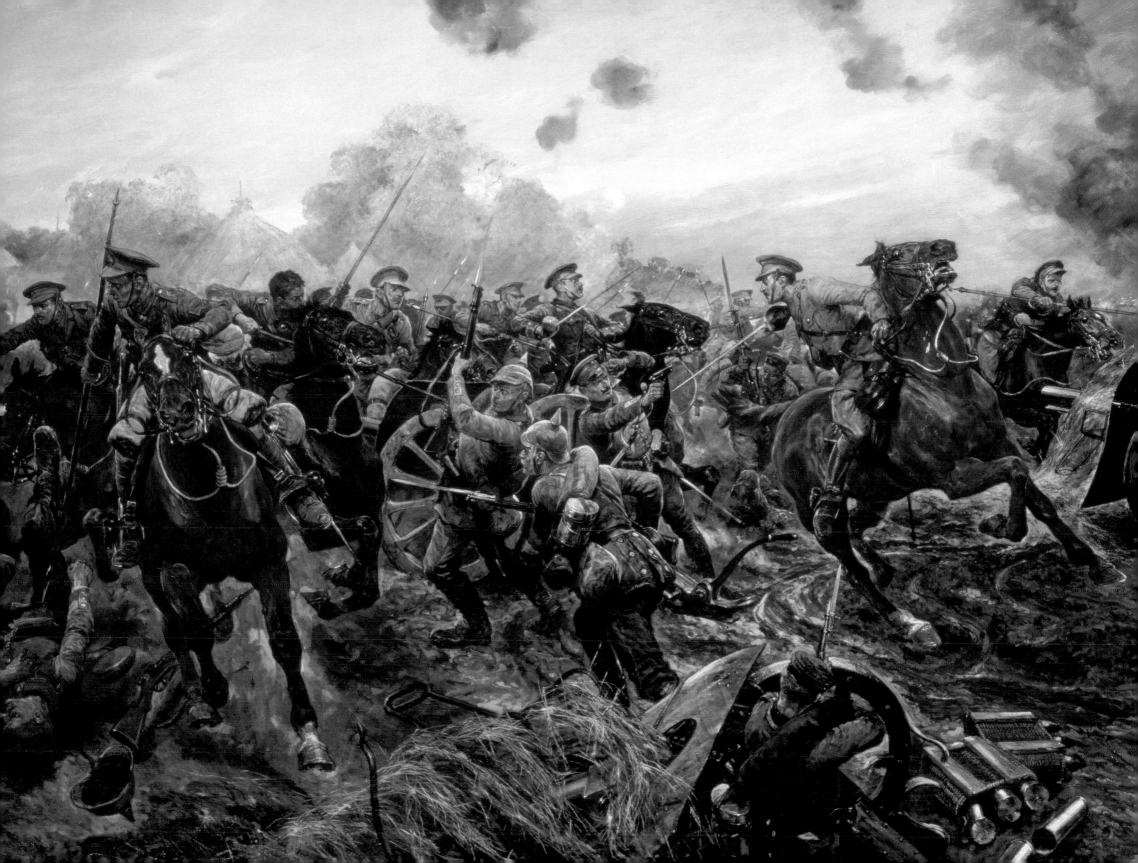

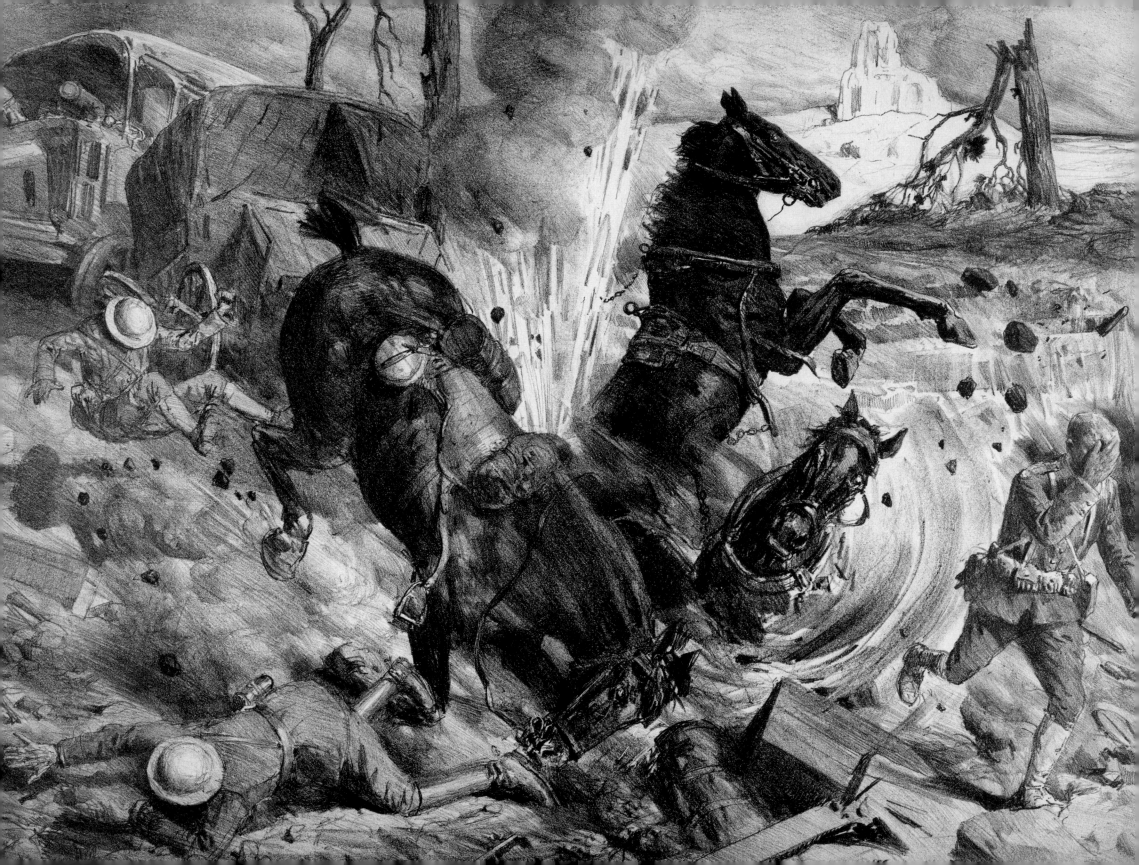

The Great War

A bullet to the jugular—along with a healthy dose of nationalism, imperialism, and a nineteenth-century tangle of alliances—led to the world's first global war.

On Sunday June 28, 1914, on a visit to Sarajevo, the car carrying Archduke Franz Ferdinand—heir to the Austro-Hungarian Empire—and his wife Sophie, turned down the wrong street where, as luck would have it, a Bosnian Serb named Gavrilo Princip spotted and shot them both. He was one of six conspirators assigned with killing the Archduke that day and this was the second attempt. The first happened not long after the couple arrived when one of the other conspirators hurled a hand grenade at their car but missed.

A TANGLED WEB

One month later Austria-Hungary declared war on Serbia and Russia, who had a treaty with Serbia, came to its defense. Germany, a close ally of Austria-Hungary, then declared war on Russia. France, honoring its treaty with Russia, was now pitted against Germany and Austria-Hungary. In order to capture Paris in the most efficient manner, Germany decided to cross through neutral Belgium which drew Britain— aligned with both France and Belgium—into the war. With Britain came her colonies: Australia, Canada, India, New Zealand and South Africa. Japan, allied with Britain, declared war on Germany shortly after that. The Ottoman Empire, honoring its August 1914 secret treaty with Germany, brought the Middle East into the fracas, and, late to the party, came the Italians (in 1915)

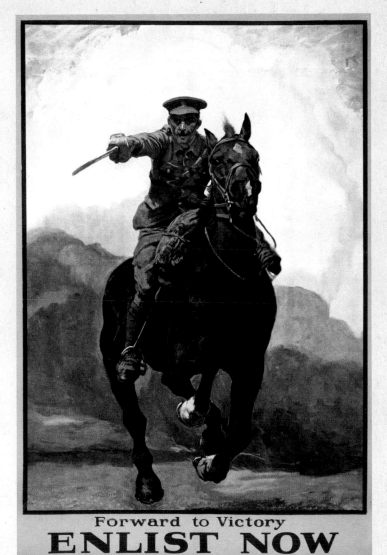

Forward to Victory
ENLIST NOW

OPPOSITE: *Night Bombing by Aeroplanes on a Road Near Soissons* by Lucien Jonas, 1927, showing a bomb strike during WWI. RIGHT: *Forward! Forward to Victory. Enlist Now*, 1915, a British World War I recruitment poster.

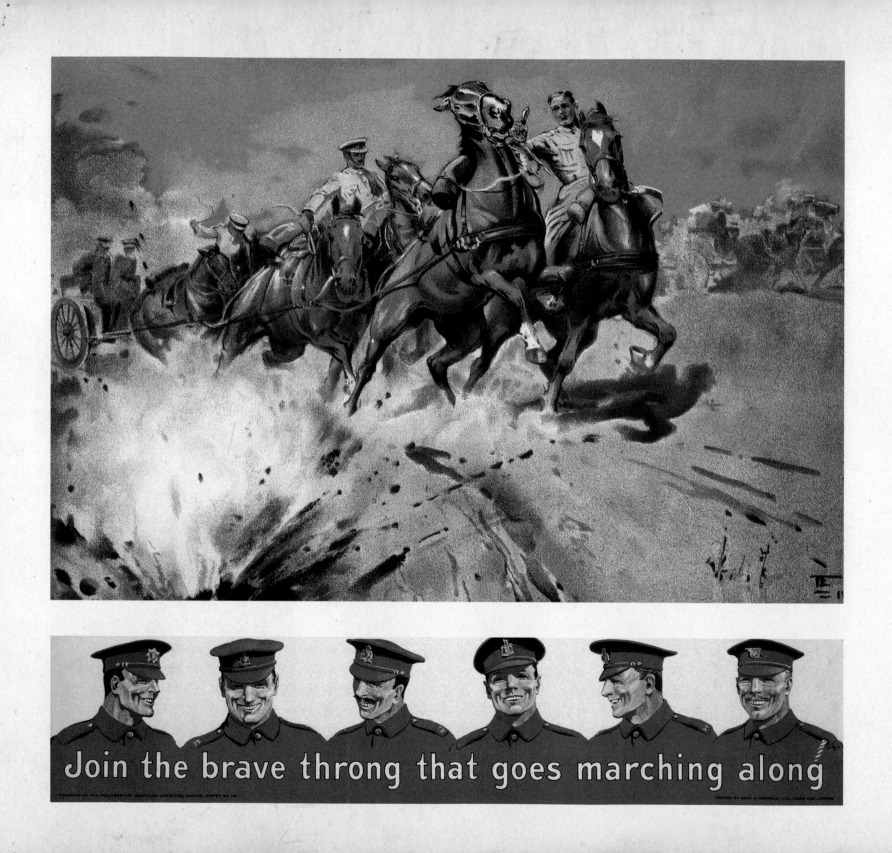

Join the brave throng that goes marching along

breaking their alliances with Germany and Austria-Hungary and siding with the Allies. Last, but not least, the United States ended its policy of neutrality in 1917 by declaring war on Germany and Austria-Hungary.

WAR OF FIRSTS

Aerial bombers, poison gas, flamethrowers and tanks were all introduced during the First World War. Submarines and battleships fought at sea and ace pilots took to the air in great number for the first time, and this was the first war to be fought on three continents. But it was the land war in western Europe, with its newly-improved artillery, modern machine guns, and barbed wire (used for the first time in war), that became the definitive face of this conflict.

Trench warfare quickly developed as a strategy because the new weapons were not particularly mobile. The side that could dig in and wait it out had the advantage, so the western front became a series of opposing trenches reaching from Switzerland to the North Sea. But while they gave shelter and protection from bullets,

trenches were wet, cold, and crowded; perfect breeding grounds for diseases like trench foot, typhus, dysentery and pneumonia. Lice and rats were everywhere. Boredom prevailed. Still, stepping out into the fray was nothing short of sheer horror.

The Battle of the Somme epitomizes the brutality of this war. On July 1, 1916, after a week of bombarding the German lines (with one and a half million shells), the Allies went "over the top," leaving their trenches behind. Sixty-thousand Brits were killed or wounded on the first day of battle alone. On November 18—more than eighteen weeks later—a snowstorm finally brought the grueling battle to a halt. The Germans suffered half a million casualties and the Allies over six hundred thousand. Only eight miles of ground were won.

ASTOUNDING LOSS

Before the Great War was over, the Germans, Russians, Austro-Hungarians and Ottomans each lost an empire. Of the sixty-five million soldiers who fought, eight and a half million were

OPPOSITE TOP: Detail of a British recruitment poster showing cavalry in battle, 1915. OPPOSITE BELOW: World War I recruitment poster showing a row of smiling British soldiers, 1915. RIGHT: Recruitment poster for the American Red Star Animal Relief (now known as the Red Star Animal Emergency Services), circa 1917.

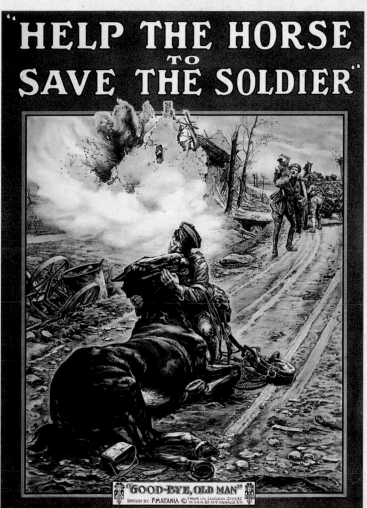

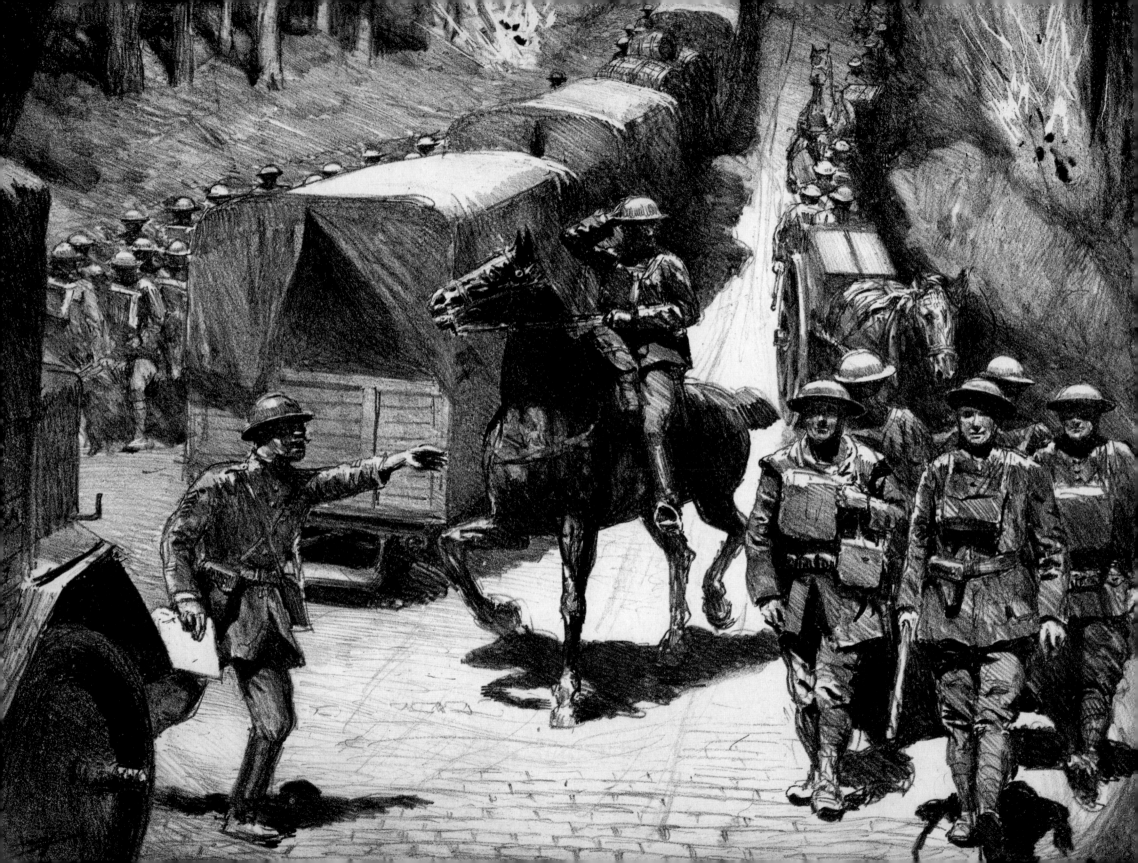

killed, over twenty-one million were wounded and nearly eight million more were captured or missing. Seven million civilians died as well, due to military action, famine, and disease.

The armistice signed on November 11, 1918 brought the fighting to an end. But the Treaty of Versailles, signed five years to the day after Archduke Ferdinand's assassination, contained a "guilt clause" that required Germany to take blame for the war and make reparations they found excessive. That clause along with the horrid social, economic, and health conditions left in the war's wake are often cited as key causes of the Second World War. ■

OPPOSITE: *A cross roads shelling of ammunition trains* by Lucien Jonas, 1927. TOP RIGHT: *"Good Friends" An artillery driver and his horse enjoy a rest*, by John Warwick Brooke, official British war photographer c. 1916 taken on the Western Front in France. CENTER RIGHT: *Scene on the Somme Front*, by Ernest Brooks, official British war photographer, 1916. BOTTOM RIGHT: *Tanks attack on Thiepval*, 1916, by Ernest Brooks showing the newly invented tank near the village of Thiepval, France, which was completely destroyed during WWI. FAR RIGHT: *British working party in German trench, recently captured*, c. 1916 by Ernest Brooks.

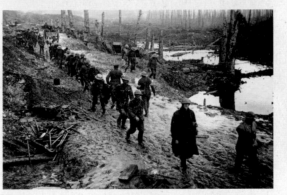

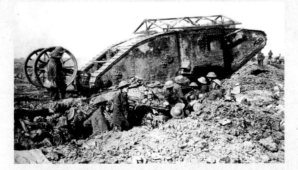

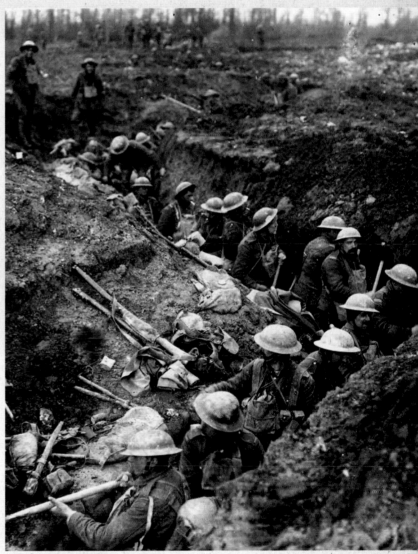

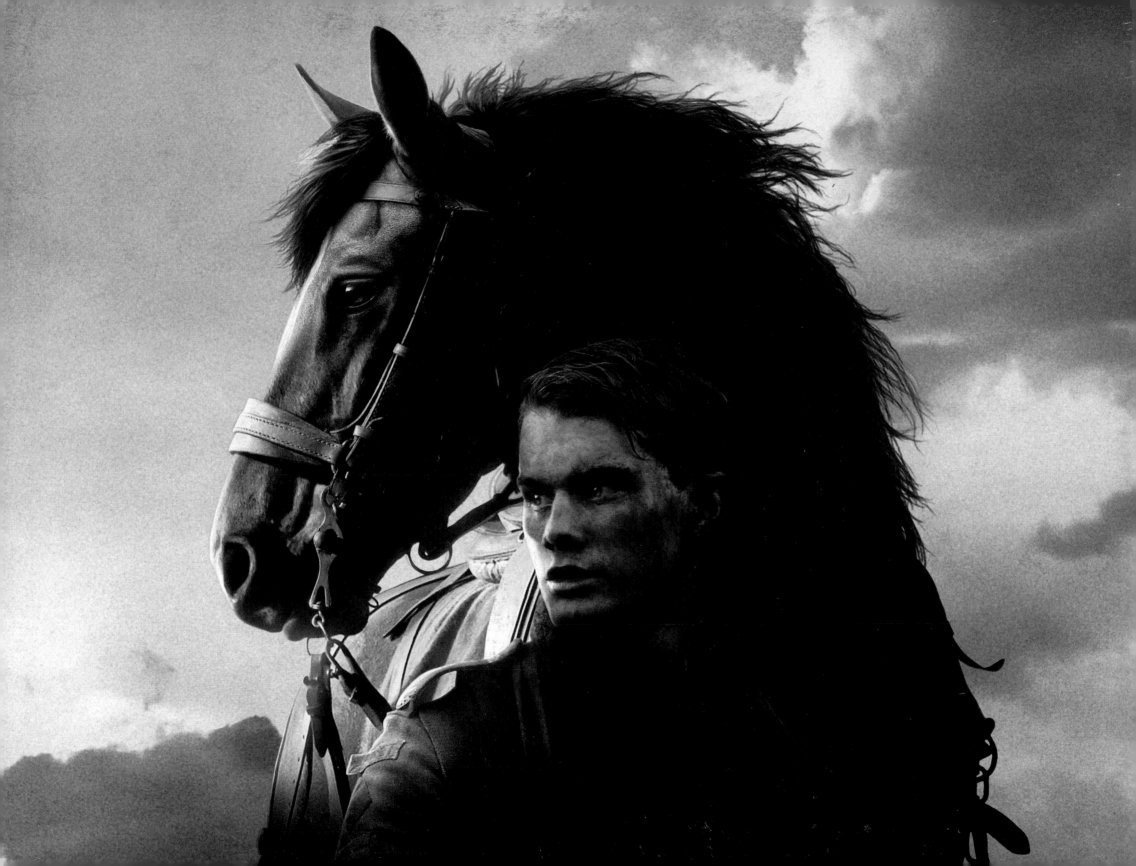

WAR HORSE

A STEVEN SPIELBERG FILM

DREAMWORKS PICTURES and RELIANCE ENTERTAINMENT PRESENT AN AMBLIN ENTERTAINMENT/KENNEDY/MARSHALL COMPANY PRODUCTION A STEVEN SPIELBERG FILM
"WAR HORSE" EMILY WATSON DAVID THEWLIS PETER MULLAN NIELS ARESTRUP JEREMY IRVINE CASTING BY JINA JAY CO-PRODUCERS ADAM SOMNER TRACEY SEAWARD
MUSIC BY JOHN WILLIAMS COSTUME DESIGNER JOANNA JOHNSTON EDITED BY MICHAEL KAHN, A.C.E. PRODUCTION DESIGNER RICK CARTER DIRECTOR OF PHOTOGRAPHY JANUSZ KAMINSKI EXECUTIVE PRODUCERS FRANK MARSHALL REVEL GUEST
PRODUCED BY STEVEN SPIELBERG KATHLEEN KENNEDY BASED ON THE NOVEL BY MICHAEL MORPURGO SCREENPLAY BY LEE HALL AND RICHARD CURTIS DIRECTED BY STEVEN SPIELBERG

DREAMWORKS
PICTURES

PG-13 PARENTS STRONGLY CAUTIONED
Some Material May Be Inappropriate for Children Under 13
INTENSE SEQUENCES OF WAR VIOLENCE

SOUNDTRACK ON SONY CLASSICAL
warhorsemovie.com

Touchstone
Pictures

Acknowledgments

PHOTO CREDITS DAVID APPLEBY: pages 5, 17, 25 (left & right), 27 (right & center), 28 (center & left), 31 (left), 34, 40, 42, 45, 46, 47, 48, 55, 59, 61–64, 68, 70, 76–82, 84, 85, 112, 122. ANDREW COOPER: pages 6, 13, 21, 24, 25 (center), 26, 27 (left), 28 (right), 29, 30, 31 (right), 35–38, 44, 49, 50, 52–54, 56, 71, 72, 87–89, 92–96, 98, 99, 101, 102, 104, 106–109, 113–121, 129. KATHLEEN KENNEDY: pages 8, 10, 22, 74.

PERMISSIONS page 132: © Shutterstock.com; 135: The First VC of the European War, 1914 (oil on canvas), Woodville, Richard Caton II (1856-1927) / National Army Museum, London / The Bridgeman Art Library International; 136: Library of Congress, Prints & Photographs Division, LC-DIG-pga-03884; 137: Library of Congress, Prints & Photographs Division, WWI Posters, LC-USZC4-11027; 138 top: Library of Congress, Prints & Photographs Division, WWI Posters, LC-USZC4-10904; 138 bottom: Library of Congress, Prints & Photographs Division, WWI Posters, LC-USZC4-11019; 140: Library of Congress, Prints & Photographs Division, LC-DIG-pga-03877; 141: All images courtesy of The Trustees of the National Library of Scotland.

Special thanks to the following:

For their wonderful Forewords, provided exclusively for this book: Director/Producer Steven Spielberg, Producer Kathleen Kennedy, Novelist Michael Morpurgo, and Co-Screenwriter Richard Curtis.

For providing interview extracts from the filmmakers, cast, and crew: the talented documentarian Laurent Bouzereau.

For their quick response and assistance in gaining permissions for various contributions to this book: Alison Metcalfe, Manuscripts Curator at the National Library of Scotland, Véronique Baxter and Laura West at David Higham Associates, Sarah McDougall at Portobello Studios, and Kay McCauley at the Pimlico Agency.

For their support for Newmarket to make this book: DreamWorks Studios Stacey Snider and Marvin Levy and the Disney/Touchstone team including Kevin Campbell, and especially to Theresa Cross and Steve Newman, whose expert guidance and vision were essential to bringing this book to completion.

For his overall editorial expertise and special contribution of *The History of War Horses* section: Christopher Measom.

For the patient and supportive HarperCollins production department, especially Susan Kosko, John Vitale, and Dori Carlson, and Newmarket's unflappable, expert project editor, Keith Hollaman, without whom this book could never have reached the finish line.

For his unique talent as a designer and great eye for choosing imagery that will not only make beautiful pages, but also give readers an opportunity to revisit the extraordinary film that this book celebrates: Timothy Shaner.

For all who entrusted us to make this book about such a remarkable movie, we are most grateful and thank you.

—*Esther Margolis, Project Director*
Newmarket Press